BURT FRANKLIN: RESEARCH & SOURCE WORKS SERIES
Art History & Reference Series 48

The Life and Works of Gilbert Stuart

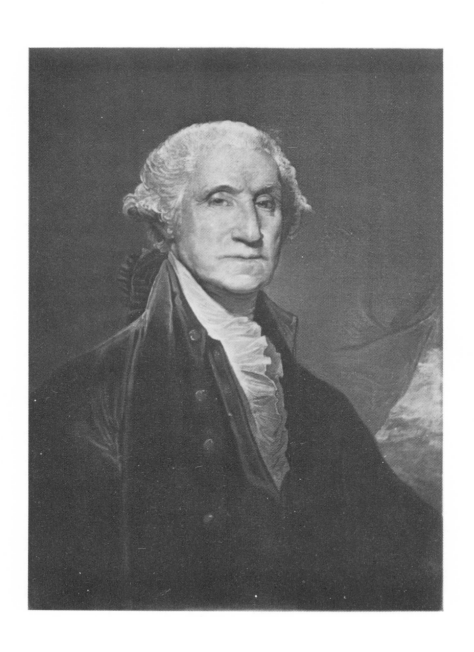

Washington

(The Gibbs Portrait)

Photogravure

The Life and Works of GILBERT STUART

By George C. Mason

With selections from Stuart's Portraits
Reproduced on Steel and by Photogravure

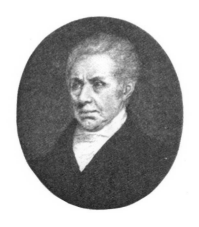

BURT FRANKLIN REPRINTS
New York, N. Y.

759.1 B
StuARt, G.

Published by LENOX HILL Pub. & Dist. Co. (Burt Franklin)
235 East 44th St., New York, N.Y. 10017
Originally Published: 1879
Reprinted: 1972
Printed in the U.S.A.

Burt Franklin: Research and Source Works Series
Art History and Reference Series 48

Library of Congress Cataloging in Publication Data

Mason, George Champlin, 1820-1894.
 The life and works of Gilbert Stuart.

 Reprint of the ed. published by Scribner, New York.
 1. Stuart, Gilbert, 1755-1828. 2. Portraits—Catalogs. I. Title.
ND1329.S7m37 1974 759.13 (B) 72-82298
ISBN 0-8337-5236-7

PREFACE.

THIS biography of Gilbert Stuart was written at the request of Miss Jane Stuart, the only surviving member of Mr. Stuart's family. Miss Stuart intended to prepare it herself, and had published three papers on the subject in "Scribner's Magazine"; but finding the work too laborious, owing to the demands of her profession on her time, and the difficulty experienced in searching out the pictures painted by Stuart (now widely scattered), it was assigned by her to other hands; with the one request, that the volume should be a faithful record, so far as the materials within the reach of the biographer would allow, of her distinguished father's life and works. The task has not been a light one. With the exception of a few letters addressed to Stuart, the drafts of a couple of letters that he wrote in 1800, and a few brief entries made in a note-book while he resided in Boston, Stuart left no papers that could be made available in sketching his career; and nearly everything that has been written of him up to the present time, has been made up of anecdotes (many of them of

questionable authenticity), first given to the world by Dunlap and Dr. Waterhouse.

But Stuart lives in his works, and an effort has been made to search out his portraits, scattered over the sea-board States and throughout England, and learn something of their history. Wherever owned they are highly prized, and in many families traditions connected with them have been preserved. It has been a pleasant task to collect these reminiscences and to bring them together. While so engaged, the author has been assisted by many admirers of Stuart's pictures. To Miss Eliza Susan Quincy, of Quincy, Mass.; Mr. Jonathan Mason, Boston; General W. Raymond Lee, Roxbury; Mr. J. M. Falconer, Brooklyn, and Mr. Henry T. Drowne, New-York; Messrs. John William Wallace, Charles Henry Hart, Herbert Welsh, W. S. Baker, and E. D. Marchant, Philadelphia; Mr. Winslow M. Watson, Washington, D. C.; Mr. Osmond Tiffany, Baltimore, and many others, his thanks are due for favors of this kind. He would also return his cordial thanks to Dr. William F. Channing, Providence; Miss Binney, Philadelphia; Miss Callender, Newport; Messrs. Charles Joseph Bonaparte, Baltimore; John R. Stevens and Egbert Benson, Jr., New-York; Henry E. Pierrepont and J. M. Falconer, Brooklyn; the New-York Historical Society, the Curators of the Academy of Fine Arts, Philadelphia, and the Art Museum, Boston, for permitting negatives to be taken of the pictures selected as illustrations of this work.

The Washington, on steel, by Burt, has never before been engraved, and the photogravure of the same portrait, by Goupil, while it shows how well the engraver has done his part, gives another and not less faithful aspect of the picture.

More than six hundred portraits by Stuart are referred to in these pages. But numerous as are the pictures here mentioned, others equally worthy of notice have probably been overlooked, for this is the first systematic effort (begun by Miss Stuart and carried on by the author) to collect even the names of Stuart's sitters; and it is only by calling attention to the subject in this way, that we shall learn where some of his pictures are still hid from sight.

It is the wish of the author that any oversight discovered by the reader may be made known to him, in order that it may be corrected in a future edition. And he would add, that in giving the name of a picture by Stuart, not mentioned in these pages, it should be accompanied by the full address of the owner.

G. C. M.

Newport, Rhode Island, 1879.

LIST OF PLATES.

LIFE OF GILBERT STUART

"I had rather leave a good portrait of myself behind me than have a fine epitaph."—HAZLITT.

"What though the dear and honored features and person on which, while living, we never gazed without tenderness or veneration, have been taken from us; something of the loveliness, something of the majesty, abides in the portrait, the bust, the statue. The heart, bereft of the living originals, turns to them, and cold and silent as they are, they strengthen and animate the cherished recollections of the loved, the honored, and the lost."
—EVERETT.

LIFE OF GILBERT STUART

"I had rather leave a good portrait of myself behind me than have a fine epitaph."—HAZLITT.

"What though the dear and honored features and person on which, while living, we never gazed without tenderness or veneration, have been taken from us; something of the loveliness, something of the majesty, abides in the portrait, the bust, the statue. The heart, bereft of the living originals, turns to them, and cold and silent as they are, they strengthen and animate the cherished recollections of the loved, the honored, and the lost."
—EVERETT.

Gilbert Stuart

From his Pen-and-Ink Drawing

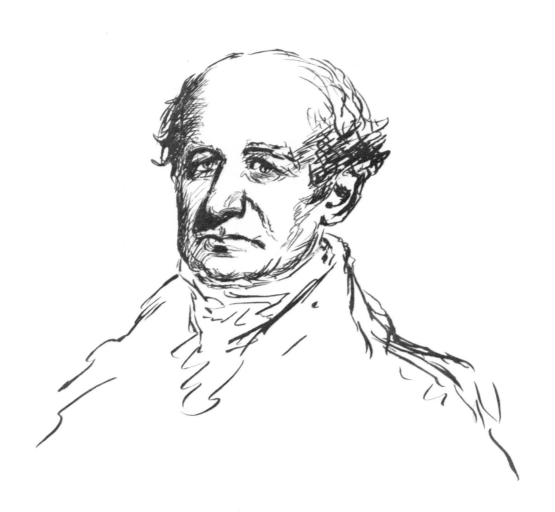

I.

AT the head of Petaquamscott Pond, in the Narragansett country, in Rhode Island, shut in by trees and far away from the din and stir of the world, there stands an old-fashioned, gambrel-roofed and low-portaled house, by the side of a tiny stream. This old house, so seldom visited and so little thought of, has a history, for it was the birthplace and early home of Gilbert Stuart, the artist.

There is little within the house to attract attention: the ceilings are low, the fire-places are wide and flaring, and the stairs steep and contracted; but the low door is opened to all who care to enter, and for the asking one may see the room in which the painter was born. It has never been altered, and the place has known but few changes, other than that the wheel that once ground snuff for the many, now grinds corn for a sparsely settled neighborhood.

In 1746, Dr. Thomas Moffatt, a native of Scotland, and a physician of the Boerhaavean school, who had been implicated the previous year in the insurrection at home, came to America and settled in Newport. He was a man of marked ability, and made many friends. But in America he lacked the excitement of politics, and as he could not be idle, he applied himself to his profession, till there was a stir about the Stamp Act. This measure, so

unpopular in New England, he advocated strenuously, and thereby brought down upon his head the wrath of a mob; his house was entered, his library and other valuables were destroyed, and to escape personal violence he sought shelter on board a frigate in the harbor.

At the time that Dr. Moffatt arrived in America, there was not a snuff-mill in the colonies, and all the snuff used was imported from Glasgow. The Doctor, seeing, as he supposed, a large profit in the trade, thought it would pay to go into the business of tobacco-raising and snuff-grinding. To this end he associated himself with a brother Scotchman, the son of a Presbyterian clergyman, and a native of Perth, by the name of Gilbert Stuart.

It has been said that Moffatt, who had known Stuart at home, and was aware that he was a good mill-wright, sent for him to come to America. But Stuart, if a mill-wright, could have had but little experience in his calling, for he was but nineteen or twenty when he came hither. The family tradition, that he was a political refugee, is probably nearer the truth. Opposed to his father in politics, he joined the Pretender, Prince Charles Edward, and after the battle of Culloden, fled to the Colonies. In America he wandered from place to place, but finally came to Rhode Island, where he chanced to meet Dr. Moffatt. It was not long before the two became warmly attached to each other, and the Doctor found he could not get on without his young friend, who, when made acquainted with the snuff-mill project, gave it much attention. From this time forward, Stuart was identified with the mill, and ever after was known as "the snuff-grinder."

Having established himself, Stuart looked around for a help-mate, and found one in Elizabeth Anthony, a most attractive young woman, whose beauty has been referred to by Sabine in his "Loyalists." She was the daughter of Albro Anthony, a native of England, then residing on a large farm in Middletown, a few miles from Newport. To the house and mill on the Petaquam-

scott (for the house and mill were one) he took his bride, and in that quiet retreat three children were born to them — James, who died in infancy, Ann, who became the wife of Henry Newton, and the mother of Stuart Newton (the artist), and Gilbert, who was born December 3d, 1755. In the record of St. Paul's Church, Narragansett, there is the following entry:

"April 11th, 1756, being Palm Sunday, Doctor McSparran read prayers, preached, and baptized a child named Gilbert Stewart, son of Gilbert Stewart, the snuff-grinder. Sureties: the Doctor, Mr. Benjamin Mumford, and Mrs. Hannah Mumford."

In this entry two things are noticeable, — the spelling of Stuart's name, and the absence of "Charles" after the Gilbert: he having been known in early life as Gilbert Charles Stuart. The first may be easily traced to inadvertency in making the entry; and the inserting of the Charles in the child's name was probably an afterthought of his father, who was as much of a Jacobite as was his friend and countryman, Dr. Moffatt. The "Charles," Stuart dropped in after years, and answered only to the name of Gilbert Stuart.

The snuff-mill was run but a few years. It had been successful up to a certain period, when a sudden turn in its affairs brought it to a close.

This was unfortunate for Stuart; but while he was casting in his mind what course to pursue, Mrs. Stuart came into the possession of a little property; and as nothing was to be gained by still residing in the mill, he deemed it prudent to remove to Newport, where, while looking for an opening, his son could have the benefit of proper schools. Up to this time Mrs. Stuart had been the lad's only teacher. From her he had acquired the rudiments of learning, and although unacquainted with Latin, and therefore unable to teach the language, she created such a desire in his mind to master it, that he soon made himself familiar with it when the opportunity offered.

At that time the Reverend George Bissit was residing in New-

port. He was the assistant minister of Trinity Church, and the head of a parochial school, founded by Nathaniel Kay, "Collector of the King's Customs." Mr. Bissit had the reputation of being a man of learning, a fine Latin scholar, and a successful teacher. On the death of Rev. Marmaduke Brown, the Rector, he was chosen as his successor, and ably presided over the parish till the breaking out of the Revolution, when, refusing to give up his allegiance to the Crown, he was forced to leave the colony. His property was confiscated; but in compliance with the earnest appeal of Mrs. Bissit, the little that he had was given up to her, and she was permitted to leave the place with her family, to join her husband in New-York. Soon after they sailed for England, never to return. Under the instruction of this good man, Stuart made great progress, and soon became a Latin scholar. But it was hard work for him to study; his spirits were too buoyant for that; he was too fond of pranks—all sorts of mischief that boys are prone to, and which often makes them hard to manage; and, moreover, he had another love, which claimed more than a share of his attention. He could curb his inclination for mischief for the moment; was willing to give up a portion of his time to his books, for he saw the need of it; but his fondness for drawing he could not suppress, nor did he attempt it.

No portfolio of Stuart's early drawings has been preserved, for he had no portfolio. No record has been made of his early efforts, —no record could be made,—for the first brush of a sleeve, the first passing shower, effaced what he had sketched with chalk or charcoal, on a fence, a slab, or a tail-board.

In these early drawings there was no attempt at anything more than the merest outline, and in work of this kind there could be little that was improving; but it was to him a delight, and at last he came to feel that he could be, must be, a painter.

But how was he to learn anything of art, and who was to teach him even the rudiments of his calling? Art was then at a

low ebb in America, and there were but few even passable pictures in the Colonies. Even the few were beyond his reach; and where was he to gain the means or secure the influence that could command the services of proper teachers? It all seemed dark to him, and gloomy were his forebodings. But light began to dawn on him when his parents removed to Newport. Here a better field, limited as it was, was open to him. On many walls he could see prints that were tolerably good; curious old Dutch tiles looked out upon him from mop-boards and mantels, and the richly colored wares of China were to be seen in almost every household. But portraits were not readily to be found. Few, indeed, were the portrait painters at that day who could support themselves with their pencils; the majority having to supplement their art by other callings. In 1773, one Halpine, a painter whose name has been preserved in this way, advertised that he had taken a room near the brick market, in Newport, where, as portrait, herald and sign painter, he solicited a share of patronage.

In almost every instance, the names of artists that have come down to us are associated with some calling not properly connected with the fine arts. Smibert was certainly well introduced, and he at once made many friends in Newport and Boston. His portraits are among the best that we have of that period, and yet he had to paint coats-of-arms as well as likenesses; and his successor, Blackburn, who had the rare merit of painting hands well, and other qualities that should have found him employment everywhere, lacked encouragement. Even at a later date, after the Revolution, when there was a greater demand for portraits, Samuel King, the instructor in drawing of both Allston and Malbone, made and sold mathematical instruments when not occupied with sitters.

But still Stuart persevered. At last he obtained colors, a palette, and—when he could find them—sitters. The earliest product of his pencil, so far as is known, is a picture owned by Thomas R. Hunter, Esq., of Newport, R. I., a couple of Spanish

dogs. The following is the history of the picture, which has been carefully preserved :

Dr. William Hunter, who came to America in 1752, had attained to a high position in his profession, and practiced medicine over a wide circuit of country, having Newport for its centre. During a professional visit at the house of Gilbert Stuart, he asked Mrs. Stuart who made all the drawings in chalk and charcoal on the sides of the barn. She replied by pointing to her son, with whom the Doctor at once entered into conversation. Before leaving, the Doctor made the lad promise (the boy's mother having given her consent) that he would come to Newport on election day and make him a visit. The boy was true to his engagement, and the Doctor, interested in the young sketcher, gave him brushes and colors, and bade him paint a picture of the two dogs that were lying on the floor under a table. Stuart at once entered upon the work, and while engaged in painting the picture, remained a guest in the house of Dr. Hunter.

At the age of thirteen, Stuart met with encouragement in the form of an order for two portraits—likenesses of Mr. and Mrs. John Bannister, of Newport. The Bannisters were then prominent in Newport, and were large land-owners. These portraits are now in the Redwood Library. They are not remarkable as pictures, but the facts connected with them make them interesting. That they were like the sitters cannot be doubted; for a very beautifully painted miniature of Bannister, of an earlier date, in a similar scarlet coat, and showing the same cast of features, may still be seen in Newport.

At the age of sixteen, Stuart painted a portrait of his father, but what became of it is not known. It had a place in the collection of Stuart's pictures exhibited in Boston soon after the artist's death, but since then all record of it has been lost.

In 1770, Stuart had the friendly advice of one qualified to help him in his art studies. That year there came to America an artist

by the name of Cosmo Alexander. But little is known of him other than his name. That he was a gentleman was clear—one who was not only fond of art, but who had made some progress as a painter. He remained in the Colonies about two years, visiting in that time many places of interest; but no inconsiderable portion of his time was spent in Newport. While here, Stuart was brought under his notice, and seeing evidence of skill in the young man, he gave him all the instruction he was capable of, in the way of his calling. The pupil was quick to catch what was said to him, and made such rapid progress that Alexander, when he returned to England, took him with him, promising to put him in the way to learn all that related to his profession. This promise he would undoubtedly have kept; but, unfortunately, he died soon after reaching Edinburgh. In his last moments, he commended Stuart to the care of his friend, Sir George Chambers. But here a new misfortune befell Stuart; for Sir George quickly followed Alexander to the grave. Stuart was thus cast suddenly upon his own resources, and these were slight indeed, for he had not attained to sufficient skill in his profession to win his way satisfactorily. Sir George, before his death, had found an opening for him in the University of Glasgow, where he was studying diligently, to make good the defects in his education. But lacking the necessary means for his support, he could not long remain there. With his brush he could earn enough to meet his own simple wants, but not enough to dress as did his fellow-students; and, keenly feeling the annoyances growing out of his position, he abandoned the pursuit and thought only of returning to America. It has been said that the voyage home was made in a collier, bound for Nova Scotia, and was attended by every discomfort. So painful was the impression made upon him while shut up in the vessel, that he could never after be induced to speak of it.

Stuart had been absent two years, and although his experience had been a hard one, he had acquired a great deal of information.

He had seen better pictures than he could see at home, and had been brought into contact with men of established reputations. Thirsting for knowledge and quick to understand what he saw in the works of others, he felt that he was better prepared than he otherwise could have been to appear before his countrymen as a portrait painter.

That his merits were recognized at this early period is evident, for he was soon called upon to paint the portraits of some of the wealthy Jews in Rhode Island; one picture, a whole length of a Rabbi, supposed to be still extant somewhere in New-York, has been spoken of in particular. Among the portraits painted at that time were those of the Lopez family. He had also many other orders. "His uncle, Mr. Anthony of Philadelphia," says Dr. Waterhouse, "was proud of his ingenious nephew, and employed him to paint a portrait of himself, and of his wife and children." This led to other commissions, and, for one so young, he had already been very successful, particularly when we take into consideration the times.

But while so engaged, Stuart did not forget or neglect to study drawing from the life; and the better to understand what he felt to be of the utmost importance, he and his friend Waterhouse clubbed together and hired a "strong-muscled blacksmith" as a model, paying him half a dollar an evening.

All this was very pleasant and very profitable; but the disturbed state of the times began to make it difficult to obtain sitters; war seemed inevitable, and the chances were that if there was an open rupture between England and America, there would be no possibility of his again visiting Europe for a long time. He had tasted of the waters that as yet were beyond his reach, and nothing short of a fuller and more complete knowledge of art, as practiced abroad, could satisfy him. To stay at home while there was so much to see and learn in other lands was distressing; his friend Waterhouse had already sailed (March, 1775); he felt that he could earn,

wherever he went, the little needed for his support; every day his touch was growing stronger, and, with it all, he had an intense desire to study under West, his countryman; and so, with but one letter of introduction in his pocket, he embarked on board the last ship that escaped detention in Boston harbor, in the spring of 1775, and sailed for Great Britain. Where he landed is not known, but it was probably in London.

II.

ONCE in the metropolis, Stuart looked for cheap lodgings, which he had no difficulty in finding, and then he cast about for employment. But sitters were not easily to be had, especially by one so little known; and if, by chance, an order was obtained, it was at so low a figure as scarce to meet his daily wants. He certainly had one letter to a man of influence, but he failed to deliver it; and so he plodded on, filling slight orders when he could get them; and still the object of ambition—to be the pupil of West—was ungratified.

Miss Stuart says that at this time one of her father's old schoolmates, then residing in London, had the privilege of visiting at West's house, but that he never thought of serving his friend by bringing him to the notice of the great painter. But this state of things could not continue long, for Stuart's necessities made it imperative that he should take some decided steps, and summoning his courage, he called upon West without an introduction.

"West was dining with some friends when a servant told him that some one wished to see him. He made answer, 'I am engaged;' but added, after a pause, 'Who is he?' 'I don't know, sir: he says he is from America.' Thereupon one of the guests, Mr. Wharton, said, 'I will go and see who it is.' Wharton was from Philadelphia, and was intimate with West's family. He went

out and found a handsome youth, dressed in a fashionable green coat. With him he talked for some time, and finding that he was a nephew of Joseph Anthony, one of the most prominent merchants in Philadelphia, and who happened to be a friend of Mr. Wharton, he at once told Mr. West that he was well connected. Hearing this, West came out and received his visitor cordially. Stuart told him of his long desire to see him, and his wish to make further progress in his calling; to all which West listened with kindness and attention. At parting, he requested Stuart to bring him something that he had painted. This Stuart did gladly; in a few days he commenced his studies with West, and shortly after, in the summer of 1777, he was domiciled in his family. At that time he was two and twenty years of age."

The above was related by Dunlap, who had it from Stuart, and Miss Stuart has given me a similar version.

It was at this time, while contending with adverse fortune, that Stuart was called to Sion House, one of the country-seats of the Duke of Northumberland, to paint portraits of the Duke and two of his children. It was then a rare thing to have such an order. But the young painter had one solace during the time that he was struggling for bread, and that was a love for music, in which he had become very proficient. Years before he had mastered a number of instruments, and he had also met with some success as a composer. This knowledge of music was a most fortunate acquisition, for it helped him to eke out his scanty earnings while still a pupil under West, who imparted to him much that was valuable, but who added but little to his resources. It was therefore a matter of necessity that he should find some means of support during his novitiate, and he was quick to avail himself of the first opening that offered. It happened thus: Walking in one of the streets of London, known as Foster's Lane, he heard the notes of an organ. Pausing a moment to listen, he followed up the sound, which led him to the open door of a church, and as there was no

one there to make objection, he did not hesitate to enter. At once he became an interested spectator, for he had stumbled upon a number of candidates for the office of organist, who were in turn playing before the vestry. Stuart asked to be a competitor, which was granted; his playing was infinitely superior to that of the others, and it resulted in his election as organist, with a salary of thirty pounds a year, he having given satisfactory reference as to his fitness and standing. His reference was Sir Alexander Grant, a Scotch gentleman, to whom he had a letter from America, but whose acquaintance he did not make till he had been with West some time. When, at length, he became known to that gentleman, he was called upon to paint his portrait, full length, and a group of his children. The time came when these pictures helped to make Stuart's reputation. Stuart retained his love of music through life, and in after years occasionally played some of the tunes he had learned in earlier days.

The intimacy between Gilbert Stuart and Benjamin Waterhouse, commenced in America, continued in England, where they were engaged in studying their professions. They had drawn from the life at home, and they were equally devoted to the study abroad. "I was often to him," says the Doctor, "what Rembrandt's mother was to that wonderful Dutchman, an object at hand on which to exercise a ready pencil. I once prevailed on him to try his pencil on a canvas of three-quarter size, representing me with both hands clasping my right knee thrown over my left one, and looking steadfastly on a human skull placed on a polished mahogany table." If this picture was ever finished it has since been destroyed, for there is no further record of it.

In speaking to Mr. Charles Fraser, of Charleston, of the manner in which he had been received by West, Stuart said he was welcomed with true benevolence, encouraged and taken into the family of his master, and that nothing could exceed the attentions of the artist to him; "they were," he said, "paternal." Stuart worked

hard while under West, and more than repaid his tutor by putting in parts of his pictures. There are conflicting stories as to his manner of study, and it has been alleged that he had not the patience to go through with an academic course of drawing; but that he was indefatigable in the study of the head, there can be no question. West saw that he had merit, and that he was remarkably successful in portraiture, and he often called upon him for assistance when so employed.

Stuart was then attending the discourses of Sir Joshua Reynolds, studying anatomy with the celebrated Dr. Cruikshank, drawing during the evening in the life school, and painting with West, who was so fully employed that he could not complete the works he had undertaken so fast as they were required. It was at this time that he took some fine colors to Sir Joshua, as a present from Mr. West. What followed is thus related by Miss Stuart:

"Reynolds took him into his painting room to show him his picture of Mrs. Siddons, as the Tragic Muse. Sir Joshua, seeing him so delighted, invited him to come and see it when it was finished, which my father was only too happy to do. Going into Reynolds's room, he found him full of anxiety and busily giving the finishing touches, his hair (or his wig) very much disheveled, his stockings rather loose, and his general appearance disordered. The instant my father looked at the picture, he caught his breath with a feeling of disappointment. Sir Joshua perceived this, and asked him if he did not think he had improved it. Stuart answered, 'It could not have been improved,' and asked, 'Why did you not take another canvas?' Sir Joshua replied, 'That is true.' My father immediately realized what a very great liberty he had taken, and was exceedingly abashed; but the good Sir Joshua bore the criticism very amiably, possibly thinking that the opinion of so young a man was not of any moment."

Stuart and Trumbull were both pupils of West, and at the same time. Stuart was the senior pupil, and having made greater prog-

ress than his friend, thought it incumbent on him to assist his fellow-pupil in his studies. This he did, to their mutual advantage. Trumbull had the use of but one eye, and, singularly enough, Stuart found it out in this way. The story was told by Sully, who had it from Stuart, who, having been puzzled by one of Trumbull's drawings, said to him: "Why, it looks as if it had been drawn by a man with one eye;" to which Trumbull, who appeared much hurt, replied: "I take it very unkindly, sir, that you should make the remark." Stuart, not understanding him, asked him what he meant. "I presume, sir," answered Trumbull, "that you know I have lost the sight of one eye, and any allusion to it in this manner is unkind." "Now," said Stuart to Sully, "I never suspected it, and only the oddness of the drawing suggested it."

Mr. Fraser said, in speaking of these early years, Stuart did not describe the course of study recommended by Mr. West, but mentioned an occasional exercise that he required of his pupils for giving them facility and accuracy of execution; which was the faithful representation of some object or other, casually presented to the eye——such as a piece of drapery thrown carelessly over a chair. Stuart's successful performance of one of these tasks attracted the notice and approbation of an eminent artist, which he said was very flattering to him. Stuart had at this time a room for painting, appropriated to himself under his master's roof. One day a gentleman entered, and after looking around the room, seated himself behind the young painter, who was at work at his easel. The artist felt somewhat embarrassed, but Mr. West, soon after coming in, introduced the stranger as Mr. Dance. Mr. West left the room, but Mr. Dance remained and entered into conversation with Stuart, who ventured to ask his opinion of his work, which was a portrait. "Young man, you have done everything that need be done. Your work is very correct." The young painter was of course delighted with the approbation of the veteran, especially as he knew the reputation of Mr. Dance for skill, correctness of eye and blunt candor.

Mr. Dance was one of those persons who petitioned the King in 1768 to found the Royal Academy, and he was thought worthy to be the third on the list; his name appearing after that of Zuccarelli, and before Wilson's.

While Stuart was studying with Mr. West, Mr. Dance said to him: "You are strong enough to stand alone; take rooms; those who would be unwilling to sit to Mr. West's pupil will be glad to sit to Mr. Stuart."

This advice, which was indorsed by his master, was good; but before acting upon it, Stuart painted several pictures, among others a full length portrait of Mr. West, who, on seeing it exhibited at Somerset House, said to him: "You have done well, Stuart, very well; now all you have to do is to go home and do better."

Mr. Fraser says: "The first picture that brought Stuart into notice before he left Mr. West's house, was the portrait of a Mr. Grant, a Scotch gentleman who had applied to him for a full length. Stuart said he felt great diffidence in undertaking a whole length, but that there must be a beginning, and a day was accordingly appointed for the sitting. On entering the artist's room, Mr. Grant regretted the appointment on account of the excessive coldness of the weather, and observed to Stuart that the day was better suited for skating than sitting for one's portrait. Stuart said that early practice had made him very expert at skating, and together they went out to try their skill. Stuart's celerity attracted crowds on the Serpentine River, the scene of their sport. His companion, although a well made and graceful man, was not as active as himself, and there being a crack in the ice which made it dangerous to continue their amusement, he told Mr. Grant to hold the skirt of his coat and follow him off the field. They returned to Mr. Stuart's room, where it occurred to him to paint Mr. Grant in the act of skating, with the appendage of a winter scene in the background. Mr. Grant consented and the picture was immediately commenced. During the progress of it, Baretti, the Italian lexicog-

rapher, called upon Mr. West one day, and coming through mistake into Mr. Stuart's room where the portrait was, then nearly finished, he exclaimed, 'What a charming picture! Who but the great artist, West, could have painted such an one!' Stuart said nothing, and as Mr. West was not at home, Baretti called again, and coming into the same room, found Stuart at work upon the very portrait. 'What, young man, does Mr. West permit you to touch his pictures?' was the salutation. Stuart replied that the painting was all his own. 'Why,' said Baretti, forgetting his former observation, 'it is almost as good as Mr. West can paint.'

"This picture was exhibited at Somerset House, and attracted so much notice that Stuart said he was afraid to go to the academy to meet the looks and answer the inquiries of the multitude. Mr. Grant went one day to the exhibition, dressed as his portrait represented him; the original was immediately recognized, when the crowd followed him so closely that he was compelled to make his retreat, for every one was exclaiming, 'That is he, there is the gentleman!'"

III.

STUART was now established as a portrait painter. Dunlap fixes the date from the following letter, written by Mrs. Hopner, and dated June 3d, 1788:

"To-day the exhibition closes. If Hopner should be as successful next year as he has been this, he will have established a reputation. Stuart has taken a house, I am told, of £150 a year rent, in Berner's street, and is going to set up a great man."

In this Dunlap has fallen into an error, for as early as 1785 Stuart was living in a house he had rented in New Burlington street, and that year he exhibited three portraits at the Royal Academy.

The fact that Mr. West and Sir Joshua Reynolds had sat to Stuart, helped to bring him into notice. Having gained a position, he demanded and received a price for his pictures only exceeded by the sums paid to Sir Joshua and Gainsborough. In this connection Stuart related the following to Sully:

"Lord St. Vincent, the Duke of Northumberland, and Colonel Barré came unexpectedly one morning into my room, locked the door, and then made known the object of their visit. They understood that I was under pecuniary embarrassment and offered me assistance, which I declined. Then they said they would sit for their portraits. Of course I was ready to serve them. They

then advised that I should make it a rule that half price must be paid at the first sitting. They insisted on setting the example, and I followed the practice ever after this delicate mode of showing their friendship."

For a time Stuart lived in splendor. Money rolled in upon him, and he spent it as lavishly, never giving heed to the morrow, nor cared he what became of his earnings. As a bird loves to sing, so he loved to paint, and with sitters waiting their turn, and with those around him with whom he could give play to his remarkable conversational powers, he was contented and happy. Daily his rooms were thronged with visitors, who thought it a privilege to sit to him, and who were ready to pay anything that he thought proper to charge them. At these sittings he was always entertaining. Dr. Waterhouse said of his colloquial powers:

"In conversation and confabulation he was inferior to no man among us. He made a point to keep those talking who were sitting to him for their portraits, each in his own way, free and easy. This called up his resources of judgment. To military men he spoke of battles by sea and land; with statesmen, on Hume's or Gibbon's history; with lawyers on jurisprudence or remarkable criminal trials; with the merchant in his way; with the man of leisure in his way, and with the ladies in all ways. When putting the rich farmer on his canvas, he would go along with him from seed time to harvest; he would descant on the nice points of a horse, an ox, a cow, sheep or pig, and surprise him with his just remarks on the process of making cheese and butter, or astonish him with his profound knowledge of manures, or the food of plants. As to national character and individual character, few men could say more to the purpose, as far as history and acute personal observation would carry him. He had wit at will—always ample, sometimes redundant."

"Stuart," said Herbert, in his "Irish Varieties," "had taken a splendid house and lived expensively. Amongst other servants he

had a French cook. He began giving dinners and invited forty-two persons to dine with him. These were men of talents in some professional line—painters, poets, musicians, droll fellows, actors, authors, etc. After dinner he said to his friends, 'I can't have you all every day, but I will have seven of you to dine with me each day in the week, and I have contrived it so that the party shall vary without further trouble. I have put up seven cloak-pins in my hall, so as the first seven who come in may hang up their cloaks and hats; the eighth man, seeing them full, will go away and probably will attend earlier the next day. Then it would not be likely that any of the party of one day would come on the next, nor until the time for the forty-two to be expended, and Sunday should not be excepted. This compact was understood, without trouble of naming or inviting. I had a different company every day and no jealousies of a preference given to any one.'"

"I tasked myself to six sitters a day," said Stuart. "These done, I flung down my palette and pencils, took my hat and ran about and around the park for an hour, then home, got ready for dinner, approached my drawing-room with the certainty of meeting as clever men as could be found in society; and what added to this comfort, I knew not what or who they might be until I saw them, and this produced a variety every day without any trouble. Oh, it was delightful solace after such labor! I assure you, my friend, it was the greatest of all human luxuries."

"It must have been expensive?"

"It was more than I calculated on; but it enabled me to support my labor on six sitters."

"How did Mr. West approve of it?"

"He shook his head and observed that it would eat itself out. It did so; for in about six months the party was broken up, some going into the country, others out of the country—John Kemble, Irish Johnstone and others. It died a natural death, greatly to our regret."

Mr. Stuart had not been long established when he married Miss Charlotte Coates, daughter of Dr. Coates of Berkshire, England. Miss Stuart says of this union:

"Miss Coates's brother and Stuart had met at the anatomical lectures of Dr. Cruikshank. They soon became intimate friends; and although the Doctor was very much attached to him and admired his genius, he was perfectly aware of his reckless habits, and, with the rest of her family, opposed the match violently, but at length consented, and they were married May 10th, 1786, by the Rev. Mr. Springate. She was extremely pretty, but her greatest charm in the eyes of Stuart was her singing. Her voice was a superb contralto, and when speaking, she was remarkably attractive. Fuseli was delighted with her singing, and often made her repeat her songs. The remembrance of this was a delight to her in after years, for he was distinguished for his fastidious and cultivated taste."

The friendship between Stuart and Mr. Dance, which began before the painter entered upon an independent career, continued during the time the two were together in London; and in speaking of Mr. Dance's interest in him, Stuart said to Mr. Fisher, "that a short time after taking rooms in London, subsequent to leaving Mr. West, Mr. Dance called upon him and communicated his intention of retiring into the country, at the same time inviting him to come to his house, and take such articles in the way of his profession as would be serviceable to him; that as he was just commencing, he would find ready to his hand many things he would have occasion for. Stuart happened to call in the absence of his friend, and merely took a palette and a few pencils. Mr. Dance, a day or two before the sale of his furniture, inquired of his servant if Mr. Stuart had been there; and on being informed that he had, and of the moderation he had shown in availing himself of the offer made, immediately sent him a mass of material for his painting room, not only in the highest degree useful, but far more costly than the

painter's finances could have permitted him to purchase at that time. The palette, Mr. Dance afterward informed him, was the one formerly owned and used by Hudson."

"Mr. Stuart," says Fraser, "made the exhibition of his palette doubly interesting by a short dissertation on the use of it, describing the colors employed by him for portrait-painting, with their several gradations. This was done at my request, with a readiness and freedom characteristic of great liberality and kindness."

IV.

IN 1788, two years after his marriage, then somewhat embar-
rassed, Stuart was induced to go to Ireland and set up his
easel. He had been frequently urged to do so, and the promise
had been held out that many persons in Dublin would be glad to
sit to him; among others, the Duke of Rutland, then Lord Lieu-
tenant, was very pressing, and at length he yielded to their wishes,
but only reached there just as the funeral cortege of the Duke
issued from the city. The disappointment that he felt of course
was great, but the visit was not an unprofitable one. "The
moment it was known that he had arrived," writes Miss Stuart,
"he was called upon by his friends and the public, and was soon
fully employed by the nobility."

At the time that Stuart visited Dublin there was not a little
interest manifested for art in that city. The Royal Academy was
founded in 1768, but as early as 1731, the Dublin artists had
formed a society, and ultimately they put up a building which was
first opened with a collection of pictures in 1763; and although
there was a schism in 1773, the annual exhibition was kept up in
Dublin till 1800.

"Stuart was delighted with the society he met in Ireland,"
writes his daughter; "the elegant manners, the wit and the hospi-
tality of the upper class of the Irish suited his genial temperament.
He was so much beloved by them that they tried to claim him as

a fellow-countryman. When Mr. Allston was there, he heard them express their grief that Stuart should have left Ireland; they would say, 'Oh, nobody ever painted such a head as our Irish Stuart could.' I am sorry to say that Stuart entered too much into their convivialities. The fact is, it was his misfortune—I might say, his curse—to have been such an acquisition to, and so sought after by, society; particularly as he felt that he must make some acknowledgment for such incessant attention and cordial hospitality. He consequently gave frequent dinner parties, as was the fashion of the day. He lived at a place called 'Stillorgan Park,' not far from Dublin. The gentlemen of the surrounding neighborhood constituted his principal society. By all accounts a more genial and elegant set of men could not be found."

But Stuart, though well employed, did not remain long in Ireland. He had become uneasy and restless; in fact, his long absence from home had made him discontented, and he had, withal, an intense desire to paint the portrait of Washington. This last wish absorbed all his thoughts, and, breaking away from old friendships, and throwing up all his orders and engagements, he sailed direct from Dublin to America, although he had pledged himself to go back to England and paint a number of portraits. His fellow-passenger was Walter Robertson, an Irish miniature painter, on his way to America to better his fortune. For a time the two got on together, but at length they quarreled, their long confinement on ship-board doubtless having something to do with it; but as they neared land they became reconciled, and even learned to like each other. Robertson was a remarkable colorist, a quality that in itself would attract Stuart; but he lacked one quality—that of originality —and was content to spend his days in copying the works of other artists, particularly those by Stuart. This he carried to such lengths as finally to annoy and alienate Stuart, who withdrew his friendship from Robertson and bestowed it upon Trott, a rival miniature painter of decided talents, though by no means so good a colorist.

V.

GILBERT STUART landed in New-York in 1792, and was received most cordially by his countrymen. He had gone abroad a poor youth to win his way in the world, and he had come back a painter without an equal in America. A painting room was secured for him in Stone street, near William street, New-York, and soon it was known that he was ready to receive sitters. Orders poured in upon him, and had he laid by but a tithe of the sums he received, his savings would have been an ample provision for his family; but he was as fond as ever of society and loved to entertain and to be entertained, and when at the board with his merry companions he still delighted to tell a good story and to sing a good song. With such tendencies, and with no knowledge of business, it is hardly necessary to say that, liberal as were the prices paid him, and great as was his facility for throwing off work, he had always an empty purse. But, embarrassing as this was, he found a way of working himself out of any pressing diffi-culty; for with his brush he could in a few hours wipe out a debt, and if the wants of the day were supplied, he never seemed to think or care for the future. As he had met want before, so he

Egbert Benson

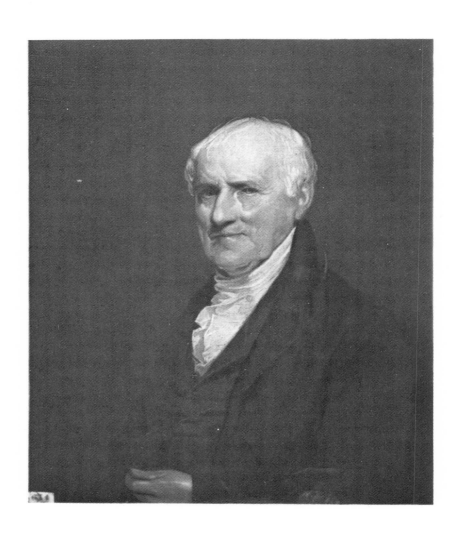

could meet it again, and so he continued to meet it till advancing years and declining health made it laborious; then, and not till then, did he see the folly of having neglected in his prime to provide for old age.

"Soon after his arrival in New-York," says Miss Stuart, "Stuart received a letter from his brother-in-law, Mr. Henry Newton, Collector at Halifax, Nova Scotia, requesting him to come there and paint the picture of the Duke of Kent, who offered to send a ship-of-war for him; but most unfortunately he declined, for it was his fixed determination to paint Washington at any sacrifice. He always looked upon his declining this offer as the most signal mistake of his life."

Tuckerman says of this period of the artist's life:

"Gilbert Stuart's most cherished anticipation, when he left England for America, was the execution of a portrait of Washington — cherishing, as he did, the greatest personal admiration of his character. His own nature was more remarkable for strength than refinement; he was eminently fitted to appreciate practical talents and moral energy; the brave truths of Nature, rather than her more delicate effects, were grasped and reproduced by his skill; he might not have done justice to the ideal contour of Shelley, or the gentle features of Mary of Scotland, but could have perfectly reflected the dormant thunder of Mirabeau's countenance and the argumentative abstraction that knit the brows of Samuel Johnson. He was a votary of truth in her boldest manifestations, and a delineator of character in its normal and sustained elements. The robust, the venerable, the moral picturesque, the mentally characteristic, he seized by intuition; those lines of physiognomy which channeled by will the map of inward life, which years of consistent thought and action trace upon the countenance; the hue that to an observant eye indicates almost the daily vocation; the air suggestive of authority or obedience, firmness or vacillation; the glance of the eye, which is the measure of natural intelligence and

the temper of the soul; the expression of the mouth, that infallibly betrays the disposition; the tint of the hair and mold of features, not only attesting the period of life, but revealing what that life has been, whether toilsome or inert, self-indulgent or adventurous, careworn or pleasurable—these and such as these records of humanity, Stuart transferred, in vivid colors and most trustworthy outlines, to the canvas. Instinctive, therefore, was his zeal to delineate Washington; a man who, of all the sons of fame, most clearly and emphatically wrote his character in deeds upon the world's heart; whose traits required no imagination to give them effect, and no metaphysical insight to unravel their perplexity, but were brought out by the exigencies of the time in distinct relief, as bold, fresh and true as the verdure of spring and the lights of the firmament, equally recognized by the humblest peasant and the most gifted philosopher.

"While Congress was in session at Philadelphia in 1794, Stuart went thither with a letter of introduction to Washington from John Jay. He first met his illustrious subject on a reception evening, and was spontaneously accosted by him with a greeting of dignified urbanity. Familiar as was the painter with eminent men, he afterward declared that no human being ever awakened in him the sentiment of reverence to such a degree. For a moment he lost his self-possession,—with him an experience quite unprecedented,—and it was not until several interviews that he felt himself enough at home with his sitter to give the requisite concentration of mind to his work. This was owing not less to the personal impressiveness of Washington—which all who came in contact with him felt and acknowledged—than to the profound respect and deep interest which the long anticipations of the artist had fostered in his own mind."

In Philadelphia, Stuart resided in the house on the south-east corner of Fifth and Chestnut streets. The building is still standing, but it has been materially altered since then. Here it was that he

painted his first portrait of Washington, and it was only when he was overrun with work and his time was too much taken up with callers, that he moved to Germantown, where the ruins of the building in which he painted may still be seen. It was a stable converted into a studio, and it stands in the garden on the estate of Mr. William Rotch Wister. Stuart's house on Chestnut street was daily the resort of many prominent and fashionable persons. Philadelphia at that time was unusually attractive. Congress met there, and the society of the place included representatives of the best people from all parts of the Union and from many foreign lands; and it was there that Mrs. Washington gave those delightful entertainments which have been described in the "Republican Court." Stuart knew almost every one, and it was his good fortune to have for his sitters the lovely women who gathered around Mrs. Washington, and the soldiers and statesmen who were the tried friends of the President. In the gay assemblages that were almost of nightly occurrence, he frequently took part, and in a manner creditable to himself; whether it was a musical party, a social gathering, or a ceremonious entertainment. At such times he had a pleasant word with those persons who were known to him; he played well on a number of instruments, particularly on the harpsichord; his voice was flexible, and his wit quick and sparkling; and if now and then his high temper came to the surface for a moment, it was more under control than in after years. Here he painted many of the beautiful portraits that have come down to us,—Mrs. Washington, Mrs. Bingham, the Marchioness D'Yrujo, Mrs. Madison, Mrs. Lawrence Lewis, and many others whose names it would be easy to recall.

The time when Stuart went to Philadelphia can be fixed almost to a day. Mrs. Jay, in a letter dated New-York, November 15th, 1794, addressed to her husband, Hon. John Jay, then in London, says: "In ten days he [Stuart] is to go to Philadelphia to take a likeness of the President." The following spring he was elected a

member of the American Academy. Stuart acknowledged the compliment in the following note:

"PHILADELPHIA, May 9th, 1795.

"To the Gentlemen of the American Academy.

"GENTLEMEN: This morning I received your letter, announcing my election to your Society. It is particularly flattering to me to be thought worthy of choice in any society among my countrymen, but more especially when that society is formed of artists.

"Permit me, gentlemen, to thank you, and assure you that my best endeavors shall not be wanting to promote the interest and honor of that Society.

"Gentlemen, believe me your closely attached friend,

"G. STUART."

From Philadelphia, Stuart removed to Washington, where his pencil was at once in demand. This was as early as 1803. His studio was on F near Seventh street. How long he remained there cannot be accurately ascertained, for he left but few papers, —he had the greatest dislike to writing,—and all details of this kind must be treated in a general way. He removed from Washington to Boston about 1805. Mr. Jonathan Mason, of Boston, who was personally acquainted with Stuart, writes thus:

"It was the privilege of the writer in early life to have formed the acquaintance and friendship of Gilbert Stuart, the distinguished artist, through the introduction of my father, a member of the United States Senate from Massachusetts, in 1803, who had sat to him for his portrait in the city of Washington.

"My father afterward induced Stuart to remove to the eastward and make Boston his head-quarters, promising him several of his family as sitters, and his influence with his connections and the public at large. The artist came to Boston and met with great success in his profession until within a few years of his death in 1828. His last years were impaired by failing health and age.

"Having relinquished mercantile pursuits and having it in my power to be of service to Mr. Stuart in a small way, I was sometimes allowed to sit behind him while he was painting, which, it was said, he allowed no other person.

"Although at times eccentric, as often men of great talents are, and at times liable to be abrupt in his address, I can conscientiously say I cannot recall ever having heard an unkind expression escape him."

In Boston, Stuart resided during the remaining years of his life; as improvident and careless in all matters relating to his own affairs as ever, and as indifferent to opportunities that were frequently afforded him to increase his gains and extend his reputation. The Pennsylvania Academy of Fine Arts would gladly have had a full length portrait of Washington from his pencil, but when applied to, with an offer of fifteen hundred dollars for such a picture, he never even answered the letter; nor did he take any notice of a letter asking him to paint his own portrait for the Academy at Florence.

Stuart's health began to fail in 1825 and 1826. This was followed by symptoms of paralysis in his left arm, which depressed him greatly; and although his mind was clear and active to the last, he never recovered from the shock to his feelings when he found that his arm was becoming useless. "If I could live and have my health," he used to say, "I could paint better pictures than I have ever done." Even at this time he had occasionally something amusing to say to a friend, but his natural flow of spirits was gone. Still he tried to paint, and with great effort succeeded in finishing a number of heads. The last picture that he began and finished was a portrait of Mrs. Samuel Hayward, of Boston. In the spring of 1828, the gout, from which he had suffered severely at times, settled on his chest and stomach, and for three months he bore the torture with the greatest fortitude. At length nature gave way, and on the 27th day of July of that year he died, having reached the age of two and seventy years. Mrs. Stuart

and three daughters survived him. Miss Jane, who early adopted the profession of her father, is the only one of the number now living.

The defects in Stuart's character were marked, and often stood in his way. If in the mood, he had the faculty of delighting all who were around him; but if not so inclined, if anything transpired to irritate him, or if any one was present who had given him offense, the rougher side of his nature was sure to appear. There was nothing false about him, and he had no power to hide his dislikes, or to keep back a sharp rejoinder, when he felt that he had occasion to express himself freely. This freedom of the tongue drove from him many who might have been friends, and alienated for a time those who knew he had a warm heart, and that when the storm of indignation had passed he would be himself again.

But constant dropping wears a stone, and those persons who could bear with his temper in early life, were not so patient in after years. Many a time, without apparent cause, he refused to go on with a picture that he had begun, and no expostulation, no apology—not even a woman's tears—could induce him to resume his brush.

Another foible grew out of the qualities that made him so popular in society. He was fond of company, and learned to love the table—learned to love it too well in England and Ireland, where he became a great favorite with a large circle of friends. He was constantly invited out, and he delighted in return to entertain his friends at his own house. He was a good liver, loved to indulge his own appetite, and to see others enjoy what was set before them. At such times no one could equal him as a story-teller. Through life he was reckless in his expenditures, and this constantly brought him into trouble. He never put any value on money, never sought to acquire it, and never tried to keep it in his possession. The consequence was, he was frequently embarrassed, and when he died he left his family wholly unprovided for.

The remains of Gilbert Stuart were deposited in the cemetery on Boston Common. A gentleman who was present told Miss Stuart that he had made a note of the number of the vault, but unfortunately he put it away and could not find it. Could the spot have been identified, a gentleman, distinguished for his liberality and kindness of heart, would have had the remains removed to Rhode Island and placed in the family burial-lot.

Washington Allston was asked to pronounce a eulogy on Stuart, but he was forced to decline, owing to failing health; he, however, wrote the following obituary, which appeared in the columns of the *Boston Daily Advertiser :*

" Gilbert Stuart.

"During the last week the remains of Gilbert Stuart, Esq., were consigned to the tomb. He was born in the State of Rhode Island, in the year 1754. Soon after coming of age, he went to England, where he became the pupil of Mr. West, the late distinguished President of the Royal Academy. Stuart there soon rose to eminence; nor was it a slight distinction that his claims were acknowledged, even during the life of Sir Joshua Reynolds. His high reputation as a portrait painter, as well in Ireland as in England, having thus introduced him to a large acquaintance among the higher classes of society, both fortune and fame attended his progress, insomuch that, had he chosen to remain in England, they would doubtless have awarded him their highest gifts. But, admired and patronized as he was, he chose to return to his native country. He was impelled to this step, as he often declared, by a desire to give to Americans a faithful portrait of Washington, and thus, in some measure, to associate his own with the name of the Father of his Country. And well is his ambition justified in the sublime head he has left us; a nobler personification of wisdom and good-

ness, reposing in the majesty of a serene countenance, is not to be found on canvas. He returned to America in 1792, and resided chiefly in Philadelphia and Washington, in the practice of his profession, till about 1806, when he removed to Boston, where he remained to the time of his death. During the last ten years of his life he had to struggle with many infirmities; yet such was the vigor of his mind that he seemed to triumph over the decay of nature, and give to some of his last productions all the truth and splendor of his prime.

"Gilbert Stuart was not only one of the first painters of his time, but must have been admitted, by all who had an opportunity of knowing him, to have been, even out of his art, an extraordinary man: one who would have found distinction easy in any other profession or walk of life. His mind was of a strong and original cast, his perceptions as clear as they were just, and in the power of illustration he has rarely been equaled. On almost every subject, more especially on such as were connected with his art, his conversation was marked by wisdom and knowledge; while the uncommon precision and eloquence of his language seemed ever to receive an additional grace from his manner, which was that of a well-bred gentleman.

"The narrations and anecdotes with which his knowledge of men and of the world had stored his memory, and which he often gave with great beauty and dramatic effect, were not unfrequently employed by Mr. Stuart in a way, and with an address peculiar to himself. From this store it was his custom to draw largely while occupied with his sitters—apparently for their amusement; but his object was rather, by thus banishing all restraint, to call forth, if possible, some involuntary traits of the natural character. But these glimpses of character, mixed as they are in all men, with so much that belongs to their age and association, would have been of little use to an ordinary observer; for the faculty of distinguishing between the accidental and the permanent, in other words, between

the conventional expression which arises from manners and the more subtle indication of the individual mind, is indeed no common one; and by no one with whom we are acquainted was this faculty possessed in so remarkable a degree. It was this which enabled him to animate his canvas,—not with the appearance of mere general life, but with that peculiar, distinctive life, which separates the humblest individual from his kind. He seemed to dive into the thoughts of men, for they were made to rise and to speak on the surface. Were other evidence wanting, this talent alone were sufficient to establish his claims as a man of genius, since it is the privilege of genius alone to measure at once the highest and the lowest. In his happiest efforts, no one ever surpassed him in embodying (if we may so speak) these transient apparitions of the soul. Of this not the least admirable instance is his portrait (painted within the last four years) of the late President Adams, whose then bodily tenement seemed rather to present the image of some dilapidated castle than that of the habitation of the unbroken mind; but not such the picture; called forth, as from its crumbling recesses, the living tenant is there,—still ennobling the ruin and upholding it, as it were, by the thought of his own life. In this venerable ruin will the unbending patriot and the gifted artist speak to posterity of the first glorious century of our Republic.

"In a word, Gilbert Stuart was, in its widest sense, a philosopher in his art; he thoroughly understood its principles, as his works bear witness,—whether as to the harmony of colors, or of lines, or of light and shadow,—showing that exquisite sense of a whole which only a man of genius can realize and embody.

"We cannot close this brief notice without a passing record of his generous bearing toward his professional brethren. He never suffered the manliness of his nature to darken with the least shadow of jealousy; but where praise was due, he gave it freely, and gave it, too, with a grace which showed that, loving excellence for its own sake, he had a pleasure in praising. To the younger artists he was

uniformly kind and indulgent, and most liberal of his advice, which no one ever properly asked but he received, and in a manner no less courteous than impressive. The unbroken kindness and friendship with which he honored the writer of this imperfect sketch will never be forgotten.

"In the world of Art, Mr. Stuart has left a void that will not soon be filled. And well may his country say, 'A great man has passed from amongst us.' But Gilbert Stuart has bequeathed her what is paramount to power,—since no power can command it,—the rich inheritance of his fame."

VI.

IT is not necessary that I should dwell on Stuart's merits as a painter: his place as an artist was early assured, and it has been conceded that he was the finest portrait-painter of his day. In confirmation of this the following has been told by Dunlap, who had it from Sully:

"Mr. Allston, at Sully's request, accompanied him to the house of Miss Gibbs, where Allston's fine picture of Elijah was to be seen. After looking at this, Miss Gibbs invited them into another room, to see a portrait of her father by Stuart. Sully says he almost started at first sight of it; and after he had examined it Allston asked: 'Well, what is your opinion?' The reply was, 'I may commit myself, and expose my ignorance; but, in my opinion, I never saw a Rembrandt, Rubens, Vandyke, or Titian, equal to it. What say you?' 'I say that all combined could not have equalled it.'"

Allston not only paid the highest tribute to Stuart as an artist, but also to the kindliness of his heart; and Leslie said it was fortunate that an artist existed in the time of Washington who could hand him down looking like a gentleman.

"Quick of apprehension," says Tuckerman, "discriminating and rhetorical, Stuart, when he chose to exert the valuable quality, could exercise rare tact, both in the labors of his art and the pleasures of

society. He had great command of satire, and where he could not win by entertaining, found no difficulty in exciting a fear of ridicule which checked the machinations of enmity. This accounts for the different impressions he created, according as the individual was fascinated or frightened. He possessed the hardihood rather than the susceptibility of genius, and effected his triumphs by the force of a comprehensive mind, which takes in all the relations of a subject and attains a complete, instead of a fragmentary, result."

It has been said that Stuart did not favor public exhibitions of pictures. He and Allston, who had suffered through the bad hanging of some of his works, held that, as a general thing, they were of no advantage to an artist. On one occasion, when this subject was discussed, Allston told the following anecdote: He had been excessively annoyed on entering an exhibition room the day before the opening, to find one of his quiet, low-toned pictures, hung by the side of a portrait in which the figure was robed in a scarlet mantle—the brightest of the bright. It had effectually killed his own picture, and, to relieve his work as much as possible, he heightened its color; only to have a friend say the next day: "Why, Allston, what have you been doing to your picture? How it swears!"

The above anecdote was related to me by Miss Stuart, who was present when it was told to her father.

I have asked Miss Stuart to give me her views of her father's manner of coloring, and she has written as follows:

"I am frequently asked by young artists to give them some account of my father's method of painting; this I am quite willing to do, so far as my early recollection will permit; but I have not the presumption to attempt to explain his wonderful effects, which were peculiar to himself; nor do I believe they could be transmitted. I do not believe there was ever a great poet, or great painter, who, after having done a good thing, could go over it and tell exactly how he did it, and at the same time give a system of reasoning for what

he had done. Poe attempted it, in his dissertation on 'The Raven,' but no one believes but that what he says on the subject was an afterthought—a play upon what he had written in a moment of inspiration. I know there is great fascination in trying to discover a secret of this kind, and that many artists have wasted their time, and in some instances have injured their pictures, in a vain attempt to get at the processes employed by the old masters. Sir Thomas Lawrence is a notable example, and some of the prominent artists of the present day have erred in the same way.

"The impression I have received from a study of Stuart's heads is, that his success was due in a great measure to his wonderful perceptive faculties.

"As Stuart was quick to read the character of a sitter, so had he a clear insight into the color of his complexion, and never was he known to fail in this particular. The arrangement of his painting room was simple—more simple than that of any other painting room with which I have been familiar. He commenced a portrait by drawing the head and features, and then he sketched in the general tone of the complexion; for this he seldom required more than four or five sittings, and frequently it was done in three sittings. The picture was never touched except when the sitter was in the chair. At the second sitting he introduced transparent flesh-tints, at the third he began to awaken it into life and give it expression, and then the individuality of the sitter came out. This was always done quickly. In the portraits of men advanced in life, where the roundness of youth is gone, we can almost fancy that he has given motion to the features—a quality seen in a marked degree in some of the portraits of old Revolutionary officers who sat to him— that, for instance, of Gen. Gates, now in the possession of the Stevens family.

"It has been said by some critics that his coloring was too strong—that there was too great a preponderance of carnation in his flesh tints; to this I cannot subscribe. Stuart did not rely on

or require strong colors to produce his effects, for he had the faculty of bringing out his heads simply by the use of middle tints and tones, giving all the required rotundity and relief without the assistance of black shadows and heavy backgrounds; and yet the faces so painted are full of character and expression. In his work there is no appearance of labor, but everything that he did showed force and energy—so long as he kept to the head. When that was completed his enthusiasm seems to have abated. With some notable exceptions, the other parts of his pictures were painted but indifferently; but if he particularly fancied the subject, or the sitter was one in whom he took more than his usual interest, he worked with the greatest care to the end. In his draperies he was exceedingly careless, but he amused himself at times by painting lace, showing with a few bold touches of his pencil how easy it is to produce an effect when one understands what he is about. But if any one of his intimate friends took him to task for carelessness in rubbing in the accessories in a portrait, he at once replied: 'I copy the works of God, and leave clothes to tailors and mantua-makers.'

"Color was one of Stuart's strong points, and on this subject he was as eloquent in conversation as he was successful with his brush, when he wished to illustrate it. He seemed to bring out the color of every object that he transferred to his canvas. The story that has been told again and again, of West's remarks to his other pupils,—'It is of no use to steal Stuart's colors: if you want to paint as he does you must steal his eyes,'—will bear repeating in this connection. And this reminds me that many artists, puzzled in their efforts to produce like effects, have imagined that he had some secret connected with the management of his colors: but this, I beg to say, was not the case.

"Stuart's arrangement of his palette, so far from being complicated, was simplicity itself. He had, of course, the primaries, and from these he formed a chromatic scale of tints, varying them to suit the major or minor tones of his sitter's complexion. These

tints were kept separate and distinct, as is apparent in his pictures; the artist trusting to time to mellow them and blend them into a whole. Where he used opposing tints he did it with judgment, and those who look upon his pictures are often astonished at his skill in bringing them together so successfully. His tints were put on at once, and not worked up, and it is this that makes it so difficult to copy his pictures; for the moment the copyist hesitates he becomes confused, and then he is almost sure to go wrong.

"The order of Stuart's palette was as follows: Antwerp blue, Kremits-white, vermilion, yellow ochre, lake, Vandyke brown (with him a favorite color), and burnt umber—the latter used sparingly. All these colors were mixed more or less with white. He never glazed his pictures, nor ever attempted in this way to strengthen his shadows, for he thought it a trick. He was always particular to keep his palette in order, and if an artist brought to him one that was not up to a proper standard, he would address to him words clearly expressive of disapprobation. He also took great pains with his pencils, and would never allow any one to touch his easel, or its surroundings; indeed, during the latter years of his life he would never allow any one to go into his painting room when he was not present. If any one touched a pencil, or moved a picture, he would be sure to find it out; so that it became a settled thing in the house that it was best to abstain altogether from going into his *sanctum sanctorum*, unless invited to do so.

"It has been thought a pity by some persons, that Stuart did not have the advantage of a visit to Italy. I doubt if it would have been of any benefit to him, judging from the works of many artists who have enjoyed that privilege; for while they have certainly gained nothing in coloring, they have lost their originality by trying to imitate what time has done, instead of confining their efforts to copying nature. I believe he thought it impossible for one to be an artist without acquiring a thorough knowledge of drawing and anatomy, and he certainly gave a great deal of time to these studies

in earlier years. Whatever information he acquired in his studies was at the disposal of others, and he never withheld anything from any member of the profession who sought his aid and advice in a proper manner; but he had a horror of anything that approached the affectation of a dilettante, or the pedantry of technical phraseology. His own views were singularly clear and to the point, and he imparted information in a way that left no doubt of his meaning on the mind of the hearer.

"I regret exceedingly that some of Stuart's pictures have been very much injured, and I cannot account for it in any other way than that he may have used magilp, made with copal instead of mastic varnish, put up by some unscrupulous dealer in artists' materials. It is curious to observe that pictures painted sixty or seventy years ago, are in perfect order and look as fresh as if painted yesterday, while others, of a later date, are sadly defaced by small circular cracks. I know that furnace heat and gas are great destroyers of paintings, and yet some of the finest of Stuart's pictures are in dwellings that are provided with 'all the modern improvements.' If he had experimented with his pictures, I should not be surprised at the result; but he avoided everything of the kind, and treated with contempt whatever looked like a trick in art. Artists frequently brought him some wonderful discovery in colors or oil, or some composition that Titian or Veronese was supposed to have used; to all which he would listen pleasantly, and then say, 'Take my advice and have nothing to do with anything of the kind, for certainly you cannot pretend to know what may be the ultimate effect on your work.' But some persons, unwilling to accept his views, would insist on leaving their wonderful concoctions with him, all of which were immediately thrown from the window. At such times he would relate some pertinent anecdote. One I distinctly remember. He had been commissioned to copy a very fine head by Sir Joshua Reynolds, and while at work on it, in a warm room, he thought he saw one of the eyes move and take a down-

ward course. A second glance showed this to be true, and it instantly occurred to him that Sir Joshua must have used wax with his colors (as is well known was the case), to give greater transparency. In an agony of mind, for the picture was one of great value, he hurried with it into the cold air, and gradually worked the eye back into its place.

"Stuart's manner was such as to make his sitters feel that he was not to be trifled with. Many a fine head was taken from his easel, and obliterated, or sent to the garret, for no other reason than that the sitter had broken his engagement, or had in some other way annoyed him."

Dunlap gives Stuart's arrangement of his colors, as he saw him set a palette in 1813. Said he to Stuart, "I do not know how to set a palette." "It is very easy," was the reply; "I will show you in five minutes;" and Dunlap goes on to say: "He pointed out on his own palette the unmingled colors, and their tints, as mixed with white or each other; first and nearest the thumb, pure white, then yellow, vermilion, black, and blue. Then followed yellow and white in gradation; vermilion and white in gradation; black and yellow; black and vermilion; black, vermilion and white in several gradations; black and white and blue and white; 'and for finishing, add lake to your palette and asphaltum.'" Later in life, when he lived on Fort Hill, Boston, he gave me another setting of the palette. This was in 1822. I passed the morning with him, and sat for the hands of Mr. Perkins' picture, for the Athenæum, of which he was the munificent endower. The palette Stuart then worked with, as he pointed it out to me, was Antwerp blue, Kremits white, vermilion, stone-ochre, lake, Vandyke brown, mixed with one-third burnt umber, and ivory black. The tints he mixed were white and yellow, vermilion and white, white, yellow and vermilion, vermilion and lake (each deeper than the other), then blue and white, black and yellow, black, vermilion and lake. Asphaltum in finishing.

Young artists, who had really something in them, always found Stuart willing and ready to aid them in their studies. This is shown in his advice to Neagle, who painted his portrait in 1825. Neagle gave the following account of the sittings :

" Mr. Stuart had stepped out of the painting room (it was at his own house), and in the meantime, as a preparation for his sitting, I placed alongside of my unfinished portrait one painted by him of Mr. Quincy, the mayor of Boston, with the view of aiding me somewhat in the coloring. When he returned and was seated before me, he pointed to the portrait of the Mayor and asked, 'What is that?' 'One of your portraits.' 'Oh, my boy, you should not do that!' said he. 'I beg your pardon, Mr. Stuart; I should have obtained your permission before I made use of it; but I have placed it so carefully that it cannot suffer the least injury.' 'It is not on that account,' said he, 'that I speak; I have every confidence in your care; but why do you place it there?' 'That I might devote my mind to a high standard of art,' I replied, 'in order the more successfully to understand the natural model before me.' 'But,' said he, 'does my face look like Mr. Quincy's?' 'No, sir, not at all in the expression, nor can I say that the coloring is even like; but there is a certain air of truth in the coloring of your work, which gives me an insight into the complexion and effect of nature; and I was in hope of catching something from the work of the master without imitating it.' 'As you have heretofore,' said Stuart, 'had reasons at command for your practice, tell me what suggested this method.' 'Some part of the lectures of Sir Joshua Reynolds,' which I repeated to him. 'I knew it,' said he; and added, 'Reynolds was a good painter, but he has done incalculable mischief to the rising generation by many of his remarks, however excellent he was in other respects as a writer on art. You may elevate your mind as much as you can; but while you have nature before you as a model, paint what you see, and look with your own eyes. However you may estimate my works,' continued the

veteran, 'depend upon it they are very imperfect ; and the works of the best artists have some striking faults.'"

The advice given by Stuart is unquestionably good, but artists have certainly derived great benefit from the study of his works, as well as from his theory. Tuckerman relates an interesting story connected with one of Stuart's pictures which had fallen into the hands of a young artist, who made it the subject of profitable study ; and as it is to the point I shall here insert it. The narrator is giving an account of his first acquaintance with Elliot, who, hid away in a little inland town, was struggling to keep his head above water. In the painter's room he found a number of fine pictures and engravings, which he showed when he had a visitor who could appreciate them. Here I take up the narrative.

"Among them was a Moreland and a Gainsborough, some fine engravings after Reynolds, prints, cartoons and crayon heads by famous artists, and two or three Hogarth proof impressions; but the treasure which riveted my friend's gaze was a masterly head of such vigorous outline and effective tints, that he immediately recognized the strong, free, bold handling of Gilbert Stuart. 'This was given to me,' said the gratified painter, 'by the son of an Edinburgh physician, who, when a young practitioner, had the good fortune to call one day upon Stuart, when he was suffering from the effects of a fall. He had been thrown from a vehicle, and had broken his arm, which was so unskilfully · set that it became inflamed and swollen, and the clumsy surgeon talked of amputation. Imagine the feeling of such an artist at the idea of losing his right arm! The doctor's visit was not professional, but seeing the desponding mood of the invalid painter, he could not refrain the offer of service. It was accepted and proved successful, and the patient's gratitude was unbounded. As the doctor refused pecuniary compensation, Stuart insisted upon painting a likeness of his benefactor; and as he worked under no common impulse, the result, as you see, was a masterpiece.'

"A few weeks after this pleasant interview, my friend had established his protégé at Utica, and obtained for him several commissions. But his medical attendant pronounced his disease incurable; he lingered a few months, conversing to the last, during the intervals of pain and feebleness, with a resignation and intelligence quite endearing. When he died, my friend advised his widow to preserve as long as possible the valuable collection he had left, and with it she repaired to one of her kindred in affluent circumstances, living fifty miles away. She endeavored to force upon his acceptance one at least of her husband's cherished pictures; but, knowing her poverty, he declined, only stipulating that if ever she parted with the Stuart, he should have the privilege of taking it at her own price.

"A year passed, and he was informed that many of her best pictures had become the property of her relative, who, however, knew not how to appreciate them. He commissioned an acquaintance to purchase, at any cost, the one he craved, when it was discovered that a native artist, who had been employed to delineate the family, had obtained this work, in payment, and had it carefully enshrined in his studio in Syracuse. This was Charles Elliot; and the possession of so excellent an original by one of the best of our artists in this department, explains his subsequent triumphs in portraiture. He made a study of his trophy; it inspired his pencil; from its contemplation he caught the secret of color, the breadth and strength of execution, which has since placed him among the first American portrait painters, especially for old and characteristic heads. Thus, in the centre of Western New-York, he found his academy, his Royal College, his gallery and life-school, in one adequate effort of Stuart's masterly hand: the offering of gratitude became the model and the impulse whereby a farmer's son on the banks of the Mohawk rose to the highest eminence. But this was a gradual process; and meantime it is easy to imagine what a treasure the picture became in his estimation. It was only by degrees that

his merit gained upon public regard. His first visit to New York was a failure; and after waiting many weeks in vain for a sitter, he was obliged to pay his indulgent landlord with a note of hand, and returned to the more economical latitude of Syracuse. There he learned that a wealthy trader, desirous of the *éclat* of connoisseur, was resolved to possess the cherished portrait. Although poor, he was resolved never to part with it; but the sagacious son of Mammon was too keen for him. Discovering his indebtedness, he bought the artist's note of the innkeeper, and levied an execution upon his effects. But genius is often more than a match for worldly wisdom. Elliot soon heard of the plot, and determined to defeat it. He worked hard and secretly, until he had made so good a copy that the most practiced eye alone could detect the counterfeit; and then, concealing the original at his lodgings, he quietly awaited the legal attachment. It was duly levied, the sale took place, and the would-be amateur bought the familiar picture hanging in its accustomed position, and then boasted in the market-place of the success of his base scheme. Ere long one of Elliot's friends revealed the clever trick. The enraged purchaser commenced a suit, and although the painter eventually retained the picture, the case was carried to the Supreme Court, and he was condemned to pay costs."

I have said that Stuart kept no record of his works, and paid no attention to details of this kind. He did not even know, at times, whether a picture he had finished had been paid for; so indifferent was he to all business matters. Before me there is a single sheet, torn from an old account book, on which there are certain entries in his own hand, which may have been quite enough to refresh his memory. The figures and letters in the left-hand column are evidently intended to designate the days of the week, but there is nothing to show what those in the right-hand column stand for.

M. 25. Miss Charlotte Morton, } Disappointed me. 11
Miss Caroline Knox. }
Rubbed in Mrs. Howard's and Mrs. Bussy's background.
Rubbed in Col. Davis' drapery.
State street altered, Mr. Appleton's engagement.
Mr. and Mrs. Grant, with a Lady and Gentleman from N. Y. Caught
in the rain at Seymour's warehouse.

T. 26. Mr. Hollowell — Mr. I. P. Davis X — Thunder, rain, and my room leaking 9
like the devil.
Mr. Appleton altered to Thursday. 11
Mr. Townsend read over the correspondence between me and Bingham.

W. 27. Coll. Boyd, Mr. Dexter and Miss E. Morton X. 11
Mr. T. H. Perkins X Dr. Danforth, Mr. Greenleaf X
Mr. McGee — Mrs. Morton — Mr. Allen, with a British officer — State
street — walked in the Mall with H. Sargent — Dr. Dix's house —
Mrs. Powell and Miss Murray X — Stackpole and Gay X — Mr. Shaw
evening is to tune my Harpsichord. 11

T. 28. Mrs. Appleton.
Mr. Pennyman. Books of Rome.
T. Governor and his Lady. Mr. Townsed
to Mr. Perkins' to dinner — Col. Apthorp, Mr. Allen.
Capt. Shepart, Mr. Richards, Mr. Callender, Mr. Amory, first salmon.

F. 29. Mrs. Swan and Mrs. Howard.
Mr. James Swan — Dr. Danforth — Judge Daws.
Walked to Roxbury with Mr. Bingham —
Saw Mrs. and Miss Knox — Mr. and Mrs. Gore —
Mr. Sears with Mr. Hallowel in a phæton.

S. 30. Mr. Hallowel. 10
Mr. Bussy — Mr. Morton and Mr. Dexter.
Mr. Townsed — 100 — Mr. Pennyman had to grind colours — Dined Dr.
Dix's House, met Mr. Hays — went to Kidder's — Farrington.

The money earned in painting the full length Washingtons that
came from his easel in Philadelphia, and from twenty other pictures
of different sizes, was invested in a farm in Pennsylvania, which he
had stocked with the Durham breed of cows. But with his usual
carelessness in such matters, he paid the money over from time to

time—as fast as he earned it—without taking a receipt, or looking to see that the estate had been properly made over to him; and before there was a final settlement the party died, of whom he had bought the property. Then it came to light that there was no evidence that Stuart had ever paid a dollar in the way of purchase money, and there was nothing among the papers or on the books of the deceased to show that any such transaction had taken place. Stuart lost his whole investment, amounting to thirty-four hundred and forty-two dollars.

On one occasion, while riding in the country, he was attracted by a crowd, and when he drew near he found a man beating a poor negro cruelly. The victim proved to be the son-in-law of an old colored woman who had once been owned by his mother and was then a servant in his own family. His appeal in behalf of the slave was of no avail, and, moved to compassion, he bought the poor creature, signing a note for an extravagant sum in payment. This was in the neighborhood of Washington. Stuart thought no more about it. In time the note, which had been discounted, fell due and was protested. He had no money to meet it, thought there need be no hurry in taking it up, and only realized his unpleasant position when a minion of the law attached his household furniture. A lady, a friend, sent for Mrs. Stuart and her family, and took them into her own home until another could be provided for them. As for Stuart, he was amazed beyond words at such a combination of circumstances.

In his declining years Stuart thought much of a son he had lost, and to whom he was strongly attached. His very fondness had caused him to err in bringing him up. In his efforts to save him from the gay company that had been the delight of his own early life, and which had cost him so much, he drew the cords too tight. He was too rigid in his treatment of the youth, was too exacting in his demands, and put too many restraints on his movements. The result was, when the young man came of age and began to

mingle more freely with the world, he was easily led into temptation, and at the age of twenty-six he went down to the grave, the victim of many irregularities. The blow was a terrible one to Stuart, who felt that he was in a great measure to blame, and tenderly he mourned with his family the loss they had sustained.

As a memento of the son who was so dear to him, he had a box or casket made, after a design of his own, and on it he spent a considerable sum. This pretty affair he valued highly, for he associated it in some way with his son; and as it stood on the sitting-room table, it was always before him, a perpetual reminder of his loss.

An incident is related by the family, in connection with this cabinet, which illustrates Stuart's carelessness in money matters. A year after it was completed and brought home, a bill was sent in for the work of making it. Stuart was indignant, and said that he had paid it; that the bill was one of the last he would have failed to have met promptly. His wife suggested that possibly he might have overlooked it. "Tom," said he,—he always so addressed her,—"Tom, I *know* I paid that bill, but what I have done with the receipt I cannot tell." A year after Stuart's death the receipted bill was found in a book, which he was probably reading at the time that he paid it.

It has been said that Stuart did not treat his nephew, Stuart Newton, properly. On this subject Miss Stuart writes:

"The story that Stuart was unkind to his nephew, Stuart Newton, is utterly without foundation. I am happy to say that Newton had the justice to contradict it the last time he was in this country. That my father was frequently out of temper, is too true; but any reasonable person could make some apology for a man harassed, as he was, with the vanity and caprice of the public, as all artists have been and ever will be. As Newton almost lived at our house, I conclude he must have witnessed some of these outbursts, which, however, he found it convenient not to notice, as it would have interfered with the advantages he was enjoying.

"One day my mother said to my father: 'Do you think New-ton has very fine talents?' He answered: 'Undoubtedly he has, but he is such a consummate coxcomb, I have no patience with him. If I attempt to instruct him, he invariably contradicts me.' Unfortunately a person present repeated this conversation, with some additions. This, I know, was the extent of the difficulty between them.

"Newton was young, and thought he knew more than his uncle did. This self-complacency is a common defect in young persons who think they are born geniuses. When he had seen more of the world, Newton became a most accomplished person and fine artist. But when I hear that he derived no advantage from being with his uncle, I am vexed at the ungenerous and absurd statement. It does not argue much for the mind of Newton to deny that he was benefited by such golden opportunities as were afforded him daily under the roof of his uncle's house. When I was a child I was often in the room when my father was instructing artists, and remember many things that were said to them when no one thought that I had two ideas on art, or anything else. It would be strange indeed if Newton, then a young man, could not comprehend him and could derive no advantage from such opportunities."

VII.

MANY anecdotes have been related of Stuart's ability to read the character of persons he chanced to meet. While painting the full length portrait of Lord Chancellor Clare, he was frequently invited to dinner. One day his lordship asked him to sit by his side, to hear some private chat. Just as the cloth was removed a gentleman came in, and looked rather confused, from not being in time. Lord Clare ordered the servant to place a small table on one side, and to get some dinner for him. "You must try and make the best of it," said his lordship; "it was your own fault; we waited half an hour." Then he turned and said: "Now, Stuart, you are so accustomed to look all men in the face who come before you, you must be a good judge of character. Do you know that gentleman at the side table?" "No, my lord, I never saw him before," was the reply. "Well, now tell me what sort of a man he is in disposition." "Is he a friend?" "No." "Then I may speak frankly?" "Yes." "Why then, my lord, if the Almighty ever wrote a legible hand, he is the greatest rascal that ever disgraced society."

Lord Clare was so amused with this true development of character that he laughed immoderately. The man was an attorney, and had been detected in acts that were far from honorable.

Horace Binney

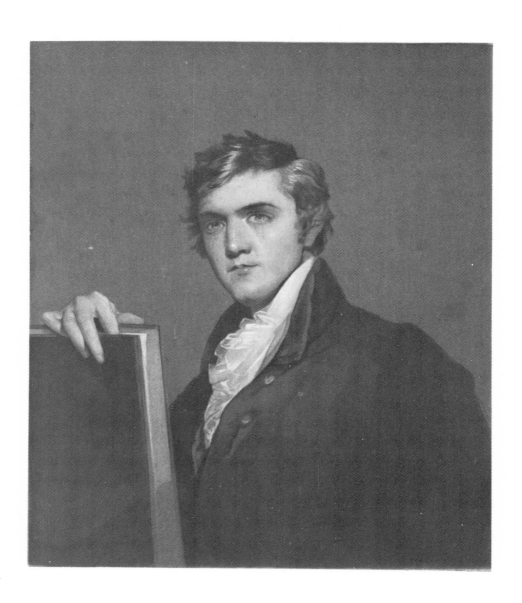

This story found its way to America and has been repeatedly told, with a few changes as to time and place, and the substituting of the name of Aaron Burr for that of Lord Clare, and Talleyrand for "the unfaithful steward."

An artist named Home was very popular in Dublin at the time that Stuart set up his easel in that city, and for a time he tried to retain his hold on the public; but the new-comer was too much for him, and he abandoned the field he could no longer claim as his own.

"Soon after Stuart's arrival," it is related by Herbert, "he was invited to dine with the artists of Dublin on St. Luke's day. He accepted the invitation, and was very communicative to those who sat near him. But Mr. Pack (one of the company), who delighted in anecdote, was relating one where he was the hero of the tale himself, and he spoke so loud as to drown Stuart's voice, so that the great visitor was obliged to be a mute listener, until he silenced the story teller. Pack was boasting of his intimacy with Sir Joshua Reynolds being so great that he had the freedom of going into Sir Joshua's study when Sir Joshua was painting, if alone. One day he entered the study where Sir Joshua was engaged designing with chalk a picture of the Holy Family.

"'Mr. Pack, I have been puzzled with this design—the fore-shortening of the infant's thigh—I must lay it by till I get a model.'

"Pack saw several lines sketched, and he said: 'Sir Joshua, your eye is fatigued; now, I come in with my eye fresh, and I think I can draw the line you want. Will you permit me'—this in a softened, low voice—'to point out what strikes me?'

"Sir Joshua handed him the chalk, and Pack drew the line—'I think it should come in so.'

"Sir Joshua thanked him, but the freedom was revoked: yet the line was adopted, as the picture (which has been finished) testifies. These were Pack's words.

"Stuart, fired with indignation at what he had heard, asked Valdre, an Italian artist who sat beside him, and in a voice as loud as Pack's, 'Who is that person relating these stories?'

"'Mr. Pack.'

"'Pack, Pack,' said Stuart; 'well, I have often heard of a pack of nonsense, but I never saw it before.'

"Such an involuntary burst of laughter took place like a volley, so general was the excitement felt, as took some minutes to relapse into a decent silence and decorum; Pack then became mute, and we were deprived of his entertaining qualities for the rest of the evening."

Herbert was invited by Stuart to visit him at his residence, promising to give him a bed and that he should "dine on pork fed on apples." The invitation was accepted.

"On the ensuing Sunday I went to Stillorgan, and as I walked up a narrow road that led to that quarter from the Black Rock, I saw some very pretty pigs; it struck me at one moment's view that they belonged to Stuart, and that I could not be distant from his house: to try that I was right in my conjecture, I took up little pebbles and threw them at them. They ran on and I followed. They led to a gate, into which they entered. It lay open, and before the house I saw Stuart, tending some flower-pots.

"'Ha,' said he, 'you are come.'

"'Yes, please the pigs.'

"Then I told him how they had led me. He was delighted at the recital, and more complimented than anything I could say in praise of his pictures. He said, 'You shall taste pork to-day of their kind, and you will acknowledge my plan to be a good one for feeding them.' He then took me to his garden, which was well cropped, all by his own hands; walked me over the grounds, and pointed out his skill in farming; he valued himself more on these points than on painting. I cordially confessed that I should rather see his works in his painting room, that I was ignorant of farming,

gardening or feeding pigs. He pitied me very much, observing what a loss I sustained by not attending to the cultivation of that on which mankind were supported and rendered wealthy and power-ful. We then got back to the house, and dinner was served. I ate the apple-fed pork, and was greatly pleased with it. Stuart entertained me till bed-time. Many other anecdotes followed, which would spin out a rare tale."

An amusing story is told of a call made on Stuart, when in Ireland, in the way of his profession. He had been asked to visit a gentleman at his castle, prepared to fill his orders. The story goes on. Arriving at his place of destination, "he found the castle was a building that had stood for centuries, but was then occupied by a tailor who had made a fortune by army contracts. This worthy told him that he had sent for him to paint the portraits of his ancestors, and on Stuart's inquiring whether he had any minia-tures or silhouettes to guide him, replied that he had nothing of the kind, but wished him to paint the portraits of such ancestors as he *ought* to have had. The artist went to work and produced a series of portraits, beginning at the Conquest: men in armor, who served in the Crusades; judges in full-bottomed wigs; civil magis-trates, with chains and furs; fair women, feeding sheep and staring at parrots, according to the times when they were supposed to have flourished. His patron was delighted with his success in thus por-traying his aristocratic progenitors, and paid him double the amount agreed upon for his services. As these pictures were painted a century ago, they are probably exhibited by the tailor's descendants as veritable likenesses, taken by contemporary masters, and thus, according to *Slender*, 'all his successors who have gone before him, and all his ancestors who come after him,' will have established their claim to an aristocratic lineage."

It was in Dublin that the following occurred: "At a dinner party composed of some of the wits of the day, among them the Rev. Mr. Best, Dean Butson and John Kemble, a violent dispute

arose as to the possession of the truest eye. It was finally proposed that there should be a mark placed in the garden, that the question might be decided by pistols. Accordingly they went out, and Stuart, soon seeing the exact state of things, walked deliberately in front of the target; when they all exclaimed: 'Stuart, Stuart! what are you about? By heavens, you will be shot!' 'Oh no,' said he, in a very quiet manner, 'from all appearances, this is the safest place.'"

"I was always very fond of hearing these old stories," says Miss Stuart; "but it gave my mother pain to remember anything associated with his reckless extravagance, or what she called his folly."

Miss Stuart, in speaking of the portraits of Washington, says:

"One morning, while Washington was sitting for his picture, a little brother of mine ran into the room, when my father, thinking it would annoy the General, told him he must leave; but the General took him upon his knee, held him for some time, and had quite a little chat with him, and, in fact, they seemed to be pleased with each other. My brother remembered with pride, as long as he lived, that Washington had talked with him. Of course, this added to my father's regard for the General.

"While talking one day with General Lee, my father happened to remark that Washington had a tremendous temper, but held it under wonderful control. General Lee breakfasted with the President and Mrs. Washington a few days afterward.

"'I saw your portrait the other day,' said the General, 'but Stuart says you have a tremendous temper.'

"'Upon my word,' said Mrs. Washington, coloring, 'Mr. Stuart takes a great deal upon himself, to make such a remark.'

"'But stay, my dear lady,' said General Lee; 'he added that the President had it under wonderful control.'

"With something like a smile, General Washington remarked, 'He is right.'

"About the time that the Washingtons were sitting for their portraits, my father's painting room was the resort of many of the most distinguished and interesting persons of the day.

"Nelly Custis, Mrs. Law, Miss Harriet Chew (afterward Mrs. Carroll), generally accompanied Mrs. Washington; General Knox, General Henry Lee, and others came with the President. The British Minister and his wife, Mr. and Mrs. Liston, Louis Philippe d'Orleans, Counsellor Dunn (an Irish barrister), and the Viscount de Noailles were fond of Stuart's society, and were frequent visitors.

"It has always been a source of great satisfaction to me, that the Washington family were so much attached to my father, on account of his portrait of the General. We have been continually sought by different connections of the family, who invariably have spoken of Stuart with gratitude; I may, indeed, say with affection. Miss Elizabeth Parke Custis (who married the Hon. Mr. Law, and afterward took her maiden name) was a great enthusiast upon the subject of this picture. She used to go about with the General, and whenever she could find an opportunity, would accompany him to my father's painting room. She has said to me with great satisfaction: 'I was present during many of the sittings, and have seen the likeness of the dear General grow under your father's pencil.' I told her that many persons thought my father's portrait of him was too fair. This seemed to provoke her exceedingly. 'Too fair!' she exclaimed; 'my dear, his neck was as fair as that of a girl of seventeen.' This was said with great indignation, as if it were an insult to his memory to suppose that Washington had a dark complexion. (She herself was a brunette, with very beautiful dark eyes.) My father painted Miss Custis about this time, and it is said to be one of the most beautiful pictures that ever came from his pencil. I did not see her until she had had much trouble and illness, but there were still remains of great beauty. When she heard that my father was ill she set out for Boston, but had only reached Newport when news reached her of his death."

Stuart could not tolerate anything done for effect—any stage trick or display of tinsel. His comments on David's picture of Napoleon are evidence enough of that. He had been urged to go and see it, and at last complied with the request of some of his friends. When fairly before the picture, and he had had time to take it in, he said: "How delicately the lace is drawn; did one ever see richer satin? the ermine is wonderful in its finish; and, by Jove, the thing has a head!"

On one occasion, having completed the portrait of a mantua-maker in Boston, who had drawn a large prize in a lottery, and had come to him loaded with all sorts of finery, he said to a friend: "There is what I have all my painting-life been endeavoring to avoid—vanity and bad taste."

While in England, he was painting the portrait of a lady of rank, who thought she could heighten her charms by resorting to the use of rouge. Through this Stuart saw at once, and it put him out of temper. He then gave her to understand that she was quite lovely enough without any artificial aid. "Oh," said she, "Mr. Stuart, have you found me out?" "Of course I have," was the reply: "any one having a knowledge of the human face knows there is a boundary to the color in every lady's cheek, and if you go beyond the line you certainly will be detected." He then told her where nature would place the color in a cheek formed like hers. She laughed, and said she would remember it; to which he made reply: "Pray do not do it; you do not need it."

The following story, of the same tenor, better known, will still bear repeating, for it is very characteristic:

"A young physician was about to be painted, and appeared punctually at the hour designated; Stuart was prepared to receive him—canvas, throne and palette all arranged. To his visitor's surprise, however, after surveying him a moment, he deliberately seated himself, and commenced a series of those interesting narratives for which he was celebrated. Time flew by, and the annoyed Esculapius heard

the hour chimed when he should be with his expectant patients. At length he ventured upon the dangerous experiment of interrupting the irascible but fluent artist. 'Mr. Stuart, this is very entertaining, but you must be aware that my time is precious. I feel very uncomfortable.' 'I am very glad of it,' replied Stuart; 'I have felt so ever since you entered my studio.' 'Why?' 'Because you look so like a fool. Disarrange that fixed-up costume, and I will go to work!' His sitter, feeling the justice of the rebuke, pulled off his stiff cravat, passed his hands through his hair, and threw himself laughing into an easy attitude. 'There,' said the painter, catching up his brushes with alacrity, and quite restored to good nature by the metamorphosis, 'now you look like yourself.'"

Dr. Waterhouse gives this reminiscence, which is in the same vein:

"A gentleman of an estimable character, and of no small consequence in his own eyes, and in the eyes of the public, employed our artist to paint his portrait and that of his wife, who, when he married her, was a very rich widow, born the other side of the Atlantic. This worthy woman was very homely, while the husband was handsome, and of a noble figure. The painter, as usual, made the best of the lady, but could not make her so handsome as the husband wished, and preserve the likeness. He expressed in polite terms his dissatisfaction, and wished him to try over again. The painter did so, and sacrificed as much of the likeness to good looks as he possibly could, or ought. Still the complaisant husband was uneasy, and the painter was teased from one month's end to another to alter it. At length he began to fret, and to pacify him Stuart told him that it was a common remark, that wives were very rarely, if ever, pleased with pictures of their husbands, unless they were living ones. On the other side, husbands were as seldom pleased with the paintings of their beloved wives, and gave him a very plausible reason for it. Once they unluckily both got out of temper at the same time, and snapped out their frettings accord-

ingly. At last the painter's patience, which had been some time threadbare, broke out, when he jumped up, laid down his palette, took a large pinch of snuff, and as he walked rapidly up and down the room, exclaimed: 'What a —— business is this of a portrait painter—you bring him a *potato*, and expect he will paint you a peach.'"

Stuart never forgot a face that he had once known; of this many illustrations have been given:

"I entered Boston in the evening," said Mr. Edwin, the engraver, "and the next day visited Mr. Stuart." "I knew you were in Boston," said he. "I only came last evening, and this is the first time I have been out." "I saw you—you came to town like a criminal—back foremost." He came by the stage and rode on the front seat. After an interval of five and twenty years, he at once recognized a gentleman who called at his painting room, addressing him by name as readily as if he had but recently met him.

The panels that Stuart used were made of mahogany, and he was not only particular as to the quality and dryness of the wood, but also as to the manner in which the surface was treated; and, to get something like the effect of the twill in the imported canvas, he had the surface of the panel dressed with a rather dull plane, having a finely serrated edge. By passing this plane over the whole surface one way, and then crossing it, the effect was produced.

There was a cabinet-maker by the name of Ruggles, on Winter street, Boston, who did a great deal of work of this kind, and it was in his shop that the artist illustrated how a secret is usually kept. He had told a friend something that he was not to repeat. The friend was urgent for permission to tell it to his friend in confidence. Just at this point they had reached the cabinet-maker's shop, when Stuart said: "Ruggles, have you got a piece of chalk?" The chalk was brought. "Now," said Stuart, turning to his friend, "I know the secret—that is one," as he made a mark on the

board; "you know it—that is two," as he made another mark by the side of the one; "and your friend knows it"—as he made another mark. "How many does that make?" "Three." "Three! bless you, the figures read one hundred and eleven! That will never do;" and the injunction was not removed.

Stuart was frequently annoyed to find that a picture he had taken great pains to paint was ruined by the splitting of the panel. On one occasion, while expressing regret at a mishap of this kind, a cabinet-maker who was present said he could bring the edges of the panel together, and join them perfectly. The panel was accordingly left with him; but judge of Stuart's anger and astonishment, when it was returned, to find that the edges had been planed down and then glued together,—a process that ran the nostrils into one, brought the corners of the mouth nearly together, and did away wholly with the bridge of the nose,—a treatment so ludicrous as to cause the artist to laugh at the absurdity of the thing, while he swore at the stupidity of the fellow.

All of Stuart's pictures, whether on panels or canvas, that were thrown aside, were carried to the garret and left there. In the course of years a large number of these unfinished pictures were heaped together. Stuart was quick to take offense at any remark or comment on his unfinished pictures, and when so annoyed nothing would induce him to resume his brush.

On one occasion a lady left her seat, and, looking over Stuart's shoulder, found fault with the likeness he was painting. He tried for the moment to be amiable, and quoted the text from St James: "A man beholdeth his natural face in a glass and goeth his way, and straightway forgetteth what manner of man he was." Then he rose from his chair, and in his most polite manner, said: "Excuse me, madam, I cannot paint by direction." Having said this, he strode across the room, rang the bell, and ordered the servant to take the canvas to the garret,—a step that brought a flood of tears to the eyes of the sitter; but they had no effect on the painter.

Numerous instances like the above might here be inserted. After the death of Stuart, there were many inquiries if such and such an unfinished picture could be had, and in a manner so imploring as to make it hard to say in a majority of cases that what was wanted could not be found.

The following anecdote was related by Doctor Waterhouse, who probably had it direct from Stuart: "The artist was traveling by stage in England. His fellow-passengers were a number of gentlemen who were strangers to him, and who, finding him very amusing, ventured to ask him who he was, and what was his calling.

"Mr. Stuart answered with a grave face and a serious tone, that he sometimes dressed gentlemen's and ladies' hair (at that time the high-craped pomatumed hair was all the fashion). 'You are a hair-dresser, then?' 'What!' said he, do you take me for a barber?'

"'I beg your pardon, sir, but I inferred it from what you said. If I mistook you, may I take the liberty to ask what you are, then?'

"'Why, I sometimes brush a gentleman's coat, or hat, and sometimes adjust a cravat.'

"'Oh, you are a valet, then, to some nobleman?'

"'A valet! Indeed, sir, I am not. I am not a servant,—to be sure, I make coats and waistcoats for gentlemen.'

"'Oh, you are a tailor?'

"'Tailor! Do I look like a tailor? I assure you, I never handled a goose, other than a roasted one.'

"By this time they were all in a roar. 'What the devil are you, then?' said one.

"'I'll tell you,' said Stuart. 'Be assured all I have said is literally true. I dress hair, brush hats and coats, adjust a cravat, and make coats, waistcoats and breeches, and likewise boots and shoes, *at your service.*'

"'Oh, a boot and shoe maker after all!'

"'Guess again, gentlemen; I never handle boots or shoes but for my own feet and legs, yet all I have told you is true.'

"'We may as well give up guessing.'

"After checking his laughter, and pumping up a fresh flow of spirits by a large pinch of snuff, he said to them very gravely: 'Now, gentlemen, I will not play the fool with you any longer, but will tell you, upon my honor as a gentleman, my *bona fide* profession. I get my bread by making faces.' He then screwed his countenance, and twisted the lineaments of his visage in a manner such as Samuel Foote or Charles Mathews might have envied. When his companions, after loud peals of laughter, had composed themselves, each took credit to himself for having 'all the while suspected that the gentleman belonged to the theatre,' and they all knew that he must be a comedian by profession; when, to their utter surprise, he assured them that he was never on the stage, and very rarely saw the inside of a play-house, or any similar place of amusement. They now all looked at each other in blank astonishment.

"Before parting, Stuart said to his companions: 'Gentlemen, you will find that all I have said of my various employments is comprised in these words: I am a portrait painter. If you will call at John Palmer's, York Building, London, where I shall be ready and willing to brush you a coat or hat, dress your hair *à la mode*, supply you, if need be, with a wig of any fashion or dimension, accommodate you with boots or shoes, give you ruffles or cravats, and make faces for you.'

"While taking a parting glass at the inn, they begged leave to inquire of their pleasant companion in what part of England he was born; he told them he was not born in England, Wales, Ireland, or Scotland. Here was another puzzle for John Bull.

"'Where then?'

"'I was born in Narragansett.'

"'Where's that?'

"'Six miles from Pottawoone, and ten miles from Poppasquash, and about four miles from Conanicut, and not far from the spot where the famous battle with the warlike Pequots was fought.'

"'In what part of the East Indies is that, sir?'

"'East Indies, my dear sir! it is in the State of Rhode Island, between Massachusetts and Connecticut River.'"

Stuart was always ready to repay the kindness he had received from his master; but, however willing to be obliging and do his best, he could not wholly overcome his love of fun, and many were the pranks he played his indulgent instructor, as is shown in the following anecdote related by Dunlap, who had it from the lips of Stuart:

"Mr. West treated me very cavalierly on one occasion, but I had my revenge. It was the custom whenever a new Governor-General was sent out to India, that he should be complimented by a present of His Majesty's likeness. My old master, who was busily engaged on one of his *ten-acre* pictures, in company with prophets and apostles, thought he would turn over the king to me. He never could paint a portrait. 'Stuart,' said he, 'it is a pity to make His Majesty sit again for his picture; there is the portrait of him that you painted, let me have it for Lord ——; I will retouch it and it will do well enough.' 'Well enough! very pretty,' thought I, 'you might be civil when you ask a favor.' So I *thought*, but I *said*, 'Very well, sir.' So the picture was carried down to his room, and at it he went. I saw he was puzzled. He worked at it all that day. The next morning, 'Stuart,' said he, 'have you got your palette set?' 'Yes, sir.' 'Well, you can soon set another; let me have the one you prepared for yourself; I can't satisfy myself with that head.' I gave him my palette, and he worked the greater part of the day. In the afternoon I went into his room, and he was hard at it. I saw that he had got up to the knees in mud. 'Stuart,' said he, 'I don't know how it is, but you have a

way of managing your tints unlike everybody else—here—take the palette and finish the head.' 'I can't, sir.' 'You can't?' 'I can't indeed, sir, as it is, but let it stand till to-morrow morning and get dry, and I will go over it with all my heart.' The picture was to go away the day after the morrow, so he made me promise to do it early the next morning. You know he never came down into the painting room, at the bottom of the gallery, until about ten o'clock. I went into his room bright and early, and by half-past nine had finished the head. That done, Rafe and I began to fence; I with my maul-stick and he with his father's. I had just driven Rafe up to the wall, with his back up to one of his father's best pictures, when the old gentleman, as neat as a lad of wax, with his hair powdered, his white silk stockings, and yellow morocco slippers, popped into the room, looking as if he had stepped out of a band-box. 'There, you dog,' said I to Rafe; 'there I have you, and nothing but your background relieves you!' The old gentleman could not help smiling at my technical joke, but soon, looking very stern, 'Mr. Stuart,' said he, 'is this the way you use me?' 'Why, what's the matter, sir? I have neither hurt the boy nor the background.' 'Sir, when you knew I had promised that the picture of His Majesty should be finished to-day, ready to be sent away to-morrow, thus to be neglecting me and your promise! How can you answer to me or to yourself?' 'Sir,' said I, 'do not condemn me without examining the easel. I have finished the picture; please to look at it.' He did so; complimented me highly, and I had ample revenge for his 'it will do well enough.'"

Another anecdote in the same vein runs as follows:

"I used very often to provoke my good old master, though heaven knows, without intending it. You remember the color closet at the bottom of his painting room. One day, Trumbull and I came into his room, and little suspecting that he was within hearing, I began to lecture on his pictures, and particularly upon one on his

easel. I was a giddy, foolish fellow then. He had begun a portrait of a child, and he had a way of making curly hair by a flourish of his brush, thus, like a figure of three. 'Here, Trumbull,' said I, 'do you want to learn how to paint hair? There it is, my boy! Our master figures out a head of hair like a sum in arithmetic. Let us see,—we may tell how many guineas he is to have for this head by simple addition,—three and three make six, and three are nine, and three are twelve——.' How much the sum would have amounted to I can't tell, for just then in stalked the master, with palette-knife and palette, and put to flight my calculations. 'Very well, Mr. Stuart,' said he,—he always *mistered* me when he was angry, as a man's wife calls him *my dear* when she wishes him at the devil,—'very well, Mr. Stuart! very well, indeed!' You may believe that I looked foolish enough, and he gave me a pretty sharp lecture without my making any reply. When the head was finished there were no figures of three in the hair."

Stuart was the warm friend of Trumbull when he was imprisoned in London, on the charge of being a spy, he having been arrested at the time of the execution of Major André. While so imprisoned, Stuart painted his portrait, and as a striking illustration of the power of the latter's pencil this anecdote is given. It is related by Miss Stuart:

"A short time previous to Trumbull's death, my sister Anne called to see him in New-York. She knocked at his door, and heard him say, 'Walk in.' He was sitting before his easel, with the picture before him, which my father had painted of him in London, but looking depressed and very much broken. The moment he recognized her he started from his seat, exclaiming: 'Good God! the spirit of your father has been hovering over me! I cannot tell what has possessed me, but I have been thinking of him all the morning, and of the many happy days of our early friendship. This it was that induced me to place this picture on the easel.' He then

spoke with great bitterness of the lies, as he called them, that had been written about my father by Dunlap. Seeing him so excited, she tried to soothe him by telling him that no one cared about it, and although she at length succeeded in turning the conversation, it was not until he had freed his mind by giving vent to the strongest language."

There are many anecdotes told of Stuart while he was with West. The following was related by Mr. Fraser: "Dr. Johnson called one morning on Mr. West, to converse with him on American affairs. After some time, Mr. West said that he had a young American living with him, from whom he might derive some information, and introduced Stuart. The conversation continued (Stuart being invited to take part in it), when the Doctor observed to Mr. West that the young man spoke very good English, and turning to Stuart rudely asked him where he had learned it. Stuart very promptly replied, : 'Sir, I can better tell you where I did not learn it—it was not from your dictionary!' Johnson seemed aware of his own abruptness, and was not offended."

Another anecdote is told by Mr. Neagle, of Philadelphia:

"When studying at Somerset House, in the school of the antique, it was proposed by his fellow-students that each one present should disclose his intentions as to what walk in art, and what master, he would follow. The proposal was agreed to. One said he preferred the gigantic Michael Angelo. Another would follow in the steps of the gentle but divine Raphael, the prince of painters, and catch, if possible, his art of composition, his expression and profound knowledge of human passion. A third wished to emulate the glow and sunshine of Titian's coloring. Another had determined to keep Rembrandt in his eye, and, like him, eclipse all other painters in *chiaroscuro*. Each was enthusiastic in the praise of his favorite school or master. Stuart's opinion being demanded, he said, that he had gone on so far in merely copying what he saw before him, and perhaps he had not a proper and sufficiently elevated notion of art.

But after all he had heard them say, he could not but adhere to his own opinion on the subject. 'For my own part,' said he, 'I will not follow any master. I wish to find out what Nature is for myself, and see her with *my own eyes.* This appears to me to be the true road to excellence. Nature may be seen through different mediums. Rembrandt saw with a different eye from Raphael, yet they are both excellent, but for dissimilar qualities. They have nothing in common, but both follow nature.' While he was speaking, Gainsborough accidentally came in, unobserved by him, and as soon as he ceased, though unknown to the speaker, stepped up to him, and patting him on the shoulder, said, 'That's right, my lad; adhere to that and you 'll be an artist.'"

As already stated, Stuart was fond of good living, and if he gave no heed to other domestic matters, he never neglected to look after his table.

There was a farmer, named Greene, who supplied him with poultry and eggs, and particularly fine butter, and when he came to the house Stuart always made it a point to see him. After one of these interviews, Stuart came into the parlor, and said, with a very grave face, "Greene is going to die."

"Going to die!" said Mrs. Stuart; "he is well enough. Why do you say so?"

"Greene is going to die," was the only response.

"Why, Mr. Stuart, what do you mean? Greene is as well as you or I."

"Greene, nevertheless, is going to die. I know it, for he has just returned to me ten dollars that I had overpaid him."

Singularly enough, they never saw Greene again, for in a short time he was taken ill, and the next they heard he was dead.

Madame Bonaparte

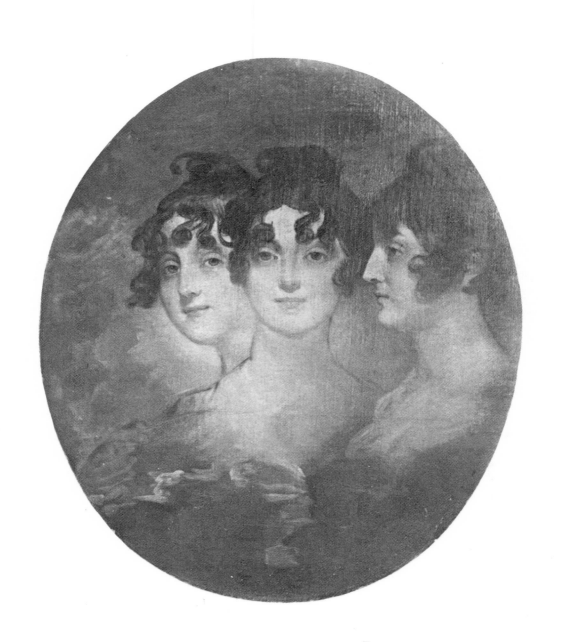

STUART'S REMARKS ON ART.

THE following "Remarks on Art" are attributed to Gilbert
Stuart. Originally they were printed on a single sheet of
paper, by James Bogle, the portrait painter. He gave two copies
to Mr. Daniel Huntington, President of the National Academy of
Design. One copy he gave to Mr. Durand, the editor of the
Crayon, in which journal it appeared in 1861. The manuscript Mr.
Bogle obtained from Matthew Jowett, who made memoranda of
Stuart's conversation when he studied with him in 1817. Mr. Hun-
tington, in speaking of the "remarks," says: "They are character-
istic and in the oracular manner of Stuart, carrying with them
strong evidence of authenticity."

REMARKS ON ART.

"There are grand stages in a head, as in an argument or plea
of any sort,—a beginning, a middle and an end; and to aim at
either of those three perfect stages should be the business of a
painter, as illustrated by three heads shown in a double mirror or
two mirrors which produce the effect of distance upon the face.
Too much light destroys, as too little hides the colors. The true
and perfect image of the man is to be seen only in a mist or hazy
atmosphere. This is illustrated in a comparative sense by the
elements of those countries where the best colorists have lived: for
instance, in the foggy climates of Germany and Holland, and about
Florence, compared to that of Rome and Paris, where good coloring

has never been seen. England, on the contrary, owing to this, in part, has produced more good colorists. Where there is too much light, there will be no flesh in the shadows; where too little, not enough flesh in the lights. Both extremes are dangerous. It is more important to give a prominent admeasurement of distances than a set of mimicking lines. Keeping is of the very highest importance to good coloring, to effect which we should see a good way from the easel, and early accustom ourselves to looking at the subject rather than at the features. The cry of the English school was, 'Sink your draperies, Stuart, and bring out the flesh!' But no! let nature tell in every part of your painting. If you cannot do this, lay by the brush.

"Never be saving of color. Load your brush, but keep your tints as separate as you can. No blending; it is destructive to clear and beautiful effect. It takes off transparency and brightness of color, and renders flesh of the consistency of buckskin. Be rather pointed than fuzzy, and rather strong than feeble. Be decided in your drawing, urge with firmness your idea, and put it down with vigor. Fog color is preferable to any other as a ground for painting upon. This is the opinion of Da Vinci; and the reason is that because being of no color it receives any color upon it. In laying on your picture, be bold and decisive as to the character, but feeble as to the effect. Short and chopping strokes are preferable to swashing handling. The last order of style is apt to toughen the skin, and render it wormy.

"Flesh is like no other substance under heaven. It has all the gayety of a silk-mercer's shop without its gaudiness of gloss, and all the soberness of old mahogany without its sadness. Sentiment, grace and character are to be worked at in your subject; in short, you cannot be too particular in what you do to see what sort of animal you are putting down. Most persons, in striving after effect, lose the likeness, when they must go together to produce a good effect. You must copy nature, but if you leave nature for an

imaginary effect, you will lose all. Nature cannot be excused, and as your object is to copy nature, it is the height of folly to work at anything else to produce that copy.

"PALETTE. Antwerp blue, white, yellow ochre, vermilion lake, burnt umber, ivory black, lake and vermilion for the blood, white and black for gray, yellow and black for green, black, vermilion, burnt umber and lake for the shadow; the three last used as glazing colors. I can produce from these what I wish, nor can any man say whether or not I put ultramarine in my flesh. It is at best a matter of fancy. Practice, with a little experience and arranging, is the life of all, without which coloring is all moonshine. Avoid dryness above all things, and the licking style. A little fumbling and a little rubbing will produce the first, and a little too much mixing the last. My idea is this: put as little color in the shadow as you can. In laying on the dead color be bold, and put on the color freely, but let it be well mixed on the palette and on the brush, that a clear and decided touch may be given; no fuzzy edges, but liquid, and all of one cast. This will give liveliness, transparency and force to the head. Until the head be forged out, and the character and drawing be correct, be not too solicitous about beauty of effect.

"I have very often roughened a second or third sitting that I might be thrown back, and by having to use more color, produce a rich effect. The reason that my paintings were of a richer character thirty years ago is that then it was a matter of experiment, and now, as everything comes to my hand, I put it down too much in place and leave it so, for want of opportunity to restore richness. One invariable rule in the management of the hand is to give the fingers a central motion toward the palm. No rule is invariable about backgrounds, but it is important that the background should contain whatever is necessary to illustrate the character of the person. The eye should apply to the parts. Illustrate the whole without taking from the main point. Too much parade in the background is apt to fatigue, by constantly shifting the attention.

Drawing the features distinctly and carefully with chalk is loss of time; all studies should be made with the brush in hand. It is nonsense to think of perfecting oneself in drawing before one begins to paint. When the hand is not able to execute the decision of the mind, a fastidiousness ensues, and on its back disappointment and disgust. This is one reason why the Italians never painted so well as other schools.

"Be ever jealous about truth in painting, and preserve as pure as possible the round, blunt stroke. The first stage of painting is blocking out the subject. The advantage of having the easel before the sitter is that by so doing you are enabled to embrace both at once. The eye, from practice, passes from one to the other with great rapidity. Never suffer a sitter to lean against the back of the chair; it constrains the attitude and general air of the person. Attend to this particularly; without this the best head is of little avail. Some faces require to be fringed up to the very making with large tools; thick-skinned faces are of this character. Be careful to blend the hair on the forehead, for dark points will otherwise show through thick paint.

"Always use spirits of turpentine with white. It carries off the oil in evaporation. Avoid by all means parallel lines. Straight or curved short lines are to be avoided.

"The nose must be indented to give zest to the eyes. Be careful never to have the head higher colored than you wish it until the last sitting. It is apt to give a heavy orange appearance. Never glaze until you have a sufficient body of color as will stand against all the accidents liable to picture-cleaning. Never put a light object in the shadows, or a dark object in the lights. To produce extreme perspective, give great glow in the foreground. Artists often mistake in giving a low, deep tone to their backgrounds; for, by so endeavoring to bring out, they sink their subject. Backgrounds, dark in the direction of the light, are oftener agreeable than when they oppose the light."

LETTERS TO STUART.

BUT few of the many letters addressed to Stuart during his long career as an artist have been preserved, and from the scanty number found among his papers the following have been taken:

Dear Sir:—Encouraged by my great fondness for the art which you profess and I am studying, I thus commence a correspondence not without risk of being thought impertinent. If I had no other motive, it would be sufficient that of possessing some pleasing evidence of your approbation or the friendly advice of so experienced an instructor.

In pursuance of the advice of Mr. West, I have settled in Philadelphia, where I have built myself a better painting room than I could rent; and for the purpose of raising money, getting practice and having a few pictures hung about, am painting for a while at half-price, as I call it (at first twenty-five now thirty dollars). My last and greatest improvement I have effected by following the advice of Sir Joshua, to study by lamp-light, the effects of which delight me by the precision of the lights, beauty of the shadows and richness of the reflections. It seems to favor the manner which I have heard you say principally distinguished you from Mr. West, in producing the effect of projection, instead of depending merely on the accuracy of the outline. Probably you were acquainted with Gainsborough, who employed this mode of study, and may have known whether Sir Joshua practiced the plan which he approved of.

Now that I feel myself reanimated with that love for the Art which is so connected with its attainment, I particularly regret the want of those conversations with which I have been occasionally indulged, and which it is not flattery in me to say, you know to render so agreeable and instructive. On reviewing them my vanity would persuade me that you were pleased to distinguish me by more than common

civility. And yet I never could so far divest myself of an unprofitable timidity as to let you know how desirous I was, upon some footing or other, to be indebted to you for further instructions. You have freely explained to me some of the principles of the Art, which have assisted me much; but how much beyond this I ought to have sought from you I could not determine, conscious as I was of being unable to make you any other return than gratitude that could be worthy your acceptance.

If in due time my portfolio should contain an answer to this, it will ever be seen with pleasure as an evidence of your good will to a young fellow-countryman seeking the path which you have trod, and which you cannot desire to see overrun with weeds.

<div align="right">Respectfully your obliged,</div>

PHILADELPHIA, *March 24th, 1806.* REM. PEALE.

<div align="right">NEW-YORK, 25th March, 182–</div>

G. STUART, Esq.

My Dear Sir:—A few days ago I received a letter from our old acquaintance, Sir Thomas Lawrence (who is painting for the Academy here, a full length portrait of Mr. West), in which is a passage which I am sure will give you great pleasure:

" I am glad to hear that Mr. Stuart is still in good health, and practicing his profession. He is one of my very earliest recollections in London; if you ever see him, pray tell him that Mr. Kemble still retains a most extravagant partiality for him."

I hope you and your family enjoy good health, after this murderous winter, and that your daughter is making progress in the Arts worthy of her beginning.

<div align="right">I am faithfully yours,</div>

<div align="right">JNO. TRUMBULL.</div>

<div align="right">NEW-YORK, July 8th, 1802.</div>

GILBERT STUART, Esq.

Sir:—My friend, Mons. Delmeis, about going to Philadelphia, has promised to bear you my respects, with a few brushes, which I accidentally met with a few days ago and quite *apropos;* for I was not provided with any so good; should this be the case with you I flatter myself the trifle will be acceptable.

I hope to visit Philadelphia once more ere I leave this country, and promise myself much pleasure from the sight of your magic productions.

With most respectful wishes for your health and happiness, which includes that of your family, I remain, sir, your most obedient servant and quondam pupil,

<div align="right">JNO. VANDERLYN.</div>

LONDON, Leicester Square, *January 6th, 1825.*

Honoured Sir:—I am incapable of expressing the degree of pleasure that I have received in looking at the portrait of Mrs. Williams, which you have lately painted. When I first saw it it was by surprise; I had just returned from France, and in paying a visit to my friend Williams, I stumbled in upon it, as it were, without knowing who was the author. I think, and I doubt not you will agree with me, that a young artist is very apt to be enamoured of the productions of his favourite master—that he admires, without discrimination, the bad as well as the good parts of his pictures. But in saying that I think this picture is one of the best portraits that I have seen, is but to speak my candid opinion, which was formed before I knew who the artist was that made it. And I am happy to say that I am not singular in my opinion.

I am not a little surprised to find that the Marquis de Lafayette has not been painted by you. I must attribute this circumstance to your illness alone; for I can conceive no other possible cause why the friends and companions of Washington should not have been painted by the same artist that has laid his countryman and the friends of Washington under so great an obligation.

For the last five months I have painted very little. I have been travelling about the United Kingdom, France, etc. While at Dublin I fell in with Mr. Comerford, miniature painter, who told me he owed more to you for what he now is (and he has an income of two thousand pounds sterling, and enjoying at the same time a considerable degree of reputation as an artist) than to all the rest of the artists in the world besides. He was most enthusiastic in your praise.

I saw several of your pictures, one a full-length of the Lord Chancellor of Ireland, Fitz Gibbon (I think that is the name), and a very fine picture it is, in a good state of preservation.

Mr. Mason has undoubtedly given you an account of the Arts in this city. This is the place where I think you should have remained, and the place where I think if you were to come now, you would command any price for your labours, and I don't hesitate to say that you would stand ahead of all, unless it be Sir Thomas Lawrence.

When I speak of Sir Thomas as the first painter of portraits in England, I must speak of Sir Wm. Beechey, Phillips, Jackson, Shee, etc., as third-rate artists in the scale of comparison.

I hope and believe that I am not wasting the good councils that you gave me from time to time, nor the fine opportunities I am conscious of enjoying. I will venture to say that I have made great improvement within the last nine months. I was an exhibitor at the different exhibitions, where I had the mortification to see myself in a true and proper light; since when I have been striving, and I hope with success, to get rid of some of those bad and false principles in Art that I before cherished.

I have as patronage [a part missing] beyond my deserts. Fortunately the people do not see the difference between a good likeness by me, and one of equally striking fidelity by better painters. I have painted within the last few months a head of the Duke of [a break in the paper] which is the best I ever painted. I am proud of it; it is, I think, a good head. I am to paint another head of the Duke of Sussex for the Duke of Hamilton. I charge twenty guineas for a head, thirty for a kit-kat and fifty for a half-length.

I speak thus freely of myself and go into this detail of my own concerns, because I think from the kind interest you have always evinced for my improvement and success, that it will not be altogether uninteresting to you.

I had a full and particular letter from Mr. Jowett not long since. He is plodding on in the old way, it seems,— is contented with his farm and circle of friends in Lexington. He spoke, as he always does, in grateful commendation of his *master*.

I beg to be kindly remembered to your family, to Mr. Allston, Mr. Mason and the rest of my fellow-labourers; and beg that you will excuse the liberty I have taken in addressing these few lines to you; and believe me your most grateful and sincere friend,

CHESTER HARDING.

The next is from Sir William Beechey:

LONDON, Harley Street, *June 19th, 1826.*

My Dear Stuart :—I take the opportunity afforded me by our young friend Fisher, just to say how very happy I was to receive a letter from my old friend in Boston, after an absence of one hundred and fifty years. If I had time I would tell you something of the present state of the Arts here, but as opportunities *now* so frequently occur of communicating with our friends in America, by means of the numerous artists residing here, I shall defer writing on that subject 'til I have more leisure; for Fisher, in this instant is waiting to receive this, and fears he will lose his dinner. I must, however, inform you that I rec'd. a bottle of linseed oil from a Mr. Smith, but I never saw the captain who sent it, nor did he leave his address.

If Mr. Smith has found out a method for making linseed oil *better* than we have in Old England, it must be very limpid and as colourless as possible, and expressed nearly if not quite cold. If the seed is good and genuine, I make no doubt he might sell an amazing quantity annually. I much wish he would try, as the article I have from him is very yellow and no better in other respects than our own.

Fisher goes on very well indeed; he is very industrious and much improved, and will turn out like all the Americans, a devilish clever fellow.

Now, God bless you, my dear Stuart: 'til I hear from you again, I remain most sincerely yours,

W. BEECHEY.

The next is from Sir Edward Kingsmill, and is addressed to The Honorable Richd. Annesley, Custom-House, Dublin :

BELFAST, *29th July, 1788.*

Dear Sir :—I received your favour. I fear it will not suddenly be in my power to leave this place. The business of the Port alone, as the collector is confined, requires my constant attention. I saw Mr. Stuart in London; his likenesses were very striking, and had not his affairs obliged him to leave it, I was to have sat to him ; however, if he does not leave Dublin soon, probably an interval of business might come, to put it in my power to apply for a few days' leave, and may be I could contrive it so as to make business a part of my jaunt to town.

I am, with every sense of your goodness to me, dear sir, yr. much obliged and affecte. humble servt.,

EDW. KINGSMILL.

WAR OFFICE, *14th February, 1798.*

Sir :—The Little Turtle, who will deliver you this, is an Indian Chief of great consequence. I am desirous of having an expressive likeness of him, at half length, taken by a painter of eminence.

Your professional abilities have induced me to apply to you for this purpose in order that, if it suits your convenience, and will not interfere with your engagements, no time may be lost in beginning and finishing such picture as soon as possible.

I am with much respect, sir, your obedient servant,

JAMES McHENRY.

The following is from Dean Butson.

Dear Sir:—You recollect you were so obliging as to promise me a bottle of varnish, for our pictures, which indeed mine seems to want, and it is a pity so capital a performance should not have every advantage; I should be obliged to you, therefore, if you will order that bottle to be left at Mr. Sam. Roberts, attorney, who lodges in Castle Street, opposite almost Latouche's Bank, at a Mr. Anderson's, a hatter, as he will forward it. I am so particularly anxious for it now as the [effaced] who was to make use of it is soon going to London. He is a native of this town, an ingenious artist in the landscape line — was never out of the kingdom, and is going to London to study. If you could favour him with a line of introduction to any artist you think will be of service to him, you will oblige me, and I am confident he will not disgrace your commendation.

The following is from a letter written by Mr. Isaac P. Davis, of Boston, the warm and intimate friend of Stuart, and was addressed to Sully, the artist. It is dated Boston, April 26th, 1830:

"Mrs. Davis will pass a few days in your good city, and expects to have the pleasure of seeing you. I have sent by her the large silver snuff-box of Stuart, which was almost a part of himself: it was as necessary for him as the palette and pencils, and always had a place on his easel. As it cannot be in the possession of any one more deserving, or will more highly prize it than yourself, I beg your acceptance of it from me, as a small token of my regard and esteem.

"As I have not time before Mrs. D. leaves to have an inscription, you will direct such an one as you may think proper, that it may be known as the box of Gilbert Stuart."

It is a plain, round silver box, four inches in diameter and two inches deep, and on it there is this inscription: "Gilbert Stuart's Snuff Box, presented to Thomas Sully by his friend, Isaac P. Davis." The box is lined with gold, and on the sides there are particles of Stuart's snuff, which have hardened there. Sully, in his will, bequeathed it, together with Stuart's walking-stick and palette, to his grandson, Garrett C. Neagle, Esq., son of Neagle the portrait painter, who has it in his possession.

Stuart one day accidentally left this snuff-box at the house of Mr. Davis, who, by way of a joke, hired a porter to take it to Stuart's house in a hand-cart.

Mention has already been made of the snuff-box presented to Stuart by Bishop Ossory, and now owned by the Boston Art Museum.

PORTRAITS OF GILBERT STUART.

THERE are a number of portraits of Gilbert Stuart, painted by different hands; but they all pale before his own pictures. He painted his own portrait in early life—the picture in the Redwood Library,—but it has been so coated with bad varnish and smoke as to be almost obliterated. Mr. Henry Graves, of London, has Stuart's portrait, painted by himself in England, but the artist left no likeness of himself taken in his prime in America. In the rooms of the New-York Historical Society, there is a portrait of him, painted by Charles Wilson and Rembrandt Peale. It formerly made a part of the Bryan collection; and in the Boston Athenæum there is the well-known portrait by Neagle, already referred to in these pages, and which was painted in Stuart's room. This head was engraved for an early number of the *Knickerbocker* Magazine. Anson Dickerson painted a miniature of Stuart on ivory. It was at one time the property of the late Dr. S. W. Francis, from whom it descended to his sons, Drs. S. W. and V. M. Francis, who presented it to the New-York Historical Society. Another miniature, the one in the title page of this volume, Miss Stuart values more highly than any other likeness of her father. It was painted on ivory by Miss Goodridge (generally written Goodrich), an artist for whom Stuart had a very warm regard, and who was greatly surprised one day to hear him say that she should paint his likeness. This miniature has also been engraved by Durand.

Of Miss Goodridge, but too little is known, and Mrs. Ephraim Stone, her sister, in reply to a letter, asking for information in regard to the artist, has kindly furnished the following sketch:

"Sarah Goodridge was born February 5th, 1788, at Templeton, Mass. Her parents, Ebenezer Goodridge and Beulah Childs, his wife, were people of comfortable means for those days, who, with industry and frugality, managed to bring up a family of eight children to maturity. Their first child died in infancy. Goodridge was a mechanic and farmer. Sarah was the sixth child, and third daughter. Her father could not afford to give any of his children a better education than they could obtain at the district schools, which were reputed better than those of the neighboring towns. She was an apt scholar, and learned all that was taught at school, except arithmetic. It was thought quite unnecessary then to teach girls that branch, which was for boys alone. Her lessons did not occupy all her time, and, lacking occupation, she studied the dictionary and made herself acquainted with the contents of Perry's small one.

"Miss Goodridge early showed a love for pictures. Paper was a scarce and expensive article. She was put upon her own resources, so she substituted white birch bark, peeling it from the great logs brought into the door-yard with the pile intended for the coming year's fuel. What she could not peel off she used on the logs, where she could find a smooth place, scratching it with a pin, working sometimes as long as the twilight would permit. She gathered it and made it into books, in which, with pen and ink, she drew pictures and copied poetry, of which she was very fond. One saw no carpets at that time; they sprinkled sand on the unpainted floors, and when they became littered a broom was drawn over them, making the surface smooth. On a surface so obtained, she could draw her figures with sticks, and they might also be seen on the whitewashed walls of the house, and wherever a place could be found to make them. She was general picture-maker for her school-mates, and, from memory, sketched likenesses of people distinguished

for beauty or deportment; not very accurately, perhaps, but so as to be recognized. She also showed some talent for sculpture, and had it been as easy to obtain materials for that branch as for painting, she might have done well in it.

"Miss Goodridge could get instruction from no one, and saw no pictures but the poorest wood-cuts. In this way she continued on, helping in the household, till she was seventeen. Her eldest brother then began housekeeping in Milton, where she went, and attended a boarding-school for a few months, with but very little advantage. She was alternately with her brother and at her father's. The former removed to Boston, and had in his family a man, possessed of a considerable knowledge of drawing, who gave her some useful lessons. She also had a little book on drawing and painting, in which were some directions for painting on ivory.

"At this time, Miss Goodridge taught a district school for two summers, and improved every opportunity that offered for getting information connected with the Art she loved. These opportunities were few and far between. At the age of twenty-four, she went to reside in Boston with her sister, the wife of Thomas Appleton, who had been with her brother in the organ-building business. At this time she began her career as a painter. The next summer, she went to Templeton, and began to take likenesses; first on coarse paper, life size, with red, white and black chalk, at fifty cents each, and then in water-colors, on paper, at a dollar and a half. In the autumn, she returned to Boston, and kept house with another brother for nearly two years, devoting herself almost exclusively to painting; gaining at every step, and with a patronage that encouraged her to persevere.

"Oil painting for a time occupied her attention, but she soon gave it up for miniature painting. At that time there was no miniature painter of any note in Boston, but afterward one came from Hartford, with whom she became acquainted, and from whom she received useful lessons. Soon she excelled him in likenesses.

With the Appletons she resided during the rest of her days; her reputation as an artist became established, and from that time forward she had as much as she could do. Two miniatures a week were as much as she could do without great fatigue, but she was often forced to paint three in that time.

"Mr. Stuart was taken to Miss Goodridge's painting room, and introduced to her by a mutual friend. He seemed pleased with her work, and gave her an invitation to his studio. She went frequently, and carried, by his request, her unfinished pictures, in their various stages, for him to criticise. At such times he gave her many hints, for which she was very grateful, for it was the most useful instruction she had ever had. She was wanting in a knowledge of perspective, and Stuart advised her to go to Mr. David L. Brown's drawing-school. Heads, and heads only, she loved to paint.

"Stuart had two faces; one full of fire and energy, seen in Miss Goodridge's miniature of him, and the other dull and heavy, 'looking' as he said—when he saw the miniature he had permitted a New-York artist to paint—'like a fool.' He was unwilling to be handed down to posterity thus represented, and so he asked Miss Goodridge to paint him. When she had developed the head, she wished to do more to it, but he would not allow her, lest she should injure the likeness.

"Miss Goodridge went to Washington twice; first in the winter of 1828–29, and again in 1841–42. She had some work to do there, but the city was filled with artists of greater notoriety, and the benefit to her was in the change of scene and life. On her return she was less hurried with work, but she had quite as much to do as her strength would warrant. She made several removes, of which she gave no notice of a change of location, and in this way many persons lost sight of her. In 1850, her eyes had become dim; she had lost, in a measure, her zeal for her work, and she felt that she could not do as well as she had done. She had for some

years looked forward to the time when she should own a cottage in the country, where she could enjoy rest from her labor. She had supported her mother during the last eleven years of her life, and a paralytic brother for the two last years of his life; had nursed her eldest sister through her last sickness of five months, and had taken an orphaned niece, of three years of age, and had kept her till fifteen, when she died.

"In 1851, Miss Goodridge bought a house in Reading, Mass., removed there with Mr. Appleton's family, had fitted it up for the occupation of her sister's family and herself, and had begun to enjoy it extremely; but this happiness was but of short duration. In 1853, while spending Christmas-day with some friends in Boston, she had an attack of paralysis which rendered her speechless, and in three days she died.

"As a miniature painter, Miss Goodridge was without an equal in Boston for many years, and she was frequently invited to other places to take the likenesses of those who could not come to her. She was of a quiet, amiable disposition, and very obliging to her friends, as she sometimes learned to her cost. She had no financial ability, and many were the loans to those who were never able to return what had been borrowed. Nor was she always successful in her investments; but even with these drawbacks, she managed to save enough for her support, and to leave something to her relatives."

Another miniature of Stuart, also on ivory, is owned by Mr. George W. Huffnagle, of New Hope, Bucks County, Pennsylvania, who has given the following history of it:

"There were but two or three of these paintings. Two he [Stuart] parted with, and I believe are now in Europe. This one he retained, and on the 21st of July, 1827, at Boston, he presented it to my mother. Gilbert Stuart was the sincere and trusted friend of my father and mother, and this friendship existed until his decease."

In 1848, the American Art Union had a bronze medal struck, known as the Stuart Medal, given to the subscribers for that year, who were so fortunate as to draw it.

A cast, made over Stuart's face, by a Mr. Brower, is spoken of by Miss Stuart as very perfect. It is now in the possession of the Brower family, and Miss Stuart has expressed a wish to have it brought before the public.

A pen-and-ink sketch of Stuart, made by himself on the back of a letter, and now owned by J. M. Falconer, Esq., of Brooklyn, has been carefully etched for this work by Mr. James Duthie.

West painted a large picture of the Order of the Garter, in which he introduced a head of Stuart among the spectators. Stuart then painted a head of West in the same group. The head of Stuart has been frequently recognized by those who have seen it.

John Callender

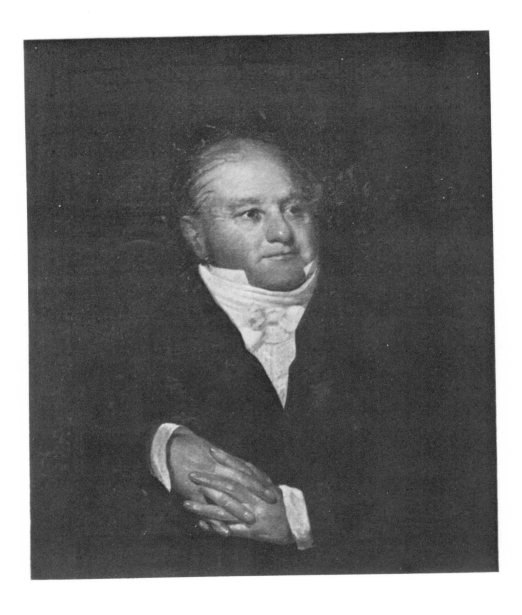

EXHIBITION OF STUART'S WORKS. — 1828.

IN the autumn of the year in which Stuart died, an effort was made to bring together as many of his pictures as it was possible to collect, and exhibit them in Boston. The movement was successful, and no less than two hundred and fourteen, all portraits, were exhibited in a large room on Pearl street, near to, but not a part of, the Athenæum building. It was the best room for the purpose in Boston, and was lighted from the ceiling. The pictures took up all the space on the walls. When the exhibition opened, the following notice of it, thought to have been written by William Tudor, author of the Life of James Otis, appeared in the *Columbian Centinel* :

"THE STUART PORTRAITS.

"Of this exhibition we could say but little hitherto, except from hearsay. Having found an opportunity, however, to spend an hour or two yesterday at the Gallery, we can now speak as one having authority. That every visitor of that magnificent collection goes thither with excited curiosity and high expectation is not at all wonderful; the wonder is that none go away without having the one amply gratified, and the other fully realized.

" There is an assemblage of the eminent and the fair,—of generations passed and passing,— telling with mute but touching eloquence the power of human art. The illustrious dead, and those that once were lovely, have come up, as it were, from the oblivious sepulchre, and the living are congregated from the four winds of heaven, to

render homage to the memory of nature's faithful student. The artist is also there, in humble guise, looking back from the confines of another world, upon that creation of his own genius which he has left behind,—a legacy to the sons of science—an enduring monument to his own fame.

"It is scarcely possible to stand in the midst of such a congress without an involuntary feeling of awe and admiration. The eyes of the great, of the truly noble, are fixed upon you,—not only in the statesmen and law-givers of our own day, earnestly bending their intellectual gaze upon the almost abashed intruder, but the heroes and patriots of yore, with a seeming expression of mingled melancholy and satisfaction, in all the majesty of mind, are peering upon their posterity through the very windows of time. Here is a study, which the man of taste and contemplation may enjoy for hours. Washington, restored to the company of his favorite generals and co-patriots,—his successors in office brought, at least to imagination, into his immediate presence, together with their respective friends and coadjutors. The high-minded Adams, as he appeared both in the zenith of his glory and the waning twilight of his days,—with Ames, and Pickering, and Otis, and Dexter, and Quincy, and a host of New England patriots; the profound and philosophic Jefferson, whose placid countenance bespeaks a power and depth of thought with which few of our race are gifted; the spirited and patriotic Madison, the energies of whose soul seem bursting from his lips in the memorable and indignant exclamation: 'It is time to assume an armor and an aptitude!' Munroe, the benignant extinguisher of every faction—the beloved of a free people; our present Chief Magistrate, with multitudes of worthy and distinguished personages, civil and military, executive, judicial, legislative and clerical.

"Into such a company, made almost to live and breathe by the magic of the pencil, the astonished spectator is at once introduced; and as his eye wanders over the august array, he feels half afraid of violating the rules of good breeding by staring directly into the face of those figures which surround him, and which seem to look upon him from every quarter as some object of special and honored attention."

STUART'S WASHINGTON PORTRAITS

Washington

(The Gibbs Portrait)

On Steel by Burt

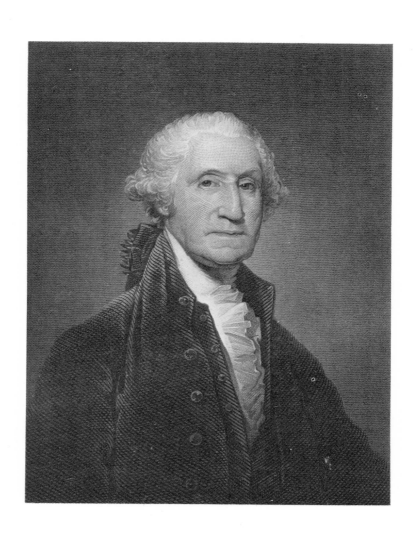

PORTRAITS OF GENERAL AND MRS. WASHINGTON.

G. W. P. CUSTIS, in his "Recollections and Private Memoirs," says: "The first portrait of Washington by Stuart created a great sensation in Philadelphia. It was soon followed by the celebrated full-length for the Marquis of Lansdowne." This last was undoubtedly the next picture to create a sensation; but there was an interval of at least a year between the painting of the first portrait and the full-length. It is now impossible to say what portraits were painted during that interval. Among Stuart's papers, the following fragment was found:

A list of gentlemen who are to have copies of the portrait of the President of the United States.

Philadelphia, April 20th, 1795.

J. Watson, Esq.,	1
Don Jos. de Jaudennes,	5
Marquis of Lansdowne,	1
Lord Viscount Cremorne,	1
B. West, Esq., P. R. A.,	1
Messrs. Pollock, N. Y. 100,	. . .	2
J. Vaughan, Esq. 200,	2
Col. Burr, N. Y. 100,	1
—— Mead, Esq.,	1
M. T. Barrow, N. Y.,	1
John Craig, Esq. 100,	1
Greenleaf, Esq.,	1
Wm. Hamilton, Esq.,	1
Mr. Chief Justice Jay,	1
Col. Read,	1
Mr. Holmes, 100,	1
Mr. Fitzsimons, 100,	1
Mr. Necklin,	1
Gen. Lee,	1
Mr. Crammond,	2
J. Swan, Esq.,	1
—— Smith, Esq., S. C.,	. . , . .	1

John Stoughton, Esq., 1	—— Crammond, Esq., 1			
Kearny Wharton, 1	Doctor Stevens, 1			
Casaubon, Esq., 153 M. J., 1	—— Scott, Esq., Lancaster, 1			
Meredith, Esq., 1	Grant, Esq., Susqueha'a, 1			
Blodget, Esq., 1	Wm. Ludwell Lee, Greenspring, Va., 1			

It is not at all probable that these pictures were all painted. Philadelphia, at that time, was full of visitors; Stuart was crowded with orders for portraits, and he was so overrun with callers that he was forced, a little later, to remove to Germantown, where he opened his studio. Even there it was impossible for him to meet all his engagements.

Rembrandt Peale, in his lecture on the Portraits of Washington, says: "Mr. Stuart's first portrait of Washington was painted simultaneously with mine, in September, 1795. From this first one he made five copies; but becoming dissatisfied with it some years afterward, sold it for $200, to Winstanley, the landscape painter. Of this I was informed by Dr. Thornton, in Washington, soon after its occurrence, so that it was not literally rubbed out, as was supposed."

The question as to priority is settled by the above list, and, although Mr. Peale may have "supposed" that the first portrait was "not literally rubbed out," we have no right, in the face of Stuart's own statement to the contrary, to entertain his views. In March, 1853, the following appeared in the *New-York Evening Post*, the editors stating at the time that the document was in the possession of a gentleman in Philadelphia:

"'*Sir:*—I am under promise to Mrs. Bingham to sit for you to-morrow, at nine o'clock, and wishing to know if it be convenient to you that I should do so, and whether it shall be at your own house (as she talked of the State House), I send this note to ask information. I am, sir, your obedient servant,

"'Geo. Washington.

"'Monday Evening, 11th April, 1796.'

"This letter was indorsed in Washington's hand-writing, 'Mr. Stuart, Chestnut Street.' At the foot of the manuscript are the following certificates :

"'In looking over my papers to find one that had the signature of George Washington, I found this, asking me when he should sit for his portrait, which is now owned by Samuel Williams, of London. I have thought it proper that it should be his, especially as he owns the only original painting I ever made of Washington, except one I own myself. I painted a third, but rubbed it out. I now present this to his brother Timo. Williams, for said Samuel.

"'GT. STUART.

"'Boston, 9th day of March, 1823.
"'*Attest :* I. P. DAVIS.
 W. DUTTON.
 L. BALDWIN.

"'N. B. Mr. Stuart painted in ye *winter season* his first portrait of Washington, but destroyed it. The next painting was ye one owned by S. Williams, the third Mr. S. has—two only remain as above.

"T. W.'"

The picture alluded to above, as owned by Stuart, is the Boston Athenæum head, and that which belonged to Samuel Williams is the Lansdowne full-length.

There are two types of the Washington portrait by Stuart: one shows the right side of the face,—these are the earlier pictures; and the other, giving the left side, takes in all the portraits painted after April, 1796,—the Lansdowne, Constable, Athenæum, and other pictures, that are generally known as "Stuart's Washington." It is very easy to establish the fact that the earlier portraits show only the right side of the face, but it is not possible now to say which of the

early portraits was the earliest. The finest, beyond all comparison, is that owned by Dr. William F. Channing, of Providence, R. I. It was painted for Colonel George Gibbs. The warmest friendship existed between Colonel Gibbs and Stuart, and we may feel sure that in painting this picture the artist aimed to do his best. It is claimed that this portrait was in Stuart's studio at a time when he was having sittings from Washington, and that the artist, availing himself of the opportunity thus afforded him, revised and corrected it from life,—a circumstance, so slight in itself as to have escaped the memory of Stuart when he wrote the above note to Samuel Williams. The picture is superb, and in it the lower part of the face, so much criticised in the well-known portraits of Washington by Stuart, is remarkably well managed. Rembrandt Peale says, in speaking of the Vaughan picture, an early Washington by Stuart: "In the lower part of the face it has the advantage over the other portraits that he afterwards painted." This quality, in a much higher degree, appears in the Gibbs picture, with which Peale was probably unacquainted. The venerable A. B. Durand, when shown a photograph of it, said: "That is a likeness. It is much superior in character to the Athenæum portrait, and should be considered the standard. Both the artist and the subject would gain by it." He also said he wished he could have known of it in earlier life, evidently meaning that he would have engraved it instead of the Athenæum portrait. The picture was sold by Colonel Gibbs to his sister, Mrs. William Ellery Channing, from whom it descended to her son, the present owner.

The exact time when the Vaughan picture was painted cannot be ascertained, but we can come near to it. This Washington portrait is in the collection formed by the late Joseph Harrison, Philadelphia. Mr. Norris, a son-in-law of Mr. Harrison, states that "it was painted in September, 1795, for Samuel Vaughan, a friend of Washington, and was purchased by Joseph Harrison of William Vaughan. On the back of the picture is written, 'Geo. Washing-

ton, by Mr. Stuart. Hallowell engraved this portrait in 1796.'" The engraving was published in London, November 2d, 1796, and it is lettered, "From a portrait painted by Mr. Stuart, in 1795, in the possession of Samuel Vaughan, Esq." Rembrandt Peale, and others, have maintained that this was the original picture, that Stuart, becoming dissatisfied with it, sold it to Winstanley for $200, who in turn sold it to Mr. Harrison. Winstanley's name will appear in these pages, but not in this connection. There is no evidence that he ever owned the picture. The other portrait of Washington, painted for J. Vaughan, and taken to England at the same time, remained there, and there it probably may still be found. This makes three of the replicas, and the fourth is owned by Mrs. Rogers, of Lancaster, Pa., a daughter of General Edward Hand, of the Revolution. All these portraits show the right side of the face, and were evidently from the same original; but the finest of them all is the Gibbs picture. One engraving from the Vaughan picture has been mentioned; another engraving from it, made by W. Ridley, was published in London, in 1800.

Stuart was overrun with orders for portraits from the moment that his picture of Washington was painted, and although, as shown by the list he made out, he had many calls for copies of his likeness of the President, but few of them were at that time filled. When, at length, he began to meet this demand,—and this was not till 1796,—his copies were all made from the picture known as the Athenæum head, which shows the left side of the face.

The first full-length of Washington was a commission from the Marquis of Lansdowne. When it was known that Stuart was to paint such a picture, Mr. and Mrs. William Bingham expressed a strong desire to be at the charge, and to be permitted to present it to the Marquis. Stuart, it is said, hesitated, but finally yielded to their wishes, and Mrs. Bingham asked the President to give the artist sittings. This was in April, 1796, as shown in the note from the President to Stuart. The picture created a great sensation

when it reached England, and the Marquis, in a letter to Major Jackson, dated March 5th, 1797, acknowledging the receipt of the picture, and speaking of Washington, said: "If I was not too old, I would go to Virginia to do him homage."

The figure in this picture has been criticised. G. W. P. Custis thus speaks of it: "The defect in the full-length is in the limbs. For the figure, a man named Smith, with whom Stuart boarded, stood—a smaller man than Washington; and the hands were painted from a wax cast of Stuart's own hand, which was much smaller than Washington's."

From another source I have a different version. Mr. John A. McAllister writes from Philadelphia: "Alderman Keppele stood for the figure. I had this from his daughter, who died a few years ago." This is the more probable statement, for Stuart, at that time, "lived in his own hired house."

But this is not the only claim for that honor, for I had it from the late Mrs. William Bingham Clymer, a few weeks before she took passage on board the ill-fated "Pommerania," that the Comte de Noailles stood for the figure. She assured me that the evidence was conclusive, and a letter addressed to her, asking for the particulars, was lying on the writer's desk when the news came of the accident that was fatal to her, and to so many others.

Miss Stuart says that while her father was painting a full-length of Washington (she cannot say which picture, but it was probably the above), he wanted to introduce a dress-sword, and the Comte de Noailles kindly furnished a superb silver-mounted rapier, which he brought himself, and presented it to Stuart, saying that it might be useful in painting other portraits of Washington. Stuart valued it very highly, but years after, when the family treasury was low, Mrs. Stuart, who never liked to see the sword in the house, had the silver mounting converted into tea-spoons; which spoons were subsequently stolen by a negro boy, the son of a faithful old servant who had long lived in the family.

The full-length of Washington was engraved in England by Heath, in a manner and under circumstances that were very disagreeable to Stuart, who could not control his temper when he learned how he had been defrauded of what was clearly his right. An account of the transaction has been thus given by Mr. Neagle, an artist who was well acquainted with Stuart, and who was at one time his pupil:

"When the picture arrived in England it attracted general attention, and Mr. Heath, the engraver, was not slow to perceive the advantage that might accrue to himself by publishing a print of it; which he did, with the consent of the Marquis, who observed at the time that Mr. Stuart would be highly gratified by having his work copied by an artist of such distinguished ability. Accordingly, the engraving was announced in London, with the usual puffs; stating that "the picture in the possession of the Marquis of Lansdowne is the production of that very excellent portrait painter, Gabriel Stuartt, a native of America, and an *eléve* of Benjamin West, Esq. His pencil has a freedom that is unaffected; his coloring is clear without glare, and chaste without monotony; his style of composition is animated, yet simple, and he has the happy faculty of embodying the mind as strongly as he identifies the person."

To the above was added the announcement that Mr. Heath was historical engraver to the King, and was one of the six associate engravers to the Royal Academy.

Washington died December 14th, 1799, and Heath's engraving was ready for the market by February 1st, 1800. Never was there a better opportunity for a publisher to realize large returns from an engraver's burin.

Neagle's narrative goes on to say: "Mr. Bingham had not made it a condition with the Marquis that a copyright should be secured for the benefit of the painter; indeed, he never mentioned Mr. Stuart's wish, intending by the next vessel to beg this provision for the painter's benefit, as an after-thought, which would not appear to

lessen the value of the present. But this proved too late for poor Stuart. When the vessel arrived, Heath had made his copy under the sanction of the owner, and the design was already on the copper. The matter, however, was never broached to Stuart, and he told me that the first he knew of it was in Mr. Dobson's book-store in Second street, Philadelphia. He was unknown to Mr. Dobson, but was in the habit of frequenting the store, and purchasing books, paper and pencils. On one occasion, when calling as usual, Mr. Dobson, having just received a box of these finished engravings, for sale on commission, opened it, and showed Stuart an impression from Mr. Heath's plate; this was the first intimation he had of the unwelcome fact, that his prospect of advantage from a copyright was annihilated, and the fruits of his labor snatched from him by one who had no share in his enterprise, or claim whatever upon that which he had invented and executed. He was unable to answer Mr. Dobson's question respecting the merit of the engraving and the prospects of sale; but when he recovered himself, he replied: 'Sir, the work is as infamous in its execution as the motive that led to it.' 'What!' said Dobson; 'have you the feeling of an American? What! do you not respect the man here represented, nor the talents of the American painter who executed the original picture? What would Mr. Stuart say if he heard you speak thus?' 'It has been my custom,' replied Stuart, 'to speak the language of plainness and truth, whenever the character and fortune of any man are thus jeopardized. By this act the family of the painter is ruined. My name is Stuart; I am the painter, and have a right to speak.'"

The whole affair was an unfortunate one. Mr. Bingham was evidently unacquainted with the rights of authors, or he certainly would not have neglected to stipulate for the copyright at the proper moment. Stuart called upon him for redress; the interview ended in a quarrel. With one of Stuart's temperament, and smarting under the loss he had sustained, it is hardly possible that such a meeting could have ended otherwise. Among Stuart's

scanty papers was found the draft of a letter addressed to Lord Lansdowne, which reads as follows :

" *My Lord :*—The liberality with which you have uniformly patronized the Arts, and a grateful recollection of my personal obligation for your approbation and countenance, have inspired a hope that your Lordship will receive with indulgence the representation of an injury, to which I have recently been exposed under the apparent sanction of your name. As a resource to rescue myself from pecuniary embarrassment, and to provide for a numerous family at the close of an anxious life, I had counted upon the emoluments that might arise from a portrait of George Washington, engraved by an artist of talent. It was, therefore, with peculiar pleasure, that I found myself invited by Mr. Bingham to take the portrait of President Washington, to be presented to your Lordship ; as I knew of no one in whose hands it could be placed with more propriety and advantage, nor one on whom I could more confidently rely to secure the rights and promote the interest of the artist.

"I complied immediately with Mr. Bingham's request, but expressly stipulated with his agent in the transaction, that no copy should be taken of the picture, nor should any engraving be allowed but with my consent, and for my benefit. Scarcely, however, had the picture been received by your Lordship, when I had the mortification to find an engraving promised to the public ; and soon afterward, at a moment when the sensibility of Europe, as well as of America, was keenly excited by the death of General Washington, the print was published in England and in the United States ; executed by Mr. Heath, for the emolument of himself and Mr. Barry, of New-York ; and stated to be taken 'from the original picture, by Gilbert Stuart, in the collection of the Marquis of Lansdowne.' Thus, without my privilege and participation, despoiled of the fair fruits of an important work, and defeated in the great object of my professional pursuit, your Lordship will readily allow me the privi-

lege to complain. There is something due to my feelings as a man, and to my character as an artist; and to repel, as far as it is practicable, the wrong that has been committed, I have issued proposals for a superior engraving, from a portrait intended to be fixed at Mount Vernon, and I address myself respectfully to your Lordship, to inquire into the source of my misfortune.

"It is obvious that to you, sir, there cannot have been a communication of the right which I reserved (for even my letter on the subject must, I presume, have miscarried), nor am I willing to impute to Mr. Bingham the suppression of so important a fact; I can only, therefore, at present, suppose that some improper artifice has been employed by the person immediately interested in the engraving, and I pray your Lordship to honour me with an explanation of the means by which so unprecedented and unwarrantable a violation of the right of property has been accomplished."

With the above, there was found the draft of another letter, evidently addressed to Mr. Barry, who, it was understood by Stuart, was connected with Heath in bringing out the engraving.

"*Sir:*—When the portrait of General Washington was undertaken for Mr. Bingham, it was on the express condition that I should retain the exclusive right of making an engraving from it. It had, indeed, been the object of the most valuable years of my life to obtain the portrait, with a view to such a right; and surely, sir, you, who have endeavoured to deprive me of it for your own emolument, could not have been ignorant of its value, when you employed Mr. Heath on the occasion. I know not on what terms Mr. Bingham presented the picture to the Marquis of Lansdowne, but I am persuaded that nobleman has either been imposed upon by some misrepresentation, or has never received the letter which I addressed to him on the subject. I shall, however, endeavour speedily and fully to develop all the circumstances of so cruel an outrage upon

the property of an artist (and the chief hope of a numerous family), and, in the meantime, I shall take proper measures to prevent, as far as it is practicable, the injury that is meditated to my fortune; and I may add, from a view of Mr. Heath's print, to my professional reputation."

It will be seen by the above how alive Stuart was to the loss he had sustained, and how keenly he felt the injury that had been done him. He never forgot it, nor did he forgive the parties to the transaction.

After the death of Lord Lansdowne, his pictures were sold by auction. The Washington was purchased by Samuel Williams, an English merchant, for $2,000. Williams subsequently became insolvent, and his creditors disposed of the Washington by a lottery. Forty tickets were sold, at fifty guineas each. The picture fell to Mr. J. Delaware Lewis, a nephew of Mr. William D. Lewis, of Philadelphia. But few Americans had ever seen the picture, and Mr. William D. Lewis, who was Chairman of the Committee on Art, obtained the loan of it from his nephew for the Centennial Exhibition. It was sent out with the loan collection from England, unpacked in Memorial Hall, and hung up in the British section before its arrival was known to the Fine Arts Committee. An effort was subsequently made to have it transferred to the American section, but it was unsuccessful. At the close of the Exhibition, it was returned to its owner in England.

While Stuart was painting the above picture, Mr. and Mrs. William Constable, of New-York, went to Philadelphia. Mr. Constable had been on the staff of General Lafayette, and both he and Mrs. Constable were intimately acquainted with General and Mrs. Washington. Mrs. Constable induced her husband to sit to Stuart. At these sittings, Mr. Constable saw the picture then in hand for the Marquis, and was so much pleased with it that he engaged Stuart to paint for him a similar picture. There is a tradition that the artist painted

on the two pictures alternately, and that Trott, the miniature painter, who was known to be on intimate terms with the artist, stood for the hands. The interest that Mr. Constable took in the picture is shown from the fact that he rode twice from New-York to Philadelphia, in his chariot and four, to watch the progress of the painting. Before the picture was sent to New-York, Stuart painted a half-length from it, which was presented by Mr. Constable to General Hamilton. This is the only half-length of Washington by Stuart that I remember to have heard of.

When the full-length was finished, it was sent to Mr. Constable's house, which stood where the Astor House now stands, on Broadway, New-York. Colonel Burr, Walter Rutherford, and Richard Harrison, the eminent lawyer and partner of General Hamilton, all neighbors, came in to see it as soon as it was opened. " Gentlemen," said Mr. Constable, as soon as it was put in its place, "there is the man," when, with one accord, they all exclaimed, " The man himself ! "

The picture, which is perfectly fresh, and in as good order as when it left the artist's studio, which cannot now be said of the Lansdowne, remained in Mr. Constable's house up to the time of his death, in 1803. By him it was bequeathed to his son William, who resided at Schenectady, and who was then but seventeen years of age. At his request, it was placed in the house of his brother-in-law, Mr. H. E. Pierrepont. In 1812, he sold it to Mr. Pierrepont for six hundred dollars, the price that Mr. Constable had paid for the picture and frame, and it was transferred to Mrs. Pierrepont. In Mr. Pierrepont's house, it was so fitted in the frame that the canvas, in case of fire, could be easily taken out and saved. It was this picture that called forth the remark from General Lafayette, when he went to call on Mrs. Constable, in 1824 : " That is my noble friend indeed."

In 1836, a French engraver, by the name of Langier, brought an introduction from Paris to Mr. Pierrepont, and asked permission

to copy the head of Washington, which was granted. He went to Boston, and examined the Athenæum head, and gave the preference to the Constable picture, saying he would prefer to engrave the latter, and would give the proper credit. He employed a painter named Cogniet to make a design, representing Washington as standing in front of his horse, which is held by an orderly. Langier engraved it in 1839, one year after the death of Mr. Pierrepont, but gave the credit to the Athenæum head, for the reason that it was better known, and would add more to the value of his print. The head, as given by him, is good, but the same cannot be said of the figure.

At the death of Mr. Pierrepont, the picture came into the possession of his widow, who, at her death in 1859, bequeathed it to her son, Mr. Henry E. Pierrepont, of Brooklyn, the present owner. At the request of the Mayor of the city of Hudson, in 1841, permission was given by Mrs. Pierrepont to an artist by the name of Prime, to make a half-length from it, for the Common Council room in that city. In 1845, Mr. Frothingham, a pupil of Stuart's, asked permission to copy the picture. Consent was given, and for three months he painted in a room in Mrs. Pierrepont's house. This copy, which in some parts is more highly colored than the original, particularly the Turkey carpet, was purchased by Mr. A. A. Low, of Brooklyn, and presented by him to Salem, the place of his nativity.

In connection with the original, the following anecdote is told: Mr. Daniel McCormick, who lived in Wall street, New-York, and died there in 1834, aged ninety-four years, was the friend of both Stuart and Mr. Constable, and he accompanied Mr. Constable when he drove to Philadelphia, to watch the progress of the picture. One day he met Mr. Stuart carrying a Turkey rug, and asked him what he was going to do with it. Stuart replied that it was for his studio. "You extravagant dog," said McCormick, "why did you not buy a Kidderminster for your studio? It would

have answered as well." "Some day, McCormick, you will say
that I have done right." When the picture, in which the rug is
skillfully introduced, was finished, and while Mr. McCormick was
looking at it, Stuart nudged him with his elbow and said, "Well,
McCormick, what do you say to my rug?" "You have done
right," was the reply.

The following is a copy of Stuart's bill for the pictures ordered
by Mr. Constable.

WM. CONSTABLE, Esq.,

TO G. STUART, DR.

1796, Nov.	To one portrait of said W., Ds.	100
1797, July 4.	One of the late President of the United	
	States, at full length,	500
	One do. half length,	250
		Ds. 850 Dollars.

PHILADELPHIA, 13th July, 1797. Received of Richard Soderstrôm, Esq., through
the hand of John Vaughan, Esq., the above sum, in full of all demands against
them and the above mentioned Wm. Constable, Esq.

G. STUART.

Dimensions given by Mr. Stuart:

5 feet & 8 feet.
3' 4 " — 4' 3"

Another full-length of Washington, unquestionably a copy of
the Lansdowne, is now owned by the Academy of Fine Arts in
Philadelphia. It belonged to Mr. Bingham, who had it at his
country-seat, Lansdowne, and in the inventory of his estate, filed
by his executors in 1807, it is specially mentioned as being there.
It was removed to the Bank of the United States for safe keep-
ing. There it remained till 1811, when it was transferred to the
Academy of Fine Arts by the executors of Mr. Bingham.

The fourth full-length was painted for Gardner Baker, of New-York. Baker was an active member of the Society of St. Tammany, a social and benevolent organization. At his suggestion, the society, in 1790, began the formation of a museum, which was placed in his hands to direct and manage. Through his zeal and industry, the collection became a large and interesting one, and a suitable place was assigned it in a building on the corner of Broad and Pearl streets. In 1795, the museum was made over to Baker, and he soon added greatly to its attractions. Among other features, he in time added a full length portrait of Washington by Stuart. In 1798, he went to Boston for the purpose of exhibiting the portrait in that city, but was taken down with the yellow fever and died there, having hardly attained to his thirtieth year. After his death his effects were scattered. Dunlap says the Washington portrait went to a Mr. Laing, as an offset to a claim against Baker, but all trace of it has since been lost. The following story in connection with it is told by Dunlap, who says that Laing was in Washington when a committee was furnishing the President's house, and that he suggested to them the propriety of buying the picture to adorn the residence of the Chief Magistrate. Ultimately the picture was purchased by the committee, and Laing, who only knew Winstanley as an artist, gave him instructions to pack and forward it to its destination. But Winstanley, instead of being true to his trust, copied the Stuart, which latter he retained, and in its place sent his own picture to the President's house. There it was put in place, and the cheat was not detected for some time. When it was discovered, it was found that Winstanley had taken the original to England, and as there was no redress, Laing refunded the money he had received.

It has been said that on the approach of the British, in 1814, the picture was cut from the frame to prevent its falling into their hands. But this cannot be correct, for, on examination, it has been found that the original nails hold the canvas to the stretcher,

and that it has never been cut. If the picture was removed at the time named, it must have been taken bodily. The picture is faded, and shows no trace of Stuart's pencil.

Stuart told this story about his first and only interview with Winstanley. I give it as related by Dunlap:

"When I lived at Germantown, a little pert young man called on me, and addressed me thus:

"'You are Mr. Stuart, the great painter?'

"'My name is Stuart, sir.'

"'My name is Winstanley, sir; you must have heard of me.'

"'Not that I recollect, sir.'

"'No! Well, Mr. Stuart, I have been copying your full-length of Washington; I have made a number of copies; I have now six that I have brought on to Philadelphia; I have got a room in the State House, and I have put them up; but before I show them to the public, and offer them for sale, I have a proposal to make to you.'

"'Go on, sir.'

"'It would enhance their value, you know, if I could say that you had given them the last touch. Now, sir, all you have to do, is to ride to town, and give each of them a tap, you know, with your riding-switch,—just thus, you know, and we will share the amount of the sale.'

"'Did you ever know that I was a swindler?'

"'Sir—oh, you mistake, you know.'"

Here the narrative goes on to say, the painter rose to his full height, as he turned upon his visitor, and said:

"You will please to walk down-stairs, sir, very quickly, or I shall throw you out at the window;" and Stuart, suiting his actions to his words, left his visitor no alternative but to hurry away from the presence of the enraged artist.

Aggravating as was this theft, it subsequently brought Stuart a good order. There are several versions of the story, but the fol-

Washington

(The Athenæum Portrait)

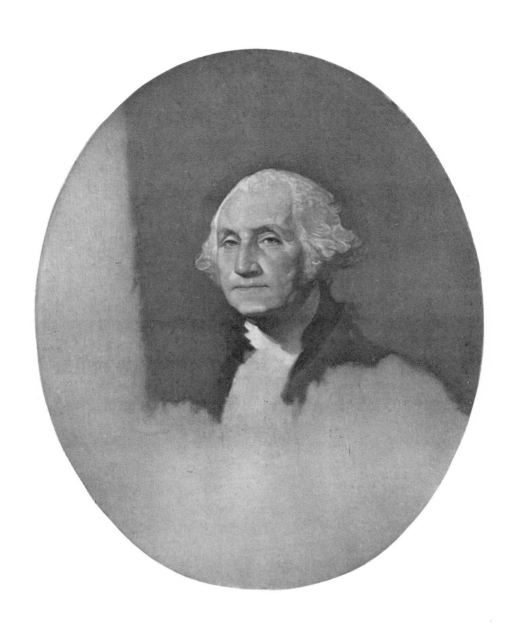

lowing is undoubtedly correct. It was furnished to Miss Stuart by an esteemed friend, whose name I am not at liberty to use:

"In an interesting conversation with Crawford, the artist, in 1846, which I recorded at the time, Mr. Quincy said: 'A full length portrait of Washington was painted by Mr. Stuart for the Marquis of Lansdowne. Winstanley went to London and made several copies of it. One of them he brought to Boston, and, by my permission, put up in my office in Court street. He wished to borrow money on it from me, but I refused. He then took it away, and afterward induced Mr. S. Parkman to lend him money on it, and then went off and left him the picture. Mr. Parkman offered to present the portrait to the town of Boston for Faneuil Hall; but when the gift was offered in a Town Meeting, a blacksmith from the north end rose up and vehemently opposed its acceptance, saying that it would be a lasting disgrace to the town of Boston to accept a copy of Stuart's portrait of Washington, when the artist himself was residing in Boston, who ought to be employed to paint an original for Faneuil Hall. The offer was declined; the blacksmith carried his point, and Mr. Parkman, apparently coinciding in his opinion, employed Mr. Stuart to paint a full length portrait of Washington, which he presented to Faneuil Hall.'"

Through some inadvertency in making up the Town Record, this picture is spoken of as a copy of Stuart by another hand. Not long since, this question was brought up, and Miss Stuart having been applied to, replied as follows:

"The picture of Washington, now in Faneuil Hall, was painted by my father, and presented to the town of Boston by Samuel Parkman. This circumstance is too much impressed upon my mind to admit of any doubt whatever. Also, that it was copied from the original head now in the Athenæum."

This letter was, with the consent of the city authorities, inserted in the "Record of the Town of Boston."

For this picture, six hundred dollars were paid—an insignificant

sum as contrasted with its present value. Stuart painted it in nine days. Miss Stuart has made several copies of the picture: the last was for the Boston Art Museum, and for it she was paid the same sum that was paid to her father, less certain expenses attending the work.

It was to Stuart's picture in Faneuil Hall that Edward Everett, in his eulogy of Lafayette, when he had apostrophized the bust of that distinguished patriot, turned and exclaimed: "Speak, glorious Washington! Break the long silence of that votive canvas!"—words that electrified every one who was present.

There are two very fine full length portraits of Washington in Rhode Island: one in the State House in Providence, and the other in the State House in Newport. The history of these pictures may thus be told: At the February session of the General Assembly, 1800, the following resolution and preamble were adopted. I give the document as it was worded, for it shows how tender was the regard for the memory of Washington:

"The citizens of this State having, on all proper occasions, uniformly expressed their inviolate attachment to the person of the late General George Washington, and their entire approbation of his conduct, in public and in private life:

"The General Assembly, deeply impressed with the importance of perpetuating his eminent virtues, which have shone with unrivalled lustre, and of transmitting to posterity the high estimate in which he is held by his fellow-citizens, and of giving them an opportunity of seeing the likeness of the man who was first in war, first in peace, and first in the hearts of his countrymen; and who expressed in his features the benevolence of his nature, maintained in his person the dignity of his mind: do resolve, that two portraits of him, drawn at full length by some eminent artist, with suitable frames, be procured at the expense of the State, and that one of them be placed in the Senate Chamber in each of the State Houses in the counties of Newport and Providence."

The committee gave this commission to Gilbert Stuart, who was then residing in Philadelphia, and who received for the two pictures the sum of twelve hundred dollars. The portraits are both admirable.

The Faneuil Hall picture was painted in Boston. The six other full-length Washingtons,—the Lansdowne, the William Constable, the Gardner Baker, the two in Rhode Island, and the one in Philadelphia, were all painted in Philadelphia.

A full-length Washington was painted for Mr. Peter Jay Munro, of New-York. The date is not known. It was purchased from his estate in 1845, and is almost identical in its details with the picture in the State House in Newport. The attitude is the same, and in both, the letters "G. St" appear on the leg of the table, the rest of the name being covered by the cloth. But there is some variation in the placing of the figure on the canvas. In this picture it is more on one side, which makes some slight change in the accessories. This picture was engraved by Sartain, of Philadelphia, and Ritchie, of New-York, for an edition of Washington's Farewell Address, printed by Mr. James Lenox, who is the owner of the original. The above portrait is now in the Lenox Library.

A portrait of Washington, painted by Stuart for Mr. I. P. Davis, of Boston, in 1810, is now owned by Mr. Ignatius Sargent, of Brookline. In a letter from Stuart to Mr. Davis, he called it his "small full-length" of Washington. This was the original sketch from which the picture owned by the city of Boston, and known as "Washington at Dorchester Heights," was painted. After having made the sketch, Stuart appears to have kept to it in painting the large picture; the pose of the figure and the accessories being the same. This picture was purchased of the heirs of Mr. Davis by the present owner.

There is a full length portrait of Washington at Carlton House, England, claimed to have been painted by Stuart; but its

history, or the particulars connected with it, I have not been able to learn.

Of portraits of Washington by Stuart, replicas of the Athenæum head, there are many; some of them are very fine, but others are quite indifferent. Stuart used to call his portrait of Washington his hundred-dollar bill, and when he wanted money he turned one off, often hurriedly. But to this there are noble exceptions.

Recently a valuable portrait of Washington, painted by Stuart for the late Solomon Etting, of Baltimore, was presented by Miss Richsa G. Etting, to the Maryland Historical Society. This picture had previously been cleaned by a Baltimore artist.

A Washington, painted for the Pinckney family, of South Carolina, is now owned by Chief-Justice Gray, of Boston, who holds their certificate of its genuineness.

A Washington, painted for the late Jonathan Mason, of Boston, is now in the possession of Mrs. William Appleton, Beacon street, Boston; and one that at one time belonged to the British Consul, Robertson, is owned by Mr. John T. Montgomery, 1815 Delancy street, Philadelphia. Robertson married the widow of Isaac Gouverneur, of New-York, whose daughter by the first marriage was the wife of Francis Rawle Wharton, of Philadelphia. Mrs. Montgomery received the portrait of Washington from the estate of the late Gilbert Robertson, after the death of Mrs. Wharton, her mother. Mr. Robertson is said to have acquired the picture from one Simpson, about whom nothing is now known. It is fresh in color and is in excellent condition.

A highly finished copy of the Athenæum head was made by Stuart, in 1810, for Hon. Josiah Quincy, which picture is still at the homestead at Quincy. There are two portraits of Washington in the Academy of Fine Arts, Philadelphia,—one a full-length, in civil dress, already noticed, and the other a head. A portrait of Washington, painted by Stuart for General Chestnut, of South

Carolina, was bought a few years ago by the Library Committee, for the Capitol at Washington, and it now hangs in the old Hall of Representatives. The spurious picture in the White House, which has been attributed to Stuart, has already been referred to.

When Stuart went to Washington, in 1803, to paint the portraits of Jefferson and Madison, he took with him a copy of his Washington, as a specimen of his skill as an artist. This picture was purchased by Colonel John Tayloe, who at the same time employed Stuart to paint his own and Mrs. Tayloe's portrait. These pictures are now owned by Mrs. B. Ogle Tayloe, Washington City. Mrs. Dallgren, also of Washington, owns a very fine portrait of the first President, painted for Robert Gilmor, of Baltimore. A Washington that belonged to the MacDonald family, and which was inherited from General Samuel MacDonald, has recently become the property of Hon. Robert C. Winthrop, Boston. Mr. F. Law Rogers, of Baltimore, has also a Washington in his possession.

The Phillips family, of North Andover, have a Washington, which they claim was painted by Stuart for Francis Lightfoot Lee, of Virginia. There were several members of the Washington and Lee families in the Andover Academy, between the years 1795 and 1804, as students, under the immediate care of Lieutenant-Governor Phillips. When they left the Academy, Mr. Lee sent this portrait to Lieutenant-Governor Phillips, in recognition of his kind attention to the youths who had been under his charge. It was the wish and intention of the family to send a portrait of Lieutenant-Governor Phillips to Mr. Lee, but the death of the latter frustrated the plan.

A Washington, owned by Professor Tucker, a well-known author in his day, was retained by him when his other pictures were sold, he valuing it highly. At his death, it became the property of his daughters, Mrs. Harrison and Mrs. George Rives, by whom it was sold to Mr. F. R. Rives, son of the late William C. Rives, who is the present owner. This is a fine specimen of Stuart's work.

The portrait of Washington, painted by Stuart, which hung on the wall at Mount Vernon, was bequeathed to, or fell to the share of, George Steptoe Washington, one of the four nephews of the General. After his death, it became the property of his son, William Temple Washington, who died at an advanced age about a year ago. He lived on the north side of the Rappahannock, near Falmouth, and during the late rebellion his farm was occupied by the national troops. To secure the portrait, he placed it between the carpet and matting in one of the upper chambers, and General Hancock, who occupied rooms at his house, often walked unwittingly over it. After the war was over, Mr. Washington sent the portrait to his cousin, Colonel Richard D. Cutts, of Washington, and one of the four swords of Washington, also inherited from his father, with a request that he would sell them, to procure the means wherewith to recuperate his farm. The portrait was, in one or two unimportant parts, slightly defaced from being so much trodden upon, although every precaution had been taken to preserve it from harm. During the winter, Colonel Cutts sold the portrait, for twelve hundred dollars, to Hon. J. V. L. Pruyn, then a Member of Congress from Albany, but only after a searching examination on his part, as to its history and authenticity. Mr. Pruyn, who has the picture in Albany, collected data from Adams, Everett, and others, in regard to it.

A portrait of Washington, that long hung in the Madison mansion, is now owned by Mr. Edward Coles, of Philadelphia. Mr. Edmund L. Rogers, of Baltimore, has one that belonged to Robert Barry, of that city; and Mrs. J. T. Cooper (formerly Mrs. C. F. Crosby), of Albany, has one that was once the property of Colonel Henry Rutgers, of New-York. Dr. Alfred Wagstaff, 27 Waverley Place, New-York, has a Washington, bought by his grandfather, David Wagstaff (an Englishman, who came to this country after the Revolution, and was a great admirer of Washington), about the year 1798. It hung in the room where the father of Dr. Wagstaff

was born in 1809, in a house on Seventy-ninth street, the family country-seat. This picture has descended in a direct line to the present owner, and has been in the family eighty years.

A Washington is owned by Hon. John Hoye Ewing, of Washington, Pennsylvania. Washington County and Borough were organized in 1781, and the town was laid out by David Hoye, of Carlisle, Cumberland County. In a few years, David Hoye conveyed all the unsold lots to his two sons, John and William Hoye, both of whom took an active part in the politics of the day. John was a State Senator from 1790 to 1794, and William was a Member of Congress about the same time. John owned the portrait, and entertaining a warm feeling for Mr. Ewing, promised him the painting after his death; but he died intestate in 1820 or '21, and Mr. Ewing purchased the picture at the administrator's sale.

Mr. William Buchler, of Harrisburg, Pennsylvania, has a Washington which has been in his family more than half a century. It was originally the property of Samuel D. Frank, who was a member of the bar, residing at Reading, Berks County, Pennsylvania, and who removed to Harrisburg about 1825, where he became the presiding judge of the district.

Miss Jo. Peter, of Lexington, Kentucky, writes: "My mother has a portrait of Washington, copied by Stuart from one of his originals. The portrait, a bust, together with its companion picture, a fine portrait of Jefferson, also by Stuart, was obtained by my maternal grandfather, Major William S. Dallam, from Mr. Lewis Saunders, in the early part of the present century. My mother thinks Mr. Saunders purchased the picture at the studio in Boston, but is not certain on that point.

"The Jefferson was sold by my aunt to Congress, in 1874, for one thousand dollars, through the agency of J. B. Beck, of Kentucky, and can be seen at the Capitol. The authenticity of these pictures has never been questioned by artists who have seen them."

A portrait of Washington, by Stuart, exhibited at the Centennial, is owned by Mr. George F. Meredith, of London, who has given this history of it in a letter to Miss Stuart:

"The picture came into my possession about twenty years since; before that time, for many years, it belonged to my wife's father, the late Mr. William Schofield, M. P. for Birmingham. He was married to an American lady, and it was a tradition that the portrait had been presented by General Washington himself to one of her ancestors attached to his staff. The canvas is about two and a half feet high by two feet wide, and the figure, a full-length, is in court dress, etc., etc." This picture, before it was taken back to England, was brought to the notice of Miss Stuart, who recognized in it the work of her father.

A copy of the Washington portrait was made by Stuart for Mr. Cumberland Williams, of Baltimore, and as Mr. Jonathan Mason, of Boston, is familiar with the circumstances connected with the painting of this picture,—was, in fact, instrumental in getting it for Mr. Williams,—he has kindly furnished the following particulars:

"Early in life, I received a letter from a Baltimore friend, who had been civil to me at the South, stating that Mr. Cumberland Williams, of that city, a wealthy gentleman, was anxious to procure a copy of Washington's portrait by Stuart, who should testify to its genuineness,—many copies having been made with his name falsely attached to them; that he was willing to pay almost any reasonable sum, and that Mr. Williams being unacquainted with me, Mr. Newman, as a Bostonian, had applied personally. Not knowing how to proceed, being deterred from applying direct to the artist, by hearing that he was not accessible to such applications, and seldom willing to copy his own paintings, I wrote to Mr. Newman that Mr. Stuart refused many applications of the like while otherwise employed, and that I feared it could not be accomplished. Many weeks after, having forgotten it, being in the vicinity of Mr. Stuart's residence on Fort Hill, I went to see him, and found him playing

on his chamber-organ. After some remarks, I told him I had a favor to ask,—one that my friends laughed at me for.

"Stuart stopped playing, and exclaimed : 'What is it? Let 's have it.'

"'To ask you to paint for me a copy of your Washington.' He took a pinch of snuff, and went on playing, and I, feeling I had made a mistake, rose to go, bidding him good-bye ; when he stopped playing, and asked, 'Will you be here the end of next week?' 'Certainly, Mr. Stuart, if I can be of any service to you.'

"Regretting my mistake, I left, fearing I had committed myself.

"I was punctual at the end of the following week, and found him at leisure, affable, and in his usual spirits, and I not a little abashed by my late application to him. Suddenly rising from his chair, he took a canvas that was facing the wall, and, placing it before me upon the easel, exclaimed : 'Now let them laugh at you!'

"I forwarded the picture immediately to Cumberland Williams, Esq., at Baltimore, and some years after, at the sale of his effects after his decease, it was purchased by an early companion and friend of mine, Thomas Handasyde Perkins, since deceased, and is now or late in the possession of his son, Augustus Thorndike Perkins. Both of these gentlemen applied to me for a written voucher of its being a genuine Stuart copy, which I readily gave, being a fine copy, of which I know of but one or two extant at the present time."

A set of the first five Presidents of the United States, by Stuart, is owned by Mr. T. Jefferson Coolidge, Boston. The pictures were bought by Mr. Coolidge at the sale of the estate of Colonel George Gibbs, deceased, for whom they were painted. They are in Stuart's best style, and Mr. Coolidge holds the following certificate from the late I. P. Davis :

"For twenty years I was intimately acquainted with Mr. Stuart, and was in the habit of making him weekly visits, and have a perfect recollection of his painting the Presidents for his friend, Colonel

Gibbs, of Newport, R. I., and am satisfied no other person was employed by him to finish the drapery. All and every part of them are from his pencil."

There was another set of the first five Presidents; three of them were destroyed by the fire in the Library building in Washington, and the other two, saved from the flames, but badly injured, are somewhere in Virginia.

Tuckerman speaks of a cabinet head of Washington, owned at one time by Mr. Gilbert, a Member of Congress from Columbia County, New-York, and now dead.

Mr. Russell Sturgis writes from London:

"I bought the Washington now in my possession some twenty years ago, and always understood it was the portrait painted for Earl Shelburne (afterward Marquis of Lansdowne), and his son, the late Marquis, who saw it at my house, confirmed my impression. * * * I have an engraving from a picture, which is like mine, except that the right hand rests upon the table, whereas in my picture it is extended, as in the act of speaking." *

"Besides the full-length, I have a kit-cat, painted by Stuart about 1809, I think, for my uncle, James Sturgis, resident in China, where it remained till my uncle's death, and then was bought by me, and so has never been out of the family."

A portrait of Washington is owned by Dr. Herbert Norris, of Philadelphia, to whom it descended from William Rawle, the elder, who was the Attorney for the United States for the District of Pennsylvania, under Washington. There is a tradition that Washington, in compliance with the wishes of Mr. Rawle, gave Stuart three sittings for this picture; but this conflicts with Stuart's own statement as to the number of original pictures. It is a fine, and probably an early, copy of the head of 1796.

* May not this be one of the copies made by Winstanley, and palmed off as Stuart's work? It is certainly not the original.

In the State Library, at Richmond, Va., there is a good portrait of Washington, claimed to have been painted by Stuart. Mr. Alexander Hamilton has one that was given by Mr. William Constable to his grandfather, General Hamilton, at whose death it descended to his widow; from her it descended to her son, and from him to his son, the present owner. It is of life size, seated, and showing in the background a stretch of water and a few passing vessels. In color it is fresh and beautiful. This picture has already been spoken of as probably the only half-length of Washington by Stuart.

At Duddington, the house of the Carrolls, Washington, there is a Washington, painted by Stuart for the late Daniel Carroll, of that city, probably at the time that Stuart had his studio there. It is not equal to the one owned by Mrs. Tayloe. A Washington owned by Mr. William H. Appleton, New-York, has on the back the original receipt, in the hand-writing of Stuart:

"BOSTON, 9th Sept., 1820.

"Received of Charles Brown, Five hundred dollars for a portrait of George Washington.

"GT. STUART."

Below it is marked: "Original, purchased from Mr. Brown by Z. Collins Lee, at Boston, Aug. 4th, 1844."

Mr. Edward Shippen, of Philadelphia, has one of Stuart's Washingtons; Mr. John C. Hamilton has one; another is owned by Mr. James Blight, 1205 Walnut street, Philadelphia (Dr. Shippen's old house), and copies are held by Mr. Elliston P. Morris, Mr. Joseph Samson Perot, Mr. Swift and Mrs. Norris, all of Philadelphia. Mr. William D. Lewis has a Washington, at Florence Heights, which, if not a full-length, is more than a head. It was painted for him by Stuart, in January, 1822, and the head was copied from the

Athenæum picture. Washington is represented in his civil dress, seated at a table, on which is spread a large sheet of paper,—possibly a map,—the ends of the fingers and thumb of the right hand resting on it, a corner of the paper being held between the thumb and forefinger of the left hand. The hilt of his sword rests on his left arm, above the elbow and against his side. Back of the figure there is a massive crimson curtain, with tassels on one side and on the other, and over the table there is a rainbow. The canvas is 3 feet 6 inches by 2 feet 9 inches.

About the close of the last century, or early in the present century, Mr. Blight, who was an India trader, took his portrait of Washington with him on a voyage to Canton. And this brings me to another phase in the history of the Washington portraits.

About 1800, or a little later, a number of portraits of Washington, on glass, were brought out from China and were offered for sale in Philadelphia, till Stuart, through the aid of Horace Binney, then a young lawyer, put an injunction on the sale. One of these pictures, now owned by Mr. Welsh, brother to Minister Welsh, is thus described by Mr. E. D. Marchant, artist, of that city :

"A member of the Welsh family, being at Canton on some commercial enterprise, met with this work, and secured it, with two others, one of which was broken on the passage. The other went, he knew not where. The one in question is of the usual size, 25×30 inches, and is on glass, reversed. Its method and material, Chinese of course, but in actual achievement far beyond anything of that nature that I have ever before seen. It is a striking reproduction of a better than an average of our Stuart's Washingtons ; it has not the slightest dash of caricature ; in fact, I do not know that it is deficient even in the dignity which we sometimes, if not always, find in the original. Finely relieved, the shadows pure and transparent, with a treatment of the eyes and mouth (which is peculiar in Stuart's Washington) that I have never seen so successfully achieved in any other copy. The 'touches' are rendered with a

Mrs. Washington

(The Athenæum Portrait)

truth, delicacy and adroitness, such as I have never met with from any other hand than that of Stuart himself. This Chinese portrait surprised me with a keen wish, were the thing possible, to see for myself the original, which the Orientals have so ably reproduced. It, at all events, establishes the fact that there was, and may be yet, one fine original of Washington by Stuart, even in Canton."

This Chinese picture calls to mind the Washington pitchers, once so common, but now so highly prized by collectors. Miss Stuart says: "Edward A. Newton, a nephew of Mr. Stuart, who was in England on business, commissioned my father to paint for him a Washington for the especial purpose of having it copied on stone-ware pitchers in Liverpool, and had some dozen struck off to send to his friends in America." This was, undoubtedly, the origin of the Washington pitchers, of which scores were afterward sent to this country.

A Stuart Washington is owned by Hon. Peter McCall, Philadelphia, probably the one formerly owned by his uncle, James Gibson. From it much of the color has flown; possibly it may have been in the hand of an unskillful picture cleaner.

A Washington that belonged to Mr. P. A. Browne, a contemporary of Stuart's, is now in the Philadelphia Club, given to the Club by Mr. Swift. It is not a good specimen of Stuart's work, and has probably been injured in some way. Another Washington is owned by Miss Waln, of that city. A print of Washington was published in London, January 15th, 1798, by Robert Cribb, who dedicated it to J. Seb'n De França, Esq., of Devonshire Place, who was the owner of the picture. The engraving was by Nutter.

It has been said that Mrs. Washington was very anxious to have a portrait of the President, painted by Stuart, and that it was in compliance with her wish that he gave the artist further sittings; it being understood that the picture, when finished, was to become the property of Mrs. Washington. This picture gave Stuart more

satisfaction than any other portrait of Washington that he had painted, and as he was not to deliver it till it was completed, he took care never to put in the background. In this way he managed to retain it. Miss Stuart gives a different version of the story :

"When General and Mrs. Washington took their last sittings, my father told Washington it would be of great importance to him to retain the originals, to which Washington replied : 'Certainly, Mr. Stuart, if they are of any consequence to you ; I shall be perfectly satisfied with copies from your hand, as it will be impossible for me to sit again at present.' The copies made from the originals were for Mount Vernon, but where they are now I do not know. A short time after these last pictures were finished, the President called on my father to express the perfect satisfaction of Mrs. Washington and himself at his success ; he promised that if he should sit again for his picture, it would be to him. My father at this time had so many commissions to copy the head of the President, and the anxiety to possess them was so great, that gentlemen would tell him if he would only make a sketch they would be satisfied ; and as he was painting other distinguished men of the day, and hurrying to complete their portraits, these Washingtons were, with some exceptions, literally nothing but sketches. He probably painted two at a time, that is, an hour on each in two mornings. So many people wrote to Stuart's family, after Washington's death, to know if certain heads of the President were from life, that my father was wont to say : 'If the General had sat for all these portraits, he could have done nothing else ; our Independence would have been a secondary matter, or out of the question.'"

These portraits, as already stated, are the two well-known heads now in the Boston Art Museum. Miss Stuart adds : "After the death of Stuart they were offered to the State of Massachusetts for the sum of one thousand dollars, which offer was declined. Subse-

quently an English gentleman offered his widow ten thousand dollars for the pair; but while she was hesitating, thinking they ought to remain in America, he became impatient, and returned to England. Some time after that, the offer of fifteen hundred dollars was accepted from the Washington Association and other gentlemen, who, in 1831, presented them to the Boston Athenæum.

"It was my father's intention to have these last heads engraved by Sharp, the finest engraver in Europe, not only for his own reputation, but in order to leave some provision for his family." The Athenæum "Washington" was subsequently engraved by Joseph Andrews, and in the most exquisite manner; but Stuart's family could derive no benefit from it, for the picture had then passed out of their possession. It was while Stuart was painting this picture that a curious scene occurred, which has been related by Sparks, as one of the few authentic instances where Washington's remarkable self-control lapsed into temporary excitement:

"One morning, as the artist approached the house, the street door and inner door were open, so that his eye led directly into the parlor, and just as he was about to ascend the steps, he saw Washington seize a man by the collar and thrust him violently across the room. This being an awkward moment to enter the house, he passed on a short distance, but immediately returned and found the President sitting very composedly in a chair. After the usual salutation, his first words were: 'Mr. Stuart, when you went away, you turned the face of your picture to the wall, and gave directions that it should remain so, to prevent it receiving any injury; but when I came into the room this morning, the face was turned outward, as you now see it, the doors were open, and here was a fellow raising a dust with a broom, and I know not but that the picture is ruined.' It so happened, however, that no essential harm was done, and the artist proceeded with his task."

Tuckerman has said of the Athenæum head of Washington: "The freshness of the color, the studious modeling of the brow,

the mingling of clear purpose and benevolence in the eye, and a thorough nobleness and dignity in the whole head, realize all the most intelligent admirer of the original has imagined,—not, indeed, when thinking of him as the intrepid leader of armies, but in the last analysis and complete image of the hero in retirement, in all the consciousness of a sublime career, unimpeachable fidelity to a national trust, and the eternal gratitude of a free people. It is this masterpiece of Stuart that has not only perpetuated, but distributed over the globe, the resemblance of Washington. It has been some-times lamented that so popular a work does not represent him in the aspect of a successful warrior, or in the flush of youth; but there seems to be a singular harmony between this venerable image —so majestic, benignant and serene—and the absolute character and peculiar example of Washington, separated from what was purely incidental and contingent in his life. Self-control, endurance, dauntless courage, loyalty to a just but sometimes desperate cause, hope through the most hopeless crisis, and a tone of feeling the most exalted, united to habits of candid simplicity, are better embodied in such a calm, magnanimous, mature image, full of dig-nity and sweetness, than if portrayed in battle array or melodramatic attitude. Let such pictures as David's ' Napoleon '—with prancing steed, flashing eye and waving sword—represent the mere victor and military genius; but he who spurned a crown, knew no watch-word but duty, no goal but freedom and justice, and no reward but the approval of conscience and the gratitude of a country, lives more appropriately, both to memory and in art, under the aspect of a finished life, crowned with the harvest of honor and peace, and serene in the consummation of disinterested purpose."

Stuart, when asked for his candid opinion of the various busts and portraits of Washington, replied: " Houdon's bust comes first, and my head of him next. When I painted him, he had just had a set of false teeth inserted, which accounts for the constrained expression so noticeable about the mouth and lower part of the face.

Houdon's bust does not suffer from this defect. I wanted him as he looked at the time."

Tuckerman, commenting on this defect in the mouth in the Washington portraits, says: "The feature, usually exaggerated in poor copies, and the least agreeable in the original [the Lansdowne], is the mouth, resulting from the want of support of the muscles, consequent on the loss of teeth, a defect which Stuart vainly attempted to remedy by inserting cotton between the jaws and the lips, and Wilson Peale, more permanently, but less effectually, sought to relieve by a set of artificial teeth."

In this connection, G. W. P. Custis, in his "Recollections," says: "In 1789, the first President lost his teeth, and the artificial ones with which he was furnished answering very imperfectly the purpose for which they were intended, a marked change occurred in the appearance of his face, more especially in the projection of the under lip, which forms so distinguishing a feature in the works of Stuart, and others who painted portraits of the great man subsequent to 1789."

The following letter from Washington to his dentist was written only a year before his death, and after the portraits now known to us were painted; but the "old bars" to which he refers were probably the ones that he wore when he sat to Stuart:

"PHILADELPHIA, 12th Oct., 1798.

"*Sir:* Your letter of the 8th came safe, and as I am hurrying in order to leave this city to-morrow, I must be short.

"The principal thing you will have to attend to, in the alteration you are about to make, is to let the upper bar fall back from the lower one, thus: [cut 1].* Whether the teeth are quite straight or inclining in a little, thus, [cut 2], or a little rounding outwards, thus, [cut 3], is immaterial, for I find that it is the bars alone both above and below, that give the lips the pouting and swelling appearance—of consequence, if this can be remedied all will be well.

* Washington inclosed three explanatory drawings.

"I send you the old bars, which you returned to me, with the new set, because you have desired; but they may be destroyed, or anything else done with them you please, for you will find that I have been obliged to file them away so much above, to remedy this evil I have been complaining of, as to render them useless, perhaps, to receive new teeth. But of this you are better able to judge than I am. If you can fix the teeth (now on the new bars which you have) on the old bars, which you will receive with this letter, I should prefer it, because the latter are easy in the mouth; and you will perceive, moreover, that when the edges of the upper and lower teeth are put together, that the upper falls back into the mouth, which they ought to do, or it will have the effect of forcing the lip out just under the nose.

"I shall only repeat again that I feel much obliged by your extreme willingness and readiness to accommodate me, and that I am, sir, your obedient servant,

"GEORGE WASHINGTON.

"Mr. JOHN GREENWOOD."

It will thus be seen that the "pouting and swelling" of the face resulted from the badly fitting teeth, and not from any trick on the part of the artist to give something like a natural look to the lower part of the face, by stuffing cotton between the jaw and the lip; or any other artifice.

"I have often heard my father," says Miss Stuart, "in conversation with Washington Allston, give his opinion of General Washington's personal appearance. He said his figure was by no means good; that his shoulders were high and narrow, and his hands and feet were remarkably large. He had 'aldermanic proportions,' and this defect was increased by the form of the vest of that day. But with all these drawbacks, his appearance was singularly fine. I have heard my mother say that the first time she saw him, he entered the hall door, as she passed from the entry to the parlor, and that she thought him the most superb-looking person she had ever seen. He was then dressed in black velvet, with white lace ruffles, etc., exactly as Stuart's picture represented him."

Here I may very properly make another extract from Miss Stuart's narrative, touching this matter of lace and ruffles worn by Washington:

"Many years after the death of Stuart, Mr. Peale gave a lecture on the Washington portraits, in which he made an attack on the style of dress in which Stuart had represented Washington, and denied his ever having worn lace on his bosom or wrists. The next day my sister Anne wrote him a note, to say that we had in our possession some lace which my father cut from Washington's linen. The circumstances were these: my father asked Mrs. Washington if she could let him have a piece of lace, such as the General wore, to paint from. She said, 'Certainly,' and then inquired if it would make any difference if it were old. He replied, 'Certainly not, I only wish to give the general effect.' She then brought the linen with the lace on it, and said, 'Keep it, it may be of use for other pictures.'

"Mr. Peale answered my sister's note very politely, and said he had never seen Washington in lace ruffles. I have given away this lace, an inch at a time, until it has all disappeared; the largest piece I gave to the late Mrs. Harrison Gray Otis, who had it framed."

A LIST OF STUART'S WORKS

PORTRAITS PAINTED BY GILBERT STUART.

* Exhibited in Boston in 1828. † Known to have been engraved.

*† ADAMS, MR. AND MRS. JOHN.

THEIR portraits were begun in 1798, but were not out of Stuart's studio till 1812.

The finest portrait of President Adams is the one that Stuart painted in 1825. Mr. Adams was then in his eighty-ninth year. The circumstances connected with this portrait are mentioned by John Quincy Adams, in his diary, under date of September 3d, 1824:

"I called, with Mr. Cruft, upon Stuart, the painter, and engaged him to go to Quincy and there paint a portrait of my father. More than twenty years have elapsed since he painted the former portrait, and time has wrought so much change on his countenance that I wish to procure a likeness of him as he is now. Stuart started some objections of trivial difficulties,—the want of an easel, of a room properly adapted to the light, but finally promised that he would go and take with him his best brush, to paint a picture of affection and of curiosity for future time."

This portrait is one of the finest efforts of Stuart's genius. There is a portrait of President Adams, by Stuart, in the collection of the New-York Historical Society, and another is owned by Mr. T. Jefferson Coolidge, of Boston, who has the only complete set of the first five Presidents of the United States; the other set,

painted by Stuart, was in the Library in Washington, burnt a few years ago.

President Adams was born at Braintree, October 19th, 1735, and died at Quincy in 1826, on the fiftieth anniversary of the Fourth of July. Mrs. Adams's maiden name was Abigail Smith, daughter of Rev. William Smith, of Weymouth. She was born November 11th, 1744, O. S., married, October 25th, 1764, and died October 28th, 1818. The above portraits are owned by Hon. Charles Francis Adams, Boston.

* † ADAMS, MR. AND MRS. JOHN QUINCY.

In his diary, under date of September 19th, 1818, Mr. Adams made this entry:

"I sat to Stuart before and after breakfast, and found his conversation, as it had been at every sitting, very entertaining. His own figure is highly picturesque, with his dress always disordered, and taking snuff from a large, round tin wafer box, holding, perhaps half a pound, which he must use up in a day."

President John Quincy Adams was born at Braintree, July, 1767, and died February 28th, 1848. Mrs. Adams was born February 12th, 1775, and died May 15th, 1852. Her maiden name was Louisa Catharine Johnson, daughter of Joshua Johnson, of Maryland. Mr. Johnson was United States Consul at London, and the marriage of Mr. and Mrs. Adams took place in that city. Their portraits are owned by Hon. Charles Francis Adams.

In Memorial Hall, Harvard University, there is a full length portrait of President John Quincy Adams—the head by Stuart, and the figure by Sully. The picture was ordered by Hon. Ward Nicholas Boylston, and by him given to Harvard. The artist, although repeatedly urged to finish it, never found the time, and at his death, with many other portraits, it was left in an unfinished state. The head is very fine.

* ALLEN, JEREMIAH.

His portrait is in the rooms of the Massachusetts Historical Society.

* ALLEN, ANDREW.

He was the English Consul at the time that his portrait was painted, and probably on his return to England he took it with him.

ALLSTON, WASHINGTON, b. November 5th, 1779, d. July 9th, 1843.

A portrait of him, a mere sketch, was painted for Mr. Edmund Dwight, whose daughter, Mrs. Mary Eliot Parkman, has it now in her possession, in Boston. The late Richard H. Dana said of this picture: "It is the mere head, but such a head! and so like the man!"

AMERSLY, RICHARD.

His portrait was painted in Dublin, and is now at Carlton House.

* † AMES, FISHER, b. April 9th, 1758, d. July 4th, 1808.

The original portrait is in the possession of Mrs. John E. Lodge, 31 Beacon street, Boston. It belonged to the heirs of Mr. Ames, and by them was given to Mr. George Cabot, who was one of his most intimate friends, and the editor of his works. From Mr. Cabot it descended to the present owner.

In Memorial Hall, Harvard, there is a copy of this picture, made by Stuart, of whom it was purchased by subscription, in 1810, and

presented to that institution. It is inferior to the original. Several copies have been made since the death of Stuart. One is owned by the descendants of Fisher Ames, and another has been placed in Dedham Court-house.

* AMORY, MRS. ELIZABETH, b. 1741, d. 1823.

Mrs. Amory was the wife of Thomas C. Amory, and daughter of William Coffin. Her portrait, painted soon after Stuart's arrival in Boston, is owned by Mr. William Amory, Boston.

* AMORY, THOMAS C., b. 1767, d. 1812.

He was a son of Mr. and Mrs. Thomas C., and the father of Colonel Thomas, William and Charles. His portrait, painted about 1810, is owned by Mr. William Amory, Boston.

AMORY, THOMAS, d. in 1823.

He was a prominent merchant in Boston, and suffered severely during the war of 1812 by the loss of his vessels. His portrait, painted soon after Stuart's arrival in Boston, is owned by his daughter, Mrs. W. Raymond Lee, Roxbury.

AMORY, MR. AND MRS. JOHN.

Their portraits are in the possession of their descendants, Misses Codman, Bristol, R. I. Mr. Amory died in Boston, September 4th, 1832, aged 73 years. Mrs. Amory's maiden name was Katharine Willard, married January 15th, 1792, and died at Roxbury, July 20th, 1831, aged about 70 years.

* AMORY, JONATHAN.

ANTHONY, CAPTAIN JOSEPH AND WIFE.

He was at the head of a prominent mercantile house in Philadelphia, and was the uncle of the artist. Mention has been made of him in these pages. Both portraits are superb works of art. Brilliant as are the majority of Stuart's pictures, these portraits stand out alone, so masterly are they wrought. They are owned by Professor Wolcott Gibbs, of Cambridge, Mass.

ANTHONY, JUDGE AND WIFE.

The Anthonys, as already stated, were related to Stuart. These portraits, when last heard from, were owned by the Clement family, Huntington, Pa. That of Judge Anthony is rather florid. Mrs. Anthony has her head powdered. She is dressed in white, which is brought into relief by a crimson curtain and a bit of landscape in the background. Through her hair a fillet of blue ribbon is twisted.

* APPLETON, MR. AND MRS. NATHAN.

"A venerable person of more than four-score years; a merchant of large enterprise and unsullied integrity, a member of many learned societies, a writer of many able essays on commerce and currency, a wise and prudent counsellor in all private and public affairs."

Mrs. Appleton's maiden name was Maria Theresa Gold, eldest daughter of Thomas Gold, of Pittsfield. She was born November

17

7th, 1786, married in 1806, and died February 10th, 1833. Mr. Appleton was born at New Ipswich, October 6th, 1779, and died at Boston, July 14th, 1861. Their portraits are owned by their descendants, and are now in the house of Mr. Longfellow, Cambridge.

ASHBURTON, LORD AND LADY.

Their portraits are in England.

ASPINWALL, DR., b. May, 1745, d. April, 1823.

He took his degree of A. B. at Harvard, in 1764, and his M. D. in 1808. His portrait, painted in 1814 or 1815, was one in which Stuart was interested, and of it he made a fine picture. It is owned by Mr. William Aspinwall, Boston.

ASTOR, JOHN JACOB, b. 1773, d. 1848.

His portrait is now owned by his grandson, Mr. J. J. Astor, of New-York.

ATHERTON, CHARLES HUMPHREY, b. 1773, d. 1853.

His portrait, which has always been considered an excellent likeness, was painted in 1823. In after years, Mr. Atherton used to speak of Mr. Stuart's entertaining manners when engaged with sitters. The portrait, owned by Mrs. Charles G. Atherton, is at Nashua.

AUCHMUTY, MRS. ROBERT NICHOLLS.

Her maiden name was Henrietta Overing, daughter of Henry John Overing, of Newport, and her husband was the fourth son of the Rev. Dr. Auchmuty, of New-York. The portrait is owned by Miss Joanna Auchmuty, Washington.

BABCOCK, MR. AND MRS. ADAM.

He is seated in a chair, holding a snuff-box in his right hand in such a way as to show only three of his fingers. Some one noticing this, asked Stuart where the other finger was; he suggested that possibly it might be in the snuff-box. The portrait of Mr. Babcock is owned by his grandson, Mr. William Babcock, of San Francisco. Mrs. Babcock's maiden name was Martha Hubbard. Her portrait is owned by her granddaughter, Mrs. Charles D. Head, Brookline, Mass.

† BAINBRIDGE, COMMODORE, b. May 7th, 1774, d. July 27th, 1833.

His portrait has been deposited in the Lyceum, at the Brooklyn Navy-Yard.

BAKER, ADMIRAL SIR HENRY LORRAINE.

His father was Robert Baker, of Richmond, England, and his mother was the daughter of George Hayley, a London Alderman, and a merchant who had extensive dealings in this country. Hayley died during the Revolution, and when peace was declared, his widow, known as Madame Hayley, came to this country to settle his affairs.

Her arrival was announced in the papers of the day. She married the second time, taking for her husband Patrick Jeffrey, a connection of Francis Jeffrey, of the *Edinburgh Review.*

Baker was with Admiral Cockburn, in 1814, when the British fleet was trying to push its way up the Potomac. At that time he was in command of a sloop-of-war, the "Fairy," and, during an engagement, was wounded in the cheek by a musket-ball. The scar can be seen in the portrait, which was painted in 1817, he having come to this country the year before, to see if he could recover land in New England that had belonged to George Hayley. The portrait is now owned by Dr. A. L. Elwyn, 1422 Walnut street, Philadelphia, who inherited it from his mother, to whom it was presented by Admiral Baker. It is a good picture, and has been well cared for.

BANNISTER, MR. AND MRS. JOHN.

They resided at Newport, R. I., and are numbered among the earliest patrons of Stuart. Their portraits, painted when Stuart was thirteen or fourteen years of age, are now in the Redwood Library.

BARCLAY, JOHN.

His portrait is owned by his grandson, Dr. Biddle, of Philadelphia. Hon. John Barclay was Mayor of the city of Philadelphia in 1791, and this portrait was painted soon after Stuart's arrival in that city, in 1794.

† BARRI, COLONEL ISAAC.

Painted in England.

Barrington, Admiral, d. 1800.

His portrait was painted in England in 1785. He was the fifth son of the first Lord Barrington; entered the British navy at an early age, and in 1800 took St. Lucia from the French.

† Barry, Commodore John, U. S. N.

This is the only portrait of Commodore Barry, who was the first Commodore in the United States Navy. It descended to the late P. Barry Hayes, of Philadelphia, and from him to his widow, who became Mrs. Dr. Leiper, of that city, the present owner. The picture has been engraved by Longacre.

Barry, James David.

He was of Irish birth, and came to this country as British Consul, in the latter years of the last century. While here he resided at New-York, and also at Washington. His portrait, and those of his daughters, Ann and Mary, were painted by Stuart. It has been said that he also painted a full-length of Mrs. Barry. The eldest daughter, a girl of remarkable beauty, fell a victim to consumption. Her father sailed with her for Madeira, in the vain hope that a change would be beneficial. She died on the return voyage. The other daughter married Dr. Ducatel, the geologist of Maryland. At the death of Consul Barry, his own portrait and those of his daughters descended to his nephew, Robert Barry, who had taken up his residence in Baltimore. At the death of Robert, by some oversight, the portrait of Consul Barry was sold. At one time it had a place in the C. M. Leupp collection. When

that collection was sold, it was purchased by Mr. John Taylor Johnston, and at the sale of his pictures it was purchased by Mr. W. T. Walters, of Baltimore, the present owner, who paid $560 for it. The portraits of the daughters became the property of Mrs. Ducatel, from whom they descended to her grandson, Mr. G. W. Whistler, of Baltimore, who now has them at his residence in that city.

* BARTLETT, DR. THOMAS AND WIFE.

Their portraits were painted about 1804, at which time Dr. Bartlett was thirty-six years of age. They are now in the possession of Mr. Thomas B. Hall, Longwood, Mass.

BARTLETT, MISSES.

They were the daughters of Dr. Thomas Bartlett. In 1816, these young ladies, Maria and Ann, the one eighteen and the other sixteen, sat to Stuart, at his studio in Roxbury. Maria became Mrs. Dwight, and is still living in New-York. Her portrait is in her possession, and is in excellent condition. The portrait of her sister is owned by her granddaughter, Miss Ann H. Parker, of Boston.

While Stuart was painting Mrs. Dwight's portrait, some comment was made on the drapery, to which the artist replied curtly: " I don't want people to look at my pictures and say how beautiful the drapery is; the face is what I care about." Mrs. Dwight, who is now eighty years of age, says of Stuart: " His anecdotes were always droll, keeping his sitters in a perpetual laugh. I remember hearing him say it was to catch the expression, which is one of the remarkable qualities of his pictures." And she adds: " I remember the snuff-box to suffocation. I often wondered he could breathe with such a nose-full. His young sitters would be sure to sneeze

under the ordeal, as did also the old, with so much snuff about. I can see him now, in his negligent attire, to which he paid less attention than to that of his portraits, which were always graceful."

BARTLETT, DR. JOHN AND WIFE.

These portraits were painted about 1814. Dr. Bartlett was a bad sitter. He was too much absorbed in his profession to give much heed to the painter. His sober, preoccupied face did not suit Stuart, who asked him how it was that he always looked " so devilish sombre." The Doctor remembered this, and in after years laughed, when he thought of the discomfiture of the artist. The portrait of Mrs. Bartlett is very beautiful: she was a fine subject and interested Stuart, who did justice to one so attractive. Their portraits are owned by their granddaughter, Mrs. S. W. Bush, Park Square, Boston.

BAYARD, MRS.

At the time that Stuart was painting in New-York, there was a place about a mile from the compact part of the city, known as " Bayard's Farm." It was owned by Nicholas Bayard, who was annoyed by money-diggers, who persisted in working on his farm under cover of night. At last he advertised, that if the seekers for hid treasures should come in the day-time, and would engage to fill up all the holes they might make, every facility would be afforded them for carrying on their work. Bayard had been a Tory; but for all that he was very popular, and it was upon his farm that the " Hamilton," drawn by ten white horses, and officered and manned by patriots, came to anchor, when celebrating the adoption of the Constitution. When they were refreshed, the crew put her under sail again, in a seamanlike manner, and returned to

town. Mrs. Bayard, who was a handsome woman, was probably Stuart's sitter. The picture has been lost sight of. Mrs. Bayard had two beautiful daughters.

BEACH, MISS CLEMENTINA.

Miss Beach, who was a native of Bristol, England, came to America about 1800, and opened a school for young ladies at Dorchester, Mass., in connection with a Mrs. Saunders. She was then about twenty-five years of age, and wishing to learn something of portrait painting, sat to Stuart between the years 1810 and 1815. When the portrait was finished, she copied it, making of it a study, and so perfected herself as to be able to paint the portraits of a number of her pupils. The original is now in the possession of Miss C. R. Smith, at Lenni Mills, a small village near Philadelphia. The copy made by Miss Beach is owned by Miss E. S. Beach, of Gloucester, Mass.

BEAN, ———.

† BENSON, JUDGE EGBERT.

There are two portraits of Judge Benson, painted by Stuart— one owned by Hon. John Jay, late Minister to Austria, who has it at Bedford, Westchester County, New-York; and the other is in the possession of the New-York Historical Society, to which institution it was presented by Mr. Egbert Benson, Jr., who had previously complied with the wish of Mr. S. Whitney Phœnix to allow him to have it engraved. This, which is among the examples of Stuart's works reproduced in this volume, is altogether a remarkable portrait. Judge Benson is dressed in black, with a white cravat

and frill, and wears his own hair. It has a dark background, which is very effective. It was painted in 1805, on a mahogany panel, and the solid masses of color in the flesh tints are, apparently, as fresh and brilliant as when laid on by the artist, seventy years ago. Judge Benson was the last survivor of the Provincial Congress of the State of New-York, 1775, and was a member of the first American Congress, and also one of the committee to arrange for the inauguration of President Washington. A memoir of Judge Benson, written for the New-York Historical Society, was published in 1825.

BETHUNE, DR. GEORGE AND WIFE.

He was the son of George Bethune, of Boston, and the third of the name. His portrait, painted about 1820, and that of Mrs. Bethune, are owned by their son, Dr. George A. Bethune, of Boston. Dr. Bethune was born 1759. Mrs. Bethune, whose maiden name was Mary, daughter of John Amory, was born January 20th, 1773, and died January 24th, 1844.

† BINGHAM, MR. AND MRS. WILLIAM, AND DAUGHTER.

This picture of the Bingham family was painted (or rather begun, for it was never finished) in England. Mrs. Bingham, whose maiden name was Ann Willing, was then about twenty years of age. It was brought to this country in an unfinished state, and in the course of time it became very much cracked. The faces alone were done, and the other parts were but little more than sketched in. Mrs. Bingham was represented as standing by the side of a horse, holding her little daughter, probably not more than ten months old, on the pommel of the saddle. This was the second daughter, who became the wife of Henry Baring. The little thing is in her night-

cap. The eldest daughter, Ann, afterward the wife of Alexander Baring,* was at the time two and a half years old. She was standing in the foreground with uncovered neck, over which her hair was flowing, and had on a broad-brimmed hat. As she pulled at her mother's dress, and looked for a recognition, she plainly showed that she was jealous of the attention bestowed on the baby. Mrs. Bingham's face was turned to her, while, with both· hands, she supported her infant. Near the head of the horse, there were the outlines of a Newfoundland dog. Mr. Bingham was in a scarlet hunting suit, and stood on the left of his wife, Ann being between them and more in the foreground.

Such was the picture, which had been little cared for, and Mrs. Bingham gave it to her brother-in-law, Henry Clymer. He, for many years, took the best of care of it, but its condition was very unsatisfactory, and he was induced to consult Mr. Sully, who advised that much of the canvas should be cut away, and that the remainder should be divided into three pictures. This was done by Mr. Scarlet, under the directions of Mr. Sully. The largest picture, about three feet square, gives the portrait of Mrs. Bingham. It takes in the figure down to the waist, which is encircled by a broad belt. She has flowing brown hair, which hangs in curls to her waist. The dress, which is white, is cut half-low, with wide ruffles at the neck and arm-holes. The arms are uncovered. A part of the dog and horse appear in this picture.

Mr. Bingham, who has just dismounted, stands with uncovered head, showing the hair fully powdered. The shoulders only are seen. His coat, of scarlet cloth, is made with a standing collar. He was then about thirty years of age, and is represented with a full, florid face and coarse features. This picture is only seventeen inches square, and the remaining picture, showing the head of Ann,

* Alexander Baring, who became the husband of Ann, was the Lord Ashburton who made the treaty with the United States touching the eastern boundary line.

is about the same size. These portraits are owned by the heirs of the late Mrs. William Bingham Clymer.

There are two other portraits of Mrs. Bingham by Stuart: one is owned by Mrs. J. F. Fisher, of Philadelphia, and the other is the property of Hon. T. F. Bayard, of Delaware.

Of another portrait of Mr. Bingham by Stuart, I have gathered the following from Mr. Hart:

"A beautiful picture, taken about 1795. The face is turned to the right three-quarters, while the body turns slightly to the left, giving a splendid air. He is dressed in a scarlet hunting-coat, with large horn buttons, and his two hands rest upon his whip. His waistcoat is elaborately damasked, his head is uncovered, and the hair is powdered. This picture belonged to the Rev. Dr. Blackwell's second wife, Hannah, sister of Mr. Bingham. She died without issue, and left the portrait to Dr. Blackwell's eldest granddaughter, who gave it to the late Mr. Thomas Balch, in whose family in Philadelphia it now remains."

BINNEY, HORACE.

From the diary of the late Horace Binney Wallace, a nephew of Mr. Binney, I am permitted to make the following extract:

"Wednesday, June 31st, 1852. I called to-day upon Mr. Binney, before leaving town for the summer. The conversation turned upon Stuart's portrait of him, which hangs in our back parlor. He said that it was painted in the autumn of 1800, when he was not twenty-one years old. Some one had brought out from Canton some Chinese copies of Stuart's Washington, and Stuart prosecuted an injunction in the Circuit Court of the United States against the sale of them. 'I was sedulous,' said Mr. Binney, 'in my attendance on the courts, and here I became acquainted with Stuart. He came frequently to my office,' continued Mr. Binney, 'which was in Front

street. I was always entertained by his conversation. I endeavored to enter into his peculiar vein, and show him that I relished his wit and character. So he took snuff, jested, punned and satirized to the full freedom of his bent.' 'Binney,' he said to one of my friends, 'has the length of my foot better than any one I know of,' meaning, I suppose, that I knew how to humor him, and give him play.

"'When your mother * requested me to give her the portrait that is in your house, I made an appointment with Stuart, and called to give my first sitting. He had his panel ready (for the picture is painted on a board), and I said: 'Now, how do you wish me to sit? Must I be grave? Must I look at you?' 'No,' said Stuart; 'sit just as you like, look whichever way you choose; talk, laugh, move about, walk around the room, if you please.' So, without more thought of the picture on my part, Stuart led off in one of his merriest veins, and the time passed pleasantly in jocose and amusing talk. At the end of an hour I rose to go, and, looking at the portrait, I saw that the head was as perfectly done as it is at this moment, with the exception of the eyes, which were blank. I gave one more sitting of an hour, and in the course of it Stuart said: 'Now, look at me one moment.' I did so. Stuart put in the eyes by a couple of touches of the pencil, and the head was perfect. I gave no more sittings.

"'When the picture was sent home,' continued Mr. Binney, 'it was much admired; but Mr. T***** M****** observed that the painter had put the buttons of the coat on the wrong side. Sometime after this, Stuart sent for the picture, to do some little matter of finish which had been left, and, to put an end to a foolish cavil, I determined to tell him of M.'s criticism; but how to do it without offending him was the question. The conversation took a turn upon the excessive attention which some minds pay to the *minutiæ* of

* Mrs. John Bradford Wallace, the oldest sister of Mr. Binney. For a tribute to the worth of this accomplished and distinguished woman, see " The Republican Court."

costume, etc. This gave the opportunity desired. 'By the way,' said I, 'do you know that somebody has remarked that you have put the buttons on the wrong side of that coat?' 'Have I?' said Stuart. 'Well, thank God, I am no tailor.' He immediately took his pencil and with a stroke drew the *lapelle* to the collar of the coat, which is seen there at present. 'Now,' said Stuart, 'it is a double-breasted coat, and all is right, only the buttons on the other side not being seen.' 'Ha!' said I, 'you are the prince of tailors, worthy to be master of the merchant tailors' guild.'

" 'Stuart,' said Mr. Binney, 'had all forms in his mind, and he painted hands, and other details, from an image in his thoughts, not requiring an original model before him. There was no sitting for that big law-book that, in the picture, I am holding. The coat was entirely Stuart's device. I never wore one of that color [a near approach to a claret color]. He thought it would suit the complexion.'

" 'On the day when I was sitting to him the second time,' said Mr. Binney, 'I said to Stuart, 'What do you consider the most characteristic feature of the face? You have already shown me that the eyes are not; and we know from sculpture, in which the eyes are wanting, the same thing.' Stuart just pressed the end of his pencil against the tip of his nose, distorting it oddly. 'Ah, I see, I see,' cried Mr. Binney.

" Mr. Binney agreed with me in thinking that the Washington was one of Stuart's least inspired heads. Stuart used to call that head, you know, his 'hundred-dollar bill.' One day, when he had his family at Germantown, and his painting room in the city, learning from Mrs. Stuart that the domestic treasury was empty, he set off to come to town, to his bank, for one hundred dollars. At a tavern, half-way, he got out of the stage to get something to drink, and in searching his pocket-book found a fifty-dollar note, which he had forgotten that he had. When the coachman called upon him to get into the coach again, he replied, 'You may go on; I mean to wait for the return coach.'

" ' Stuart,' Mr. Binney said, ' thought highly of his portrait of John Adams. Showing it one day to Mr. Binney, ' Look at him,' said he. ' It is very like him, is it not? Do you know what he is going to do? He is just going to sneeze.'

" ' Stuart had an anecdote illustrative of physiognomy—its truth or falsehood. There was a person in Newport celebrated for his powers of calculation, but in other respects almost an idiot. One day, Stuart, being in the British Museum, came upon a bust, and immediately exclaimed to his companion, who was also a Rhode Island man : 'Why, here is a head of Calculating Jemmy.' He called the curator and said : ' I see you have the head of Calculating Jemmy here.' ' Calculating Jemmy !' said the curator ; ' that is the head of Sir Isaac Newton.' "

The portrait of Mr. Binney above described, Mr. John William Wallace gave back to his uncle in his old age. It is a picture of a youth of twenty years, having a high complexion, bright chestnut-colored hair and splendid blue eyes. Hon. Horace Binney died in 1875, aged 96 years. The portrait is now in the possession of Miss Susan Binney, of Philadelphia.

BINNEY, MISS MARY.

She became the wife of Lucius Manlius Sargent, of Boston, and her portrait is now owned by her son, Mr. Horace Binney Sargent, of Salem, Mass., to whom it was given by his aunt, Mrs. Wallace, as a great treasure.

† BLODGET, MRS. SAMUEL, b. April 11th, 1772, d. March 9th, 1837.

She was the daughter of Rev. William Smith, D. D., Provost of the University of Pennsylvania, and was justly celebrated for her

beauty. As a work of art and a picture of female loveliness, her portrait has been highly extolled. It is owned by Mr. Henry C. Carey, of Philadelphia.

In a forthcoming life of Rev. Dr. Smith, the father of Mrs. Blodget, by Mr. Horace W. Smith, she is thus spoken of: "The daughter, of whom a lovely portrait by Gilbert Stuart attests the justice of the social judgment, was one of the most admired beauties that ever adorned the drawing-rooms of Philadelphia, and as much distinguished by sprightliness and wit as by personal comeliness. The portrait of her by Stuart has been universally acknowledged, I think, to be the finest female head that Stuart produced. Boston has good works of this kind, I know; but they are in Stuart's later style. That of the lady has a purity, an etherial charm, which his pencil lost some time after the beginning of the nineteenth century. As a general thing, Stuart's women were not successful. It seemed as if he required a male head, and one, moreover, of a high intellectual order, like that of the father, Dr. Smith, whom he painted; or Bishop White, or Robert Morris, or William Lewis, or Chief-Justice Shippen, or Thomas McKean,—all of whom he painted,—to bring out the full power of his wonderful pencil. He had to become interested in what he did, in order to do it well; but when the interest that he felt was that which beauty inspires, then, too, his pencil became inspired. It seemed as if the very angels guided it. This was the case in regard to the portrait of Mrs. Bingham, and of her sister,—by some thought to be the handsomer person,—Mrs. Major Jackson. It was as much so, or more, in regard to the beautiful daughter of Dr. Smith."

The above portrait is a mere head, no attention having been paid to the drapery.

There is another portrait of Mrs. Blodget, on the back of which there is the following inscription:

"Original portrait of Mrs. Blodget and child, painted by Gilbert C. Stuart, and presented through J. Neagle to the Artist Fund

Society, of Philadelphia, by Isaac P. Davis, of Boston, Mass., Nov. 23d, 1838. Painted in Philadelphia after Mr. Stuart's arrival in this city."

BONAPARTE, MADAME.

This portrait is among the plates here given. It is now the property of Charles Joseph Bonaparte, Esq., but is in the keeping of the Maryland Historical Society. Mrs. Seaton, in speaking of her in one of her entertaining letters, says: "Madame Bonaparte is a model of fashion, and many of our belles strive to imitate her, but without equal *éclat*, as Madame Bonaparte has certainly the most transcendently beautiful back and shoulders that ever were seen." Again she says: "To her mental gifts was added the beauty of a Greek, yet a glowing type, which not even the pencil of Stuart adequately portrayed in the exquisite portrait that he wished might be buried with him; nor yet on his other canvas, which, with its dainty head in triple pose of loveliness, still smiles in unfading witchery."

Of this picture Miss Stuart writes: "Jerome Bonaparte, the husband of Madame Bonaparte, was anxious to have her portrait completed, it having been in an unfinished state for some time; but as sitters were crowding in upon my father, this request could not be immediately complied with. Bonaparte deemed it an insult to be so neglected, and when the two came together,—Bonaparte and Stuart,—the painter thought that the remarks addressed to him were impertinent; the result was Bonaparte could not get possession of his own or his wife's portrait on any terms. He sent his friends to offer any price, but these offers made no impression on Stuart.

"In time, Mr. Patterson, Mrs. Bonaparte's father, came to Boston and sat for his portrait. In the course of conversation with Stuart,

this picture was mentioned, when the painter had it brought down from the garret. Mr. Patterson was delighted with it, and my father presented it to him, which he could ill afford to do, to convince the world that he did not value his work as much as he did his position as an artist.

"With this picture I have some interesting associations, for the garret where these discarded pictures were heaped was my playroom when a child, and this beautiful sketch of Madame Bonaparte was the idol that I worshiped. The stretcher had been taken from it, and the canvas, unrolled, was lying on the floor. Over it I would sit for hours, wondering if I should ever be old enough and clever enough to copy it. At last, at the mature age of thirteen, with the aid of my sister Anne, I obtained colors and an old panel. Thus equipped, I went into a corner and worked away on the picture in a state of enjoyment not to be described; when, suddenly, I heard a frightful, roaring kind of noise, and soon it was evident that the kitchen chimney was on fire. I felt very much alarmed, but could n't leave the picture: that was totally out of the question, even if the house itself was on fire. Presently I heard my father ascend the stairs, take hold of the knob and almost break the door open in his haste to see if the fire was likely to do any damage. I shall never forget the expression of astonishment on his face, as he caught sight of me, seated as I was before an easel. He saw I was very much annoyed and looked very foolish, for I was sensible of my own assurance in attempting such a task, and he passed on, pretending not to see how I was employed. To the top of the house he mounted; but when he came down, he could not resist coming up to me and looking over my shoulder.

" 'Why, boy,' said he, for so he used to address me, 'you must not mix your colors with turpentine; you must have some oil.' "

Jerome Bonaparte.

This is an unfinished picture, and, with the above, is in the collection of the Maryland Historical Society. There was a portrait of Jerome, Jr., I have been told, but I have not been able to find it.

* Bond, Mr. and Mrs. Nathan.

Mr. Bond was born at Concord, March 31st, 1752, and died January 5th, 1816. He graduated at Harvard in 1772, and then studied for the ministry, but his feeble health made it necessary to adopt a more active life, and he became a merchant. His portrait was painted in the summer of 1815. At that time he was consumptive, and a hectic spot is seen on the cheek in the picture.

Mrs. Bond, whose maiden name was Joanna Sigourney, was the Widow Doane at the time that she married Mr. Bond, June 1st, 1783. She was born August 8th, 1750, and died November 3d, 1828.

These two portraits are owned by their grandson, Mr. George William Bond, of Boston, who has given me the following reminiscence: " I remember, when a boy, going with my father to Stuart's studio, then in the house that was Washington's headquarters during the Revolution, upon the Neck, to see these pictures. I think they were not brought home till after my grandfather's death. I also remember repeatedly visiting the studio of Mr. Stuart when he lived in Essex street. Late in life his hand shook so it seemed impossible that he could paint. The last time I saw him, I think, he was painting the portrait of Josiah Quincy. Stuart stood with his wrist upon the rest, his hand vibrating, and, when it became tolerably steady, with a sudden dash of the brush he put the color on the canvas,"

From other sources I have had a like description of Stuart's manner of painting in the last years of his life.

BOOTH, KIRK, b. at Derby, England, 1755, d. Boston, 1817.

His portrait must have been painted a short time, a year or two at most, before his death. He sat to Stuart at the request of his eldest daughter, Mrs. William Wells, who retained the picture up to the time of her death, 1873. It is now in the possession of Mr. Kirk Booth Wells, of Philadelphia.

BORDLEY, MISS ELIZABETH B.

She became the wife of James Gibson. Her portrait, which was as much admired for the beauty of the subject as for the admirable skill displayed by the painter, long hung in the Gibson mansion, Eighth and Spruce streets, Philadelphia. It is now owned by Mr. Edward Shippen, of that city. It was probably painted before 1816. Miss Bordley was the warm and intimate friend of Nellie Custis.

BORLAND, MRS. LEONARD VASSALL, b. 1762, d. 1836.

Her maiden name was Sarah Lloyd, daughter of James Lloyd, M. D., of Cambridge, and sister of James Lloyd, U. S. Senator from Massachusetts. She was married February 8th, 1785. Mr. Borland died on board the ship "John Jay," June, 1841, while on a return voyage from Batavia. The portrait of Mrs. Borland, painted at about the age of forty, is in the possession of Mr. John Jeffries, Beacon street, Boston. It is on a panel.

BOWDOIN, JAMES, b. September 22d, 1752, d. October 11th, 1811.

The eldest son of Governor Bowdoin; he was a patriot under arms at Dorchester Heights, and, with Washington, crossed over to Boston when the British left that town. In 1804, he was appointed Minister to the Court at Madrid. After his return to America, he gave his whole attention to agriculture, and passed the remainder of his days at Nashaun, on which island he died. His portrait is in Bowdoin College.

BOWDOIN, MR. AND MRS. JAMES TEMPLE.

His portrait, painted in 1826, is now at Florence, in the possession of the Princess di Pandolfina, who has also the portrait of Mrs. Bowdoin, painted from sketches and crayons after her death.

Some notice of portraits of other members of the Bowdoin family will be found with those of the Temples.

BOWDITCH, DR. NATHANIEL, b. March 26th, 1773, d. March 17th, 1838.

In the records of the East India Marine Society, under date of January 23d, 1827, there is this entry: "It was voted that a portrait of Dr. Bowditch be procured at the expense of the Society, and John B. Osgood, William Fettyplace, and John W. Rogers, were appointed a committee to procure it, and to ask Dr. Bowditch to sit for it." This picture was begun by Stuart, but he did not live to finish it.

After the death of Stuart, Dr. Bowditch bought the unfinished picture of the heirs, for he was unwilling that an imperfect portrait of himself (as it was then called) should be paid for by his friends. But, unfinished as it is, it is a valuable picture, and one that shows the artist's powers as a painter. The artist and sitter were evidently in accord, for this anecdote is related of them. The Doctor used to tell the story with a relish, and I have it .from his son. He did not want to have his portrait painted, and only submitted to what he called an infliction, to gratify his friends. He was in the habit of going daily to the Life Insurance Company of Boston, of which he was Actuary, and he agreed with Stuart that he should be at the studio at eight o'clock, and under no circumstances were the sittings to last longer than one hour. With this understanding his first appointment was kept, and with the sitting a most lively conversation commenced. The artist told anecdotes of the most amusing character, and soon the pair were in high glee, the painter at the same time working away. When, at length, the sitter looked at his watch, he was amazed to find that instead of a sitting of one hour he had given the painter two. It was ten o'clock.

This picture was left in a very unfinished state; only one-half of the mouth can be made out, and scarcely any outline of the ear can be seen; and yet the effect is fine, and conveys the impression that the head is that of a man who was possessed of a remarkable intellect. Some injudicious friends proposed that an artist should be employed to finish the picture. "Fortunately," says Mr. Henry J. Bowditch, "that poet and lover of beauty in nature and art, Henry Pickering, protested against any change; by his effort, the fragment left by the artist was saved. On the back of the canvas was written by him, 'Sancte inviolateque servatum sit.'"

The portrait of Dr. Bowditch remained in the homestead, in Boston, till the city took possession of the house to lay out Devonshire street. In the distribution made at that time, it fell to Mr. William J. Bowditch, of Brookline, who is now its owner.

BOYLSTON, WARD NICHOLAS.

Mr. Boylston, born at Boston, 1749, lived in England from 1775 to 1800. After his return to America, he lived alternately at Jamaica Plain and Princeton, till his death, in 1828. He built the homestead at Princeton; there he received many distinguished guests, and there he sat to Stuart, who was long remembered as a great talker and a great snuff-taker.

There are two portraits of Mr. Boylston at Princeton. One is a sketch, a profile, showing vigorous drawing and Stuart's rich coloring. The hair is left in a very unfinished state, and there is no background. It was painted to aid in preparing the medal, which is given as a premium by Harvard College, for the best medical dissertation, when the student prefers a gold medal in place of money. The size of the panel is 17 × 21 inches.

A finer and more finished picture is a three-quarter length, but it has not the strong characteristics of the sketch. He is sitting in a high chair, and is dressed in a fur-lined wrapper, buff embroidered waistcoat, shirt frill and white neck-cloth. The hands are introduced and are well painted. This picture measures 28×32 inches. With it there is the following receipt:

"BOSTON, April 25th, 1825.

"Recd. of Ward Nichs. Boylston, Two Hundred Dollars, being in full for a picture of himself.
"$200. "G. STUART."

The signature only is by Stuart, and that in a trembling hand.

Mr. Boylston was a benefactor of Harvard College and the founder of the Boylston premium fund, for medical dissertations, etc. In the Medical College there is a portrait of Mr. Boylston, essen-

tially the same as that above. All three portraits were painted at the house in Princeton.

* BRADLEE, MR. AND MRS. JOSIAH.

Their portraits, painted in Boston, are now owned by their daughter, Mrs. Sheber, of Philadelphia.

BRESCHARD, THE CIRCUS-RIDER.

Mr. George W. Riggs, of Washington, has an unfinished picture, which, there is strong reason for believing, was painted by Stuart. Breschard, sometimes called Pritchard, was well known to Stuart. He was a noted rider in his day. The head alone is finished. Two heads of horses are introduced,—one in the background, and the other only faintly sketched in.

* BREWSTER, MRS. OLIVER, b. Feb'y 18th, 1784, d. April 2d, 1831.

Her maiden name was Catharine Jones, and her portrait, painted about 1820, is remarkable not only for the richness of the coloring, but also for the amount of work in the details. She is dressed in a velvet robe, with a camel's hair shawl thrown around her; the latter, with the Mechlin lace that is introduced with it, Stuart worked up with a finish that has tested the skill and delicacy of touch of every artist who has attempted to copy it. Mrs. Brewster was a favorite with Stuart: this, probably, led him to prolong the sittings, and to give more than usual attention to the details. The picture is owned by her daughter, Mrs. Augusta Brewster Thayer, wife of Rev. Christopher Thayer, 131 Beacon street, Boston,

* † Brooks, Governor John, b. May, 1752, d. March, 1825.

His portrait, painted about 1820, is owned by Mr. Francis Brooks, who has placed it temporarily in the Museum of Fine Arts, Boston.

Brown, ——.

Of this picture I have not been able to gather any particulars, other than that Stuart painted two heads,—portraits of two young men from Liverpool,—on one canvas.

* Brown, Moses.

He was born at Waltham, April, 1748, graduated at Harvard, 1768, entered the army in 1775, and served till his corps was disbanded in 1777. After the war, he resided at Beverly, where he engaged in business with his brother-in-law, Colonel Israel Thorndike. In 1800, he retired from business with an ample fortune, and died in 1820. He was an active, public-spirited man, and in politics a Federalist. His portrait, painted about 1816, is at 52 Commonwealth Avenue, Boston, and is owned by his grandchildren, heirs of the late Charles Brown.

* † Buckminster, Rev. Joseph Stevens, b. 1784, d. 1812.

He was pastor of the Brattle Street Church, and entered upon his ministry in 1805. A portrait of Dr. Buckminster is owned by

Mr. George W. Lyman, of Waltham, Mass.; and another, also by Stuart, is in the Boston Art Museum.

BULLUS, MRS. DR.

This picture belonged at one time in New-York. I have not been able to obtain any facts about it, other than that she was represented as in a garden, surrounded by flowers.

* BURROUGHS, REV. CHARLES, D. D., b. 1787, d. 1826.

Dr. Burroughs was Rector of St. John's Church, Portsmouth, N. H., during a period of nearly fifty years, but resigned some time before his death. This portrait was painted at the request of his father, Mr. George Burroughs, who paid for it and had it in his possession up to the time of his death. From him it descended to his eldest son, Henry, who in turn bequeathed it to his son, Rev. Henry Burroughs, Rector of Christ Church, Boston, who now has it in his possession. It was painted about 1826.

Stuart began a portrait of Mrs. Burroughs; but for some reason she did not continue the sittings, and at the death of Stuart the picture was not far enough advanced to be preserved.

BUTSON, DEAN.

With the Dean, Stuart was very intimate while in Ireland, and the portrait was painted there. A letter from the Dean to Stuart will be found on another page.

* Bussey, Mr. and Mrs. Benjamin.

* Bussey, Benjamin, Junior.

These portraits are owned by Mr. Thomas Motley, Woodland Hill, Jamaica Plain, Mass. That of Benjamin, Junior, was painted from a plaster cast. These pictures date from 1808 or 1809.

Cadwalader, Lambert.

This is a full-face, to the right, and a poor specimen of Stuart's work. It is owned by his grandson, Hon. John Lambert Cadwalader, of New-York. At present it is in the possession of his sister, Mrs. S. Weir Mitchell, of Philadelphia.

Colonel Lambert Cadwalader, the son of Dr. Thomas and Hannah [Lambert] Cadwalader, of Philadelphia, was born in Trenton, N. J., in 1742. He was a brother of the distinguished General John Cadwalader, and on the breaking out of the Revolutionary war, immediately took an active part in behalf of the Colonies. In January, 1776, he was appointed Lieutenant-Colonel of Shee's battalion, and in the following June marched with the Pennsylvania troops to New-York, and encamped toward King's Bridge, on the site of the future Fort Washington. In October, he was commissioned Colonel of the Fourth Regiment of Foot in the army of the United States, and took a gallant part in the defense of Fort Washington, on the 16th of the following November, when, on its surrender, he became a prisoner of war. Owing to some kindness shown by his father to General Prescott, when a prisoner in Philadelphia, Colonel Cadwalader was released without parole, and sent home. In 1784, he was elected a Deputy to the Continental Congress, and, after the adoption of the Constitution of the United States, a representative from New Jersey to the first Congress.

He married, at the advanced age of fifty-one, Mary, daughter of Archibald McCall, of Philadelphia, and died September 13th, 1823, leaving one son, the late Thomas Cadwalader. C. H. H.

† CADWALADER, FRANCES, LADY ERSKINE.

This portrait, a bust, faces left, with a veil draped over the head and falling below and behind the shoulders. It is in the possession of the Erskine family, in England, and was engraved in 1834 for the "English Annual."

Frances Cadwalader was a daughter of General John. Cadwalader (brother of the preceding), by his second wife, Williamina Bond. She married, in 1800, David Montague Erskine, eldest son of the distinguished lawyer and orator, Thomas Erskine, who, upon being appointed Lord High Chancellor of Great Britain, in 1808, was raised to the peerage as Baron Erskine. On the death of the first Lord Erskine, in 1823, the husband of Miss Cadwalader succeeded to the title and estates. Lady Erskine died March 25th, 1843. She was the mother of five children. The second son, John Cadwalader Erskine, is the present peer. Lord Erskine married, secondly, July 29th, 1843, his first wife's cousin, Ann Bond, daughter of John Travis, Esq., of Philadelphia. C. H. H.

* CALLENDER, THOMAS, b. 1778, d. 1830.
CALLENDER, JOHN, b. 1782.

They were brothers, and their portraits are owned by Miss Callender, daughter of Thomas, who has them at her house, in Newport, R. I. That of Thomas is an ordinary picture, but that of John is superb. This portrait is one of those copied in this volume.

CALVERT, MR. AND MRS. GEORGE.

These portraits were painted about seventy years ago. In one of them a child has been introduced. They are in a good state of preservation, and are owned by Hon. George H. Calvert, Newport, R. I.

CAMPBELL, JOHN.

He resided at Jamaica, West Indies. His portrait, on canvas, is a three-quarter length, with hands. It was probably painted in Boston, about 1810, or possibly a little earlier. It remained in the possession of Mr. Campbell's family, in New Jersey, until left by the last surviving member to a near relative ·of Mr. James Lenox, from whom it passed by gift to Mr. Lenox, fifteen or twenty years ago. It is now in the Lenox Gallery, New-York.

CARY, MRS. SAMUEL, b. 1753, d. 1825.

She was of Chelsea. Her maiden name was Sarah Gray, daughter of Ellis Gray, of Boston, and her portrait is in the possession of her daughter, Miss Ann Montague Cary, of Chelsea.

† CARROLL, ARCHBISHOP, b. 1735, d. 1815.

While residing in Baltimore, he was a frequent guest at the hospitable mansion of Robert Barry, an Irish gentleman, and at Mr. Barry's request, he sat to Stuart for his portrait. Stuart at that time had his studio in Washington. He is painted in his Episcopal robes (he was not then an Archbishop), and was seventy years

of age at the time. At the death of Mr. Barry, the portrait was put up for sale without the knowledge of his family, and was sold to Mr. Lloyd Nicholas Rogers, of Druid Hill, near Baltimore. This portrait was engraved in 1843, for Brent's Life of the Archbishop. It is now owned by Mrs. J. M'D. Goldsborough, of Easton, Md.

CHANNING, REV. WILLIAM ELLERY, D. D.

Born at Newport, R. I., in 1780; made regent of Harvard University in 1801; licensed to preach in 1802; ordained in 1803, and died October 2d, 1842. Dr. Channing was a ripe scholar and a forcible writer,—a man of the purest nature and the most guileless life. His portrait, owned by his heirs, is now in the possession of Rev. George G. Channing, Milton, Mass.

CHANNING, MR. AND MRS. WALTER AND DAUGHTER.

CHASE, SAMUEL, b. about 1707, d. at Corinth, N. H., 1800.

He was a Judge of the courts in New Hampshire, and was painted in his judicial wig. The portrait shows him to have been a very old man at the time that it was painted. On the back of the canvas, in a large coarse hand, the name of Gilbert Stuart is written, evidently with a paint-brush. It has always remained in the possession of the family, and is now owned by Dudley T. Chase, of Claremont, N. H.

It is understood by the family that Stuart also painted the portraits of General Jonathan Chase (son of Samuel) and his wife, which pictures are said to be owned by Jonathan Chase, son of the General.

CHAUNCEY, COMMODORE.

His portrait is in the Lyceum, at the Brooklyn Navy-Yard.

CHEW, MISS HARRIET.

* CHEVERUS, BISHOP.

He came to this country as a missionary, and was made Bishop of Boston by Pius VII. in 1808. He was recalled three times. In response to the first and second call he urged that he could do more good here than at home. When the third call came he felt that it was imperative that he should go at once. This was in 1826. On reaching France, he was made Archbishop of Bordeaux; in 1836, he was honored with a Cardinal's hat. The same year he died. He had been painted twice by Stuart, but I have only been able to find one picture. When it was known that the Bishop was about to leave the country, Mrs. John Gore, who was an intimate acquaintance, asked him to sit to Stuart, and he kindly gave the artist a number of sittings. The portrait, which is very highly finished, is a three-quarter length, and represents the Bishop in his robes.

CHIPMAN WARD.

His portrait is at St. Johns, New Brunswick.

CHIPMAN, WARD AND WIFE.
CHIPMAN, WARD.

The two Chipmans, father and son, were both Judges of the Supreme Court of New Brunswick, and their portraits are owned

by Chief-Justice Horace Gray, Mount Vernon street, Boston. The portrait of Mrs. Ward, whose maiden name was Hazen, is at St. John's.

CLARE, LORD CHANCELLOR.

† CLARKSON, GENERAL MATTHEW, d. April 22d, 1825, aged 66 years.

General Clarkson entered the army as a private, at the age of seventeen, rapidly rose in rank, and was in many of the battles of the Revolution. He is dressed in the Continental uniform, with the order of the Cincinnati in his button-hole. One hand rests upon his sword and the other, crossed over it, holds his military hat. His hair is powdered. The original picture, a three-quarter length, is in the possession of Matthew Clarkson, Esq., 15 West Forty-fifth street, New-York, and was painted as early as 1793 or '4, at the time that Stuart had his studio in Stone street. A number of copies of this picture have been made: one by Mrs. Peter A. Jay, a daughter of General Clarkson, and an amateur, and owned by Miss E. C. Jay; one by Frothingham, in the possession of Mr. John Clarkson Jay, and one by Waldo, owned by Mrs. Henry E. Pierrepont, Brooklyn. The head of General Clarkson, in Trumbull's historical picture, was copied from the portrait by Stuart.

CLIVE, LADY CHARLOTTE.

This picture is in England.

CLYMER, MRS. HENRY, b. 1770, d. 1852.

Her portrait was painted at the age of twenty-seven. She was the daughter of Thomas Willing, of Philadelphia, and was married,

in 1794, to Henry Clymer, son of George Clymer, one of the signers of the Declaration of Independence. She is seated in an upholstered chair, which is covered with red satin damask, put on with brass nails. In her left hand she has a book, held open by her thumb, and it is crossed on her lap by the other hand. This book, she said in after years, was " Gregory's Advice to Young Ladies." Her hair is fully dressed and powdered; and as she was a pale brunette, her sister, Mrs. Bingham, and the artist, put on her head an East India plaid cotton handkerchief, such as were then worn by Creoles, who frequently came to Philadelphia from the West Indies. The dress is white, high in the neck, with long sleeves, ruffled at the neck and wrists with willow-green ribbon. It is cut long-waisted, and is belted. This picture is owned by Miss Mary Willing Clymer, Trenton, N. J.

There was another portrait of Mrs. Clymer, painted by Stuart at about the same time, for which she gave the artist three sittings, but I have not been able to find it.

† COBB, GENERAL DAVID.

This portrait, which has been engraved, is in the possession of Mr. George F. Wilde, Boston.

COBB, LIEUTENANT-GOVERNOR.

His portrait is now in the rooms of the Massachusetts Historical Society.

COBB, MR. AND MRS.

They were painted in Ireland.

CODMAN, CHARLES RUSSELL, b. Dec. 19th, 1784, d. Jan. 16th, 1852.

There are two portraits of Mr. Codman ; one, a half-length, painted at about the age of twenty-five, is owned by his son, Mr. Charles H. Codman, 57 Marlborough street, Boston, and the other, which is the finer of the two, painted at about the age of thirty, belongs to Mr. James M. Codman, Brookline, a younger son.

* COFFIN, ADMIRAL SIR ISAAC, b. 1759, d. 1839.

He was the son of Nathaniel Coffin. Entered the British Navy in 1772, as a midshipman, and rose, by bravery and courage displayed on various occasions, to the rank of rear-admiral. He was created a baronet in 1804. An institution for learning was founded at Nantucket by Rear-Admiral Coffin, and in various other ways he sought to promote the interest of the country of his birth. The portrait is owned by Mr. William Amory, of Boston.

* COFFIN, DR. NATHANIEL AND WIFE.

They belonged in Portland, Maine. Dr. Coffin's portrait is owned by Mrs. George Derby, 102 Charles street, Boston, and the portrait of Mrs. Coffin is in the possession of Mr. William S. Appleton, of the same city.

CONSTABLE, WILLIAM.

His portrait, painted at the time that Stuart was engaged on the Landsdowne full-length, in 1796, is in the possession of his grandson, Mr. John Constable, Constableville, Lewis County, N. Y. Inman said of this picture : "It is the finest portrait ever painted by the hand of man."

Cook, George Frederick, b. 1775, d. 1812.

Cook came to this country in 1810, and made his first appearance at the old Park Theatre, New-York, in November of that year. His fame as an actor had preceded him, and whenever he appeared on the stage he was greeted with applause. He had one infirmity, that at times more than mastered him,—a love of the cup,—but the public was tolerant and nightly flocked to see him.

Dunlap relates that when Cook sat to Stuart he fell asleep, and the artist, incensed, added asses' ears to the head. But Dr. J. W. Francis, who knew the parties well, refutes this story, so far as relates to the ears, in his "Old New-York": "Cook, when the painter Stuart was engaged upon the delineation of his noble features, chose to select these hours for sleeping; yet the great artist triumphed, and satisfied his liberal patron. Once, Stuart proved a match for him, by occasionally lifting the lid of his eyes."

If we could get at the facts, probably many similar stories, told of Stuart by Dunlap, might be set aside in the same way.

The skull of Cook came into the possession of Dr. Francis; from whom it passed into the hands of his son, Dr. V. M. Francis, who now has it.

* Coolidge, Joseph.

This portrait was painted in 1820, for Mrs. Coolidge. There was a warm intimacy between Stuart and Mr. Coolidge, and the artist is said to have looked upon this portrait as one of his most successful efforts. It was inherited by Mr. Coolidge's granddaughter, who was the wife of Samuel Wyllys Pomeroy, of Pomeroy, Meigs County, Ohio; from her it descended to her daughter, Miss Pomeroy, and is now in the keeping of Mrs. H. C. Haight, New-York, a granddaughter of Mr. Coolidge.

Another portrait of Mr. Coolidge, painted for his son, in 1813, is now owned by his grandson, Mr. Joseph Coolidge, 184 Beacon street, Boston. It is a full-face with powdered hair.

COOPER, THOMAS APTHORPE, b. 1776, d. 1849.

He was a man of fine attainments, having been liberally educated, and for a period of thirty years he held a leading place on the American stage. A daughter married a son of the late President Tyler. A careful search has not brought the portrait to light.

COOPER, WILLIAM.

He is represented seated in a chair, with his hands resting on a table, covered with a red cloth. In one hand he holds a map of "Cooper Town." He is dressed in a suit of black, with large white cravat, and powdered hair falling over the collar of the coat. The portrait is in the possession of Paul F. Cooper, Albany, N. Y., the youngest child of James Fenimore Cooper.

Judge Cooper was born in Chester County, Penn., but settled in Burlington, N. J., whence he removed to Otsego County, N. Y., in 1785, and became one of the largest land-owners in the state. The following year he settled the town which bears his name, on Otsego Lake, at the head-waters of the Susquehanna. He was a member of Congress from 1795 to 1801, during which period his portrait was probably painted. He died at Albany, N. Y., December, 1809, at the age of fifty-five.

Judge Cooper was a man of strong characteristics, great talents, and much benevolence. C. H. H.

† Copley, John Singleton, R. A., b. 1737, d. 1815.

From Mrs. Charles Amory, a granddaughter of Copley, I have learned the following :

"At a late visit to London, I saw the painting often, and admired it more than ever; and was not surprised to hear that Lord Lyndhurst was in the habit of saying that it was the best and most agreeable likeness ever executed of his father; and this was no small praise, for Mr. Copley painted several portraits of himself at different epochs of his life; not one, however, gives us as agreeable an impression of the artist as the one by Stuart.

"I recommended it for the terra cotta 'Rondel' which now adorns the exterior of the Art Museum building, in Boston. I have a small engraving from the picture, which gives a very correct idea of the work; it has, however, I am sorry to say, beneath it the name of Gainsborough instead of Gilbert Stuart."

The above portrait is in the possession of Lady Lyndhurst, Eaton Square, London.

Stuart always spoke highly of Copley, when an opportunity offered. There was a fine portrait of Josiah Quincy, of Braintree, at Quincy. Stuart, while dining there, in 1825, greatly admired it, and said: "There is as much work in one of those hands as I put in a whole portrait. Why, I could take off that wig. Copley put the whole man upon the canvas. Mr. Quincy had a white hair in his eyebrow, and there it is. The industry of Copley was marvelous."

* Cordis, Mr. and Mrs. Thomas.

Their portraits are owned by Mr. Francis Temple Cordis, Long Meadow, Mass. Mr. Cordis was born in 1771, and died December

8th, 1854. Mrs. Cordis, whose maiden name was Rebekah Russell, was born in 1790, and died July 25th, 1832. She was a descendant of Richard Russell, who came to America in 1632, and was celebrated for her beauty. Her portrait shows her to have been about twenty-two years of age at the time that it was painted.

COTTRINGER, MRS.

She was the wife of an Irish gentleman, who, at one time, was a merchant in Alexandria, where he died in 1804. The above portrait, now in Washington, is owned by the last surviving daughter of Mrs. Cottringer.

CRAIG, MRS. WILLIAM.

The portrait is at 1020 Arch street, Philadelphia.

CROCKER, ALLEN.

He was a successful broker in Boston, and acquired a handsome property, on which he retired. A man of excellent understanding and of pleasing manners, he was surrounded by a large number of friends, who were strongly attached to him. He was never married. His portrait, painted about 1815, was bequeathed to the late Samuel Crocker, of Taunton, in 1825, and his daughter, Mrs. Abby Crocker Richmond, of that place, now owns it.

Another portrait of Mr. Crocker, by Stuart, was owned by Mrs. Henry Gardner, who bequeathed it to the late George S. Hillard, who in turn bequeathed it to Mrs. Eliza S. Rogers, his cousin.

CUNNINGHAM, MRS.

Her portrait is owned by her son, Dr. Edward L. Cunningham, who has it at his residence, Newport, R. I.

CURTIS, ———.

CUSHING, MRS. THOMAS, b. 1792, d. 1872.

Her maiden name was Eliza Constantia Watson, daughter of Colonel Marston Watson, an eminent merchant in his day, and a Revolutionary officer of Plymouth origin. He removed from Marblehead to Boston, prior to 1800. The above portrait was painted about 1814 or 16, soon after Mrs. Cushing's marriage. It is that of a handsome young woman, in the full flush of health, and in the costume of the period. It is now in the possession of her granddaughter, Mrs. J. L. Chickering, 54 Chestnut street, Boston.

† CUSTIS, G. W. PARKE.

CUTTS, MR. AND MRS. RICHARD.

These portraits are numbered among the finest of Stuart's works. Mrs. Cutts's maiden name was Ann Payne, sister of Mrs. Madison, and she was married in 1804. In the drapery of her portrait, Stuart drew his own profile, blending it in so quietly that no one would ever notice it, if his attention were not called to it. The pictures were painted in Washington, and before leaving that city, Stuart wrote a note to Mrs. Cutts, thanking her for some service, and alluding pleasantly to her portrait and his profile. These pictures

have been frequently loaned to artists, who have desired to make a study of Stuart's coloring. They are owned by Colonel Richard D. Cutts, Washington.

* DABNEY, MRS. CHARLES W.

Her maiden name was Frances Alsop Pomeroy. Her portrait was painted in 1819. The same year she was married at Brighton (then near to, but now a part of, Boston), to Charles W. Dabney, of Fayal, Azores, to which place she went to reside with her husband. There she died in 1826. The portrait is still at Fayal.

† DALLAS, MR. AND MRS. ALEXANDER JAMES.

There is an impression that the portrait of Mr. Dallas was painted at Philadelphia, prior to his appointment as Secretary of the Treasury. He was born at Jamaica, 1759, and died in 1817. The portrait of Mrs. Dallas is that of a beautiful woman.

Both of these portraits were given by Mr. Dallas to his eldest daughter, Mrs. Sophia Bache, who left that of Mr. Dallas to her son, Alexander Dallas Bache; and by him it was given to Mrs. Matilda W. Emery, wife of Major-General Emery, U. S. A., of Washington, as a memento. The portrait of Mrs. Dallas became the property of Mrs. Irwin, sister of Mrs. Emery, and is now at her residence, 1834 Spruce street, Philadelphia. They are both fine pictures.

* DANFORTH, DOCTOR, b. 1739, d. November 16th, 1817.

His portrait, painted about 1809, is said to be a striking likeness. It is owned by his granddaughter, Miss Elizabeth S. Danforth, Boston.

DASCHKOFF, COUNT AND WIFE.

He is said to have been the first Minister sent to the United States by the Emperor of Russia, and arrived in 1809. He was cordially received by the President, and much attention was paid him and Madame Daschkoff in Philadelphia. But his stay in this country was attended with some unpleasant circumstances, and he was recalled in 1819. When he returned to Russia, he probably took the pictures with him.

* DAVIS, GENERAL AMASA.

He was an officer of the Revolution, and his portrait is now in the possession of Mr. Ernest Lemist, of Roxbury, Mass.

DAVIS, WILLIAM.

* DAVIS, MRS. ELEANOR, d. 1825.

Mrs. Davis became the wife of Mr. John Derby. Her portrait, painted prior to 1820, is owned by her grandson, Dr. G. C. Shattuck, Boston.

* DAVIS, MRS. I. P.

She was the daughter of Dr. Jackson, of Philadelphia, and Susan Kemper Jackson, his wife, a sister of S. Kemper Morton. The late eminent Dr. Jackson, of Philadelphia, was her brother. Her portrait, with that of her sister, Mary Jackson, who became

Mrs. Bernard Henry, are on one canvas. These portraits, though unfinished, are very beautiful. Mary Jackson was celebrated for her beauty, and mention is made of her in one of Mr. Twing's letters, published in his memoirs. This picture is owned by Mrs. F. O. Prince, a daughter of Mrs. Henry, Beacon street, Boston.

Mr. Davis was an intimate friend of Stuart's. The artist painted the portraits of these ladies more than once, but always felt that he had not done them justice. At one time he painted a portrait of Mrs. Davis engaged in painting a portrait of Mrs. Henry; but not being satisfied with it, he cut out the head of Mrs. Henry, which was framed by itself. At another time he painted her with her son, an infant; but this picture he also destroyed.

* DAVIS, MR. AND MRS. CHARLES.

Their portraits, painted in 1808 or '9, are owned by Mr. Thomas Motley, Woodland Hill, Jamaica Plain.

DAVIS, MR. AND MRS. MORTON.

Owned by their daughter, Mrs. George Bancroft, Washington, D. C.

DAVY, J. BROWNE.

This portrait, evidently painted by Stuart, was purchased some years ago, at an auction, by the present owner, Mr. H. H. Furness, of 222 Washington Square, Philadelphia. It has the appearance of having been the portrait of some young English officer. The name of the sitter is on the back of the picture,

* DAWES, COLONEL THOMAS, b. Aug. 5th, 1731, d. Jan'y. 2d, 1809.
* DAWES, JUDGE THOMAS, b. July 8th, 1758, d. July 21st, 1825.

Judge Dawes, who married Margaret, daughter of William Greenleaf and granddaughter of Rev. Samuel Greenleaf, was a Judge of the Supreme Court of Massachusetts from 1792 to 1802, and later filled the office of Probate Judge for Suffolk County. After his death, the portraits of Judge and Colonel Dawes were left in charge of Mrs. James Hayward, of Roxbury, youngest daughter of Judge Dawes, till about 1844, when, by a family arrangement, they became the property of the late Thomas Dawes Eliot, of New Bedford, grandson of Judge Dawes. They are still in what was his house, and are in the possession of Mrs. Eliot, his widow. Both pictures are in excellent condition, and they were probably painted at one time.

* DEARBORN, MAJOR-GENERAL HENRY, U. S. A., b. 1751, d. 1829.

General Dearborn was a distinguished officer of the Revolution. He served with honor at Bunker Hill, Ticonderoga, Monmouth, Yorktown, and on other important fields. In 1801, he was appointed Secretary of War, and served through both terms of President Jefferson's administration. In 1812, he received the appointment of Major-General, and in 1822 he was sent as Minister to Portugal. During his residence in that city, he and other foreign Ministers were instrumental in saving the King and his Court from a conspiracy of the Queen and her son, Don Miguel. As an expression of his gratitude, the King conferred orders of distinction upon all the foreign Ministers, except General Dearborn, who, by the laws of his country, could not receive a favor of this kind. The King, not willing to let such services pass unrecognized,

presented him with his own miniature, set with large diamonds. This miniature, with a portrait of General Dearborn, by Stuart, is in the possession of his great-granddaughter, Mrs. Winthrop G. Ray, 57 Clinton Place, New-York.

Another portrait of General Dearborn, painted by Stuart, is owned by his grandson, Mr. H. G. R. Dearborn, 33 Bartlett street, Roxbury. This fine portrait was painted in 1812, and represents the General in the uniform of his rank. This is the original picture. It has been copied five times and by different artists,—Stuart, Joseph Cole, Brackett and Tenny. That by Stuart is the one above mentioned, owned by Mrs. Ray. That by Cole was made at the request of Colonel Joshua Howard, of Dearbornville, Michigan. Brackett's was for the War Department, Washington. Tenny's was for the State-house, Concord, Mass. The fifth, in the Boston Museum, was probably by Greenleaf, formerly proprietor of the New England Museum.

Another portrait of General Dearborn is owned by Mr. Herbert Welsh, 927 Clinton street, Philadelphia. It was formerly the property of John Neagle, the artist, who was a pupil of Stuart's. This picture he valued highly, and kept it by him in his studio. At his death it descended to his son, Mr. Garrett Neagle, who disposed of it to Hon. John Welsh, who in turn gave it to his son, the present owner. It is painted on a panel, and on the back, in Mr. Neagle's hand, are these words: "Portrait of Maj. Gen. Henry Dearborn, by G. Stuart." It represents a large, fleshy-faced, but fine-looking, man, with short gray hair coming nearly to a point on the crown of the head, blue eyes, without high lights, looking at the spectator with a quiet, kindly expression. The mouth is painted as only an artist of the highest order could paint it, with a faint smile lurking around the corners, giving the idea that the figure is about to speak in reply to some remark that has been made. The coat, rich in color, is a brownish black, and on the breast hangs the order of the Cincinnati.

* DEARBORN, GENERAL H. A. S.

He was a son of the Major-General, and was Collector of the Port of Boston and Adjutant-General of the State of Massachusetts. His portrait, painted about 1812, is owned by his son, Mr. H. G. R. Dearborn, Roxbury.

The portrait of Mrs. Dearborn, which was also painted by Stuart, is in the possession of Hon. A. W. H. Clapp, of Portland, Maine.

† DECATUR, COMMODORE AND WIFE.

The portrait of Commodore Decatur was presented to the Lyceum of the Brooklyn Navy-Yard by Stephen Price, Esq. In an old newspaper, the following was found: " Married, at Norfolk, March 8th, 1806, the gallant Stephen Decatur, Jun., of the U. S. Navy, to the accomplished and much-admired Miss Susannah Wheeler, only daughter of Luke Wheeler, Esq., of this Borough." The portrait of Mrs. Decatur is owned by Mr. Charles Wilmer, Baltimore.

DELANO, MR. AND MRS. ABISHA.

They were natives of Nantucket. Mr. Delano was born on that island, July 24th, 1763, and died at Charlestown, December 26th, 1830. Mrs. Delano, whose maiden name was Eliza Hammatt, was also born on Nantucket, April 1st, 1779, and died at Charlestown, February 4th, 1858. Their portraits, which are fine, were painted for their son-in-law, Samuel G. Williams. At his death they became the property of his widow, who died in 1878. They are now owned by their grandson, Mr. W. Roscoe Williams, Boston.

* DENNIE, MR. AND MRS. THOMAS.

Their portraits are in the possession of their son, Mr. James Dennie, Pinckney street, Boston.

* DERBY, JOHN.

This portrait was painted before 1812. He was the great-uncle of the present owner, Dr. G. C. Shattuck, of Boston, Mass. The likeness has always been thought a good one.

DERBY, MRS. RICHARD M.

She was Miss Coffin, daughter of Dr. Nathaniel Foster Coffin, of Portland, Maine, and her portrait is now owned by Mrs. Dr. Perry, 113 Madison Avenue, N. Y.

DEVEREUX, MR. AND MRS. HUMPHREY.

These portraits remained in Stuart's studio a long time, waiting to be finished. They were finally sent home in 1821. That of Mr. Devereux, who died in 1867, aged 88 years, shows a strong, manly face. Mrs. Devereux, who was the daughter of Israel Dodge, and who died in 1828, aged 43 years, was in delicate health at the time she was painted. She was then about thirty-five years of age. Stuart, in painting her portrait, was able to give it the bloom of health without impairing the likeness. The hair is short, as it was frequently worn at that time, and around the throat there is a deep ruff. The head is beautifully painted, but the rest of the picture, as was often the case with Stuart, was treated indifferently. Mrs. Dev-

ereux would have asked the artist to make some change in the drapery, but while casting in her mind how to introduce the subject in a manner that would be least annoying, a lady called to make a similar request. Stuart immediately replied that he was "not a milliner." Mrs. Devereux at once decided that she had rather leave her portrait, the head of which was all that she could desire, as it was, than run the risk of losing it altogether by irritating the painter. It is now the property of her daughter, Mrs. Marianne C. D. Silsbee, Milton, Mass.

D'WOLF, CHARLES.

His portrait is in the possession of Mrs. William Bradford D'Wolf, Bristol, R. I.

* DEXTER, MR. AND MRS. ANDREW.

They resided in Mobile. The portrait of Mr. Dexter was at one time sent to Doll & Richards for sale, and by them disposed of to Mr. B. C. Porter, of the Artist Studio Building, Boston, who now has it. A search for the portrait of Mrs. Dexter has not been successful.

* DEXTER, SAMUEL, d. 1816, aged 55 years.

His portrait, painted prior to 1819, is owned by Mrs. Franklin Dexter, Beverly, Mass.

DEXTER, MISS MAHITABLE.

The daughter of Knight Dexter, who kept the "Public House" in Providence during the Revolution, and sister to Knight Dexter,

whose name is associated with the Asylum in that city. The picture has been in the family sixty years. There is no positive proof that it was by Stuart, but it has many qualities that lead to this conclusion. It is owned by Mrs. Dorcas B. Greene, Warwick, R. I.

DICK, LADY.

Her portrait was painted in Dublin.

* DOGGETT, MR. AND MRS. SAMUEL.

He was a descendant of Thomas Doggett, of Marshfield (1664), born October 5th, 1751. Served as Lieutenant in Colonel Henry Knox's regiment of artillery in 1776, and then as First Lieutenant of the Suffolk Militia in the Revolution. Mrs. Doggett, whose maiden name was Elizabeth Badlam, was born December 20th, 1753, and died December 22d, 1832. They were married June 1st, 1777, and made their home in Dedham. Their portraits, painted in 1815, are now the property of Mr. Jonathan Cobb, of Dedham. Mrs. Cobb is a granddaughter of Mr. and Mrs. Doggett. Both the portraits are said to be excellent likenesses.

DORR, MRS. SULLIVAN.

* DORSEY, MRS. HAMMOND.

Her maiden name was Elizabeth Pickering. She was the daughter of Colonel Timothy Pickering. The portrait was painted for her brother, the late Henry Pickering, and is now owned by her daughter, Mrs. Thomas Donaldson, of Baltimore.

DUANE, COLONEL WILLIAM, b. 1760, d. 1835.

He was an active politician at a time when the strife between the Federalists and Democrats knew no bounds, and in the turmoil of that day, Colonel Duane found a field for the display of his talents, as editor of *The Aurora.* His portrait, owned by his granddaughter, Miss Duane, is deposited in the Academy of Fine Arts, Philadelphia.

* DUNN, COUNSELLOR.

He was an Irish gentleman who came to this country partly, perhaps wholly, to study the Indian languages. He was here about the time Stuart painted the Washington portraits, and remained in the United States about three years. His portrait, by Stuart, he gave to Mrs. Perez Morton, whose husband for many years was Attorney-General of Massachusetts. After the death of Stuart, the picture was bought of Mrs. Morton, or of her family, by Mr. George W. Brimmer, of Boston, who paid $150 for it. It is now in the possession of Mr. Brimmer's nephew, Mr. Martin Brimmer. Mr. Dunn is represented as a man about forty years of age.

There are two of these portraits of Counsellor Dunn. The first painted, Stuart would never part with, and it is now in the possession of Miss Stuart. Stuart said of his portrait of Dunn, that he was willing to stake his reputation as an artist upon its merits.

* DUNN, MR. AND MRS. S.

Their portraits are owned by Mrs. Burgess, wife of Rev. Thomas Burgess, and are now at St. Luke's Rectory, St. Albans, Vt. The maiden name of Mrs. Dunn was Cutler.

* Dunn, Mrs.

Durant, Miss.

She was a beautiful West Indian, and married Andrew Ritchie. After the death of Mr. Ritchie the portrait was given to Hon. James T. Austin, his intimate friend and classmate, who in turn gave it to his son-in-law, Dr. G. H. Lyman, of Boston, who now has it in his possession.

* Dutton, F. L.

This is one of the very few pictures by Stuart in which there is any departure from the strict line of portraiture. It is a picture of a lad in a garden, chasing a butterfly, with morning-glories twining over his head. It is known as the "Boy and Butterfly," and is owned by Mrs. Henry D. Dalton, a niece of F. L. Dutton.

* Dwight, Mrs. Edmund, b. 1788, d. 1846.

Her maiden name was Mary Harrison Eliot, eldest daughter of Samuel Eliot, of Boston. She was married in 1809, and in the winter of 1808–9 her portrait was painted. It is now in the possession of her daughter, Mrs. Wells, widow of the late Judge John Wells.

* Dwight, Mrs. John.

* † D'Yrujo, the Marquis and Marchioness.

Sally McKean, daughter of Chief-Justice McKean, became the very beautiful wife of Don Carlos Martinez, Marquis D'Yrujo, the

Spanish Minister, who was received at Philadelphia in 1796. This picture, engraved as one of the illustrations of "The Republican Court," is owned by Mr. Pratt McKean, of Philadelphia. The portrait of the Marquis is also owned by Mr. McKean.

* ELIOT, MR. AND MRS. SAMUEL.

He was born in 1740, and died in 1820. These portraits were painted soon after Stuart's arrival in Boston, and are now in the possession of President Eliot, who has them at his house in Cambridge. Mrs. Eliot, whose maiden name was Catharine Atkins, died in 1829.

ELIOT, SAMUEL A., b. 1798, and d. 1862.

His portrait, painted in 1817 or 1818, is now in the possession of Mrs. A. Norton, Cambridge, Mass.

* ELLERY, JOHN STEVENS, b. July 29th, 1773.

His portrait was painted in 1810 for his sister, Mrs. Sargent. It is now owned by his nephew, Mr. Ignatius Sargent, Brookline, Mass.

* ELLIOT, JAMES HENDERSON.

A superb portrait, owned by his niece, Mrs. Spooner, of Boston.

† ERSKINE, LORD AND LADY.

These portraits belong to the heirs of the late John Cadwalader,

of Philadelphia. Hon. John Cadwalader was the nephew of Lady Erskine. There is another portrait of Lady Erskine, by Stuart, owned by the family in England. It has been engraved.

* EUSTAPHIEVE, MR. AND MRS. ALEXIS.

He died in New-York, in 1857, aged about 82 years, and Mrs. Eustaphieve died in the same city in 1853, aged 64 years. She was of English birth, and noted for her beauty. The portraits are in excellent condition, and are much admired. They are owned by their son, Mr. A. A. Eustaphieve, of Buffalo, New-York.

* EVERETT, EDWARD.

The head is alone finished, and it now hangs on the wall of one of the rooms of the Massachusetts Historical Society.

Stuart left another unfinished head of Mr. Everett, dressed in the robes of a clergyman, and after his death some one finished it. The head alone was the work of Stuart. It is now owned by Mrs. Everett's family.

* FALES, SAMUEL, of Boston, b. August 23d, 1775, d. August, 1848.

The portrait was painted in 1806. Mr. Fales took some friends to see it while it was still in the artist's studio, to get their opinion of it. When they had gathered in front of the picture, Stuart asked, in a jocose way, whether they thought it a good likeness of "the Great Mogul," as he facetiously styled his sitter. The verdict was most satisfactory, and Stuart, as he cleaned his brushes and laid down his palette, said there was nothing more to be done to it.

The picture, as bright and fresh, apparently, as when first painted, is owned by his son, Mr. Samuel Bradford Fales, 707 Vine street, Philadelphia.

FARNHAM, LORD.

His portrait was painted in Dublin.

FITZGERALD, LORD, b. 1763.

His portrait was painted in Dublin. In 1784 he had a seat in the Irish Parliament, and in 1798 he died in prison, where he was confined for treason.

FITZGIBBON, LORD, b. 1749, d. 1802.

He was Lord Chancellor of Ireland. The portrait, a whole length, was painted in Dublin.

FLUKE, COUNT.

He was a Russian gentleman.

FORREST, EDWIN.

This portrait, painted at the close of the artist's life, when his eye was dim and his hand had but little control over the brush, is but an indifferent specimen of Stuart's work. It has a place in the Forrest Gallery.

FORRESTER, MRS. JOHN.

Her portrait is owned by her daughter, Miss Forrester, 9 Oliver street, Salem. Mrs. Forrester was a sister of Chief-Justice Story.

FRANCIS, MRS.

She was Dolly Willing, daughter of Thomas Willing, and is represented as a beautiful girl, holding a small dog in her arms. The portrait is owned by her granddaughters, Misses Willing.

FRANK, COLONEL.

Owned by Mr. George W. Huffugle, New Hope, Bucks County, Pa., who holds Stuart's certificate.

* FREEMAN, REV. JAMES, D. D., b. April 22d, 1759, d. Nov. 4th, 1835.

He was a classmate at Harvard with Dr. Bently, Judge Dawes, and Rufus King, and graduated in 1779. In 1782 he was invited to act as reader at King's Chapel, Boston, and was ordained as pastor in 1787, a connection that was not severed till he resigned his charge in 1825. His portrait, which belongs to Mrs. Colonel William E. Prince, of Newport, R. I., is hanging in the house of her sister, Mrs. Sweet, 63 Beacon street, Boston.

† GANSEVOORT, GENERAL PETER.

He was an officer of the Revolution, and his portrait, by Stuart, is owned by his daughter, Mrs. Catharine Gansevoort Lansing, Albany, N. Y.

* GARDINER, REV. JOHN SYLVESTER JOHN, b. 1775, d. 1830.

There are two portraits of Dr. Gardiner, who was born in South Wales: the first, at the age of forty, hangs in the library of his son, Rev. W. H. Gardiner, Brookline, Mass., and the other, painted about twenty years later, is owned by his grandson, Mr. John Gardiner Cushing, who has it at his residence in Boston. Both pictures are good likenesses. Dr. Gardiner came from the line of Gardiners of Narragansett, the birthplace of Stuart. William, who was his great-grandfather, one of the early settlers, died there in 1732. Sylvester Gardiner, his grandfather, was a skillful physician and surgeon, having been educated for his profession in England. John, his father, was also sent to England, to be educated. He married in South Wales, and there the subject of this sketch was born.

Dr. Gardiner was educated in Boston, but had the advantage of a visit to England, where he became the pupil of Dr. Parr. When he returned he was called to Trinity Church, Boston, and was the Rector of that Parish up to the time of his death in 1830. He was an accomplished and eloquent divine, and a fine classical scholar.

* GARDNER, MRS. SAMUEL P., b. May 17th, 1779, d. May 11th, 1853.

Her maiden name was Rebecca Russell Lowell, daughter of John Lowell, Judge of the United States Circuit Court. Her por-

General Gates

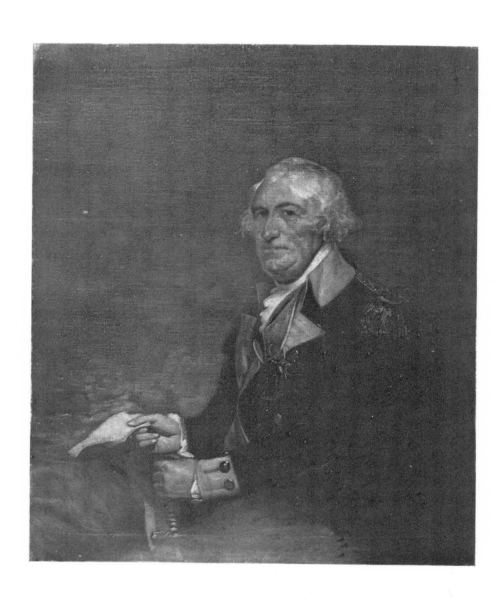

trait, painted about 1810, shows her to have been thirty or thirty-five years of age at the time that it was painted. It is owned by her daughter, Mrs. John C. Gray, Boston.

GATLIFF, SAMUEL.

He was an Englishman, and the first husband of Mrs. Elizabeth Griffin, whose portrait is mentioned under its proper head. His portrait is owned by Miss Cornelia E. Taylor, of Philadelphia, and was painted between the years 1796 and 1800.

† GATES, GENERAL HORATIO, b. in England, 1728, d. 1808.

This is one of the most remarkable of the Stuart portraits for power, strength and individuality. After the death of General Gates it passed into the possession of the late Horatio Gates Stevens, and from him it descended to his son, Mr. John R. Stevens, of New-York, the present owner. It is a superb work of art, and though the colors are somewhat darkened, making the task of photographing it one of unusual difficulty, it has been chosen for reproduction here because of its representative character.

GEORGE III.

Stuart, while a pupil with West, painted a portrait of the King. Mention has already been made of this picture. The following anecdote connected with it, and which has never appeared in print, was told by Stuart himself, who, after working at the picture for some time, was quite dissatisfied with the mouth. His efforts to improve it were not successful, and at last, in anger, or through impetuosity,

he made a pass at it with his brush, intending to paint out the mouth, but the brush, by a happy coincidence, gave such a turn to the outline as exactly met the wants of the painter, who, seeing the unexpected result of his impatient blow, jumped up and down before the King, exclaiming, "I 've got it, your Majesty!" "Got what?" "Your mouth, your Majesty." At which there was a great laugh, at Stuart's expense.

George IV.

His portrait, while Prince of Wales, was also painted by Stuart.

* Gerry, Elbridge, d. 1867.
* Gerry, Thomas Russell, U. S. N., d. 1846.
Gerry, James Thompson, U. S. N.

James was lost at sea, in the sloop-of-war "Albany," which vessel he commanded. These portraits are owned by their sisters, Misses Gerry, 127 Temple street, New Haven. They cannot be classed with Stuart's best works.

Gibbs, George, b. 1734, d. October, 1803.

He was a successful merchant, at Newport, R. I., and was at the head of the house of Gibbs & Channing. Mrs. Gibbs also sat to Stuart. She was Miss Ruth Channing, and was painted in her widow's weeds, between the years 1803 and 1820, in which latter year she died. These portraits, numbered among the finest that Stuart ever painted, are owned by Professor Wolcott Gibbs, Cambridge.

GIBBS, COLONEL GEORGE, b. 1780, d. 1853.

His portrait, also on a panel, was painted between 1825 and 1830, is owned by his son, Professor Wolcott Gibbs. It is a very fine picture. A very valuable collection of minerals, now owned by Yale College, was made by Colonel Gibbs, and was purchased by that institution in 1825.

GILES, COLONEL.

GILES, GOVERNOR WILLIAM B., b. 1762, d. 1830.

In a letter, under date of March 30th, 1866, Hugh Blair Grigsby, LL. D., of Edge Hill, near Charlotte Court House, Va., addressed to the Massachusetts Historical Society, the writer states that he was so fortunate as to become the purchaser of Stuart's portrait of Governor Giles, painted prior to 1795, and which represents him as a very handsome man. Mr. Grigsby adds: "I knew him personally as far back as forty years ago, when he was one of the *homeliest* men I ever saw. His health was bad for many years before he died."

GILMOR, ROBERT.

Owned by Mr. W. G. Hoffman, Baltimore, Md.

GOLDSBOROUGH, MRS., *née* WILHELMINA SMITH.

This picture is somewhere in Maryland.

GORE, MRS. JOHN.

Her maiden name was Mary Babcock, daughter of Adam Babcock, of Boston. She was very beautiful. At the time that she sat to Stuart she was dressed in a riding habit, buttoned high in the throat. Her neck was altogether too handsome in the eyes of the artist to be covered up, and at his request, she opened the throat of her habit; but he, not content with this, and using an artist's license, painted her with a low-cut waist, much after the style of many of his pictures. Some time after completing the picture, he met her on the road, riding, when he stopped and said: " Mrs. Gore, my portrait of you is not half handsome enough, I wish you would sit to me again."

This striking portrait is in the possession of Mrs. Horatio Greenough, Cambridge. Mrs. Gore, later in life, became Mrs. Joseph Russell, of Boston.

GOUVERNEUR, ISAAC.

Stuart made two sketches of his head, but they did not satisfy him and he rubbed them out. While he was doing this Mr. Gouverneur took a pinch of snuff. " Stop," said Stuart, " and stay as you are." He then sketched him with his snuff-box in hand, and he is so represented in the portrait, which belonged to the late Gouverneur Kemble, who bequeathed it to Mr. Gouverneur Paulding, of Cold Spring, Putnam County, N. Y.

* GRAFTON, MR. AND MRS. JOSEPH.

Their portraits are in the possession of their daughter, Mrs. Charles H. Minot, 1 Berkeley street, Boston, but are owned by

Mr. Joseph Grafton, who is now in Europe. Major Grafton, born in Salem, May 11th, 1782, and died March 24th, 1857, entered the army in the war of 1812 as Major, joined the 21st regiment on the Canadian frontier, and took part in several battles during the war. He was complimented in general orders, and received many other testimonials to his military character. Mrs. Grafton, whose maiden name was Ann Maria Gurley, granddaughter of William Stackpole, was born in 1800, married at sixteen, and died in June, 1850. At the time of her marriage she was a reigning belle, and was accounted one of the most beautiful girls in New England. Her portrait was painted in 1818 or '19.

* GRANT, MR. AND MRS. PATRICK.

Their portraits were painted about 1810—certainly earlier than 1812, in which year Mr. Grant was lost at sea, on board a Baltimore clipper, which foundered. Mrs. Grant was a daughter of Jonathan Mason, and died in 1861. Their portraits are owned by their son, Mr. Patrick Grant, Boston.

W. GRANT.

In the month of January, 1878, there was an exhibition of "Pictures by the Old Masters," at the Royal Academy, London. No. 128, in Gallery 111, was entered as "A Portrait of W. Grant, Esq., Congalton, Skating in St. James' Park, Thomas Gainsborough, R. A. (?)": the interrogation point showing very clearly there was some doubt in the mind of those who made the catalogue, as to the propriety of attributing the picture to Gainsborough. The exhibition had hardly opened before attention was called to this superb picture, and in the papers of the day there was much dis-

cussion as to who was really the painter, for but few believed that it was by Gainsborough. *The Saturday Review* said, January 12th: "The query is certainly pertinent, for, while it is difficult to believe that we do not recognize Gainsborough's hand in the graceful and silvery look of the landscape in the background, it is not easy to reconcile the flesh tones of the portrait itself with any preconceived notions of Gainsborough's workmanship. The face has a peculiar firmness and decision in drawing and painting which remind one rather of Raeburn than of Gainsborough, though we do not mean by this to suggest in any way that Gainsborough wanted decision in either painting or drawing, when he chose to exercise it."

The following is from the *London Illustrated News* of January 19th :

"Another portrait, about whose authorship there is much doubt, is that of W. Grant, of Congalton, skating in St. James' Park. In the catalogue it is attributed to Gainsborough, but with a very suitable mark of interrogation after the name. That it is a magnificent picture, magnificently painted, is patent to all eyes; but there is too much masterly solidity about it—the modeling of the face,—and of the whole figure for that matter—for Gainsborough's hand; moreover, the costume is of a later period than his time, and the name of the portrait does not occur in his works. One of our weekly contemporaries assigns it to Romney, but the same objection holds good. Besides, Lady Hamilton's adorer could never have painted so complete and finished a work as this, only to commemorate the face and form of a private person. He would have wearied of the task long before it was half done. The only man, in our opinion, who was capable of painting this grand picture, and whose period of art activity would coincide with the costume worn, was Sir Henry Raeburn. It possesses, from hand to foot, all his solid modeling and fine handling, and, although there is a look of Gainsborough in the background, the landscape is too

vigorous in its leading lines and general suggestions to have come from his dainty hand."

Under date of March 22d, Somerset House, London, Miss Stuart received a letter from Mr. Mulgrave Phipps Jackson, son of the late John Jackson, R. A., from which I am permitted to make the following extract:

"A discussion has arisen in the British press as to the artist who painted a very finely painted whole length portrait of Mr. Grant, of Congalton, *represented skating on the ornamental waters in St. James' Park.*

"The picture has been variously assigned to Sir Martin Archer Shee, Raeburn, and others, as its author, but I, on the authority of a letter I have received from the grandson of the Mr. Grant, the original of the portrait, have stated it is by *the* great portrait painter of America, Gilbert Stuart. Can you kindly assist me to the facts? And if you can add any particulars as to the artist, who, I am informed was your father, and of whom we know but too little in this country, I should be most grateful."

To this note Miss Stuart replied, and in return received the following from Mr. Jackson:

"My dear Madam:—Permit me to assure you that I feel extremely obliged to you for so kindly answering my enquiry as to the 'Skating Portrait,' and in so very interesting a manner.

"I was somewhat pledged, having stated in the newspapers that the work was by your father, when subsequently a letter appeared in the *Times* newspaper, from Mr. Graves, the well-known printseller, saying positively the portrait was by the late Sir Martin Arthur Shee.

"The son of Sir Martin I know personally, and on my applying to him he told me he could give no information.

"I received my intelligence in the matter from the uncle of Mr. Charles A. Grant, who is a grandson of the Mr. Grant in the picture, himself a promising young (American) artist.

"I knew the instant I saw the portrait it was not by Gainsborough, whose name was given in the Royal Academy as the artist, it being far more solid and sound in execution than the works of even that great master. Nor was it in the least in the manner of Raeburn, to whom also it was attributed by the more learned connoisseurs."
The above portrait is owned by Lord Charles Pelham Clinton.

GRATZ, MRS. MICHAEL.

Her portrait, painted by Stuart, in 1802, is now in the possession of Mr. Benjamin Gratz, Lexington, Ky., who is also the owner of a portrait of Mr. Gratz, painted by Sully. Mr. Benjamin Gratz has reached the ripe age of ninety years.

* GRAY, MR. AND MRS. WILLIAM.

The portrait of Mr. Gray, who died November 3d, 1825, aged 75 years, was painted in 1807, and is owned by Mr. William Gray, of Boston, and that of Mrs. Gray, who died September 29th, 1823, at the age of 67, and whose maiden name was Elizabeth Chipman, is in the possession of Mr. John C. Gray, of that city.

* GRAY, WILLIAM R., d. July 28th, 1831, aged 48 years.

His portrait is owned by Mr. William Gray, Boston.

GRAY, JOHN C.

His portrait, painted at near the close of Stuart's life, is in his possession.

GREENLEAF, MRS. JAMES.

She was the daughter of Chief-Justice Allen. In her portrait she is dressed in white, with a light-blue sash. It belonged to the late J. Gillingham Fell, Philadelphia, who also owned a "portrait of a gentleman," by Stuart, painted with great freedom, and very rich in color.

GREENLEAF, JAMES. 24 × 30.

Faces to the left. This picture was painted in 1795, and is a perfect gem of modeling and color, in Stuart's purest manner. It represents a remarkably handsome man, with hair powdered and tied in a cue. He is dressed in a tightly-buttoned double-breasted blue coat, with gilt buttons, large white neckerchief and ruffled shirt. The background is a rich crimson curtain, festooned to show in the distance the blue and cloud-flaked sky. Nothing finer as a work of art ever proceeded from Stuart's easel.

Mr. Greenleaf was born in Boston, June 9th, 1765, and was one of fifteen children of the Hon. William and Mary Brown Greenleaf. He was appointed, very early in life, Consul of the United States to Amsterdam, where he amassed a large fortune, and married Antonia Cornelia Elbertine Scoten, by whom he had one son, and from whom he was subsequently divorced. Returning to this country, in 1795, he embarked in speculations with Robert Morris and John Nicholson, and became, with them, one of the founders of the celebrated North American Land Company, which resulted in the ruination of its originators. Afterwards he took up his residence in the District of Columbia, and died in the city of Washington, September 17, 1843, in his seventy-ninth year.

Mr. Greenleaf married, April 26, 1800, Ann Penn Allen, daughter of James Allen, the founder of Allentown, Pa., and son of William

Allen, Chief-Justice of the Province before the Revolution. Her mother was Elizabeth Lawrence, a granddaughter of the distinguished Tench Francis, the uncle of Sir Philip Francis, the accredited author of JUNIUS. Mrs. Greenleaf's portrait, by Stuart, is also a beautiful picture, of which there were three painted — the original being in the possession of her daughter, Mrs. Thompson Livingston, of Paris; the second belongs to the estate of the late J. G. Fell, Philadelphia, and the third is owned by Bishop Kep, of California.

The portrait of Mr. Greenleaf is owned by his daughter, Mrs. Walter Livingston, of Philadelphia.　　　　C. H. H.

GREENOUGH, DAVID S.

His portrait is in the possession of Mrs. David S. Greenough, the widow of his son. A duplicate is owned by Mr. Richard Greenough, and is at present stored in Newport, R. I.

GRIFFIN, COLONEL SAMUEL.

He was an officer of the Revolution, and a brother of Cyrus Griffin, the last President of the Continental Congress. The picture is owned by Miss C. F. Taylor, Philadelphia.

GRIFFIN, ELIZABETH.

She was the daughter of Colonel Samuel Griffin, and is represented as holding her daughter, a lovely babe, in her arms. It is the property of her granddaughter, Miss C. F. Taylor, Philadelphia.

GRIFFITH, MR. AND MRS. R. M. EGLESFIELD.

Their portraits were painted in 1800, and are the property of their daughter, Mrs. Edward Coleman, Philadelphia. That of Mrs. Griffith is very beautiful, and the coloring in both pictures is remarkably fine.

* HALE, WILLIAM.

Mr. Hale was a fine specimen of manly beauty. He died in the West Indies at the early age of 26 years, leaving a widow and three children. His portrait descended to his grandson, the late J. D. Parker, Jr., of Boston, and is now in the possession of his widow, at 25 Chestnut street, in that city.

HALL, JOHN, b. 1739, d. 1797.

This portrait of the eminent engraver belonged to the Alderman Boydell collection, and was presented to the National Gallery, London, in 1850, by Messrs. Graves & Co., successors to Alderman Boydell. It is a half-length. In the background may be seen a sketch of " Penn's Treaty with the Indians," which was engraved by Hall.

* HALL, MRS. JOSEPH, JR.

HALLOWELL, ROBERT, OF BOSTON.

His son took the name of Robert Hallowell Gardiner, and the portrait is in the possession of his grandson, Robert Hallowell Gardiner, of Gardiner, Maine.

* HATCH, MATTY.

She was a great beauty, and her appearance on the street is said to have created a sensation. "In her prime," says one who knew her,—Mr. J. Ingersoll Bowditch, the present owner of her portrait,—"she was the 'observed of all observers,' as she gracefully moved down Washington street." One of the old Boston merchants of that day laughingly said that all business was suspended when it was reported that Miss Hatch was coming down the street, and every one in the shop, boys and all, rushed to the door to see her. In her later days she kept a boarding-house, in order to support herself and her aged mother. Dr. Bowditch boarded with her, when in Boston as one of the Governors' Council. "He, like all others who knew her, was fascinated by her dignified deportment, her lady-like manners, her intelligence and queenly form and features." At the time that Dr. Bowditch removed to Boston, she had retired from her occupation with a small sum, barely enough to support her in old age. Dr. Bowditch advised her to buy an annuity with it from the office of which he was actuary, and, until his death, he was her friend and counsellor. A few days before he died he told his son, J. Ingersoll Bowditch, to go to her after he had passed away, and say that his father had told him to take care of her, as he had done. The son was faithful to the trust, and she, in gratitude, gave him the choice between her portrait by Stuart and her miniature by Malbone. He chose the portrait, and it is now at his house, Jamaica Plain.

HARE, ROBERT, SENIOR.

Miss Stuart relates the following anecdote in connection with this picture. When the portrait was finished and ready for delivery,

Mr. Hare offered to pay for it, which Stuart declined, with the remark that it had already been paid for. " Excuse me for contradicting, Mr. Stuart, but it has not, I assure you," said Mr. Hare. The portrait is in the possession of his grandson, Judge Hare, of Philadelphia.

In this portrait the figure is shown almost to the feet. Mr. Hare is seated upon a sofa of a reddish hue, and his form is relieved by a red curtain of a deeper shade. His daughter, a child of six years, dressed in white, is standing by his side. The expression of her face, particularly of the mouth, is fine. Mr. Hare is dressed in a blue coat and pale buff pantaloons. The hair is powdered. The picture is pervaded by a silvery gray tone that is charming.

HARMAN, MRS. THOMAS L.

She was the daughter of Sturgis Gorham, of Barnstable, and at the time of her marriage Mr. Harman was living in New Orleans. The portrait was painted in 1816, during a visit to Boston. It is owned by a son-in-law of Mrs. Harman, now residing in London.

HARRISON, RICHARD.

He was an agent of the Confederation, and represented the American cause in Spain in the Revolution. By General Washington, who valued him as a personal friend, he was made Auditor of the Treasury,—an office that he filled up to the time of Jackson's administration. The portrait is now in the possession of Mr. J. H. E. Coffin, of Washington, D. C., whose wife was a grand-niece of Mr. Harrison, and was adopted by him when she was a child.

HARTIGAN, MRS. BETSEY.

She was the sister of the late Carlisle Pollock, of New-York. The portrait is now in the possession of Commander Edward Terry, U. S. N., to whom it has descended from his grandfather, Mr. Pollock. It was painted in Dublin, Ireland, where Mrs. Hartigan resided at the time. Her husband was an eminent physician of that city.

HAVEN, MR. AND MRS. JOHN.

Their portraits are owned by their son, Mr. George W. Haven, of Portsmouth, N. H., and hang on the wall where they were placed by his father fifty-four years ago. On the frame of Mr. Haven's portrait are these words, in his own hand-writing: "January, 1824. John Haven, aged 57 years." He died in 1849. Mrs. Haven, who was two years younger, died in 1845. These pictures are as fresh in color as they were half a century ago.

HAVEN, NATHANIEL APPLETON, b. July 19th, 1762, d. March 13th, 1861.

Dr. Haven studied medicine, after graduating at Harvard, and served during the Revolution as a surgeon on board an American armed vessel, and was captured and confined for a time on board the Jersey prison-ship. In 1812, he was elected a member of Congress by the Federal party, and was succeeded by Daniel Webster, his life-long friend. His portrait, now in the possession of his granddaughters, Misses Eliza A. and Charlotte M. Haven, of Portsmouth, N. H., shows him to have been a man of about five and forty years at the time that it was painted. John and Nathaniel were brothers.

* HAYWARD, MRS. DR. LEMUEL, b. 1763, d. 1848.

It was stated, in the catalogue of 1828, that this was the last portrait begun and finished by Stuart. At the request of Mrs. Hayward, whose maiden name was Sarah Henshaw, the artist had his name and age and the date put upon the canvas. He said he had never signed his pictures, but he would willingly have this one marked as she desired, and asked Mr. George Brimmer to do it for him, his own hand being too tremulous. It is owned by Mrs. Harriet S. Wyman, of Wayland, Mass.

HAYES, JUDAH.

* HEAD, JOSEPH.

His portrait is owned by Mrs. M. J. Rheer, Freehold, New Jersey.

* HENRY, MRS. BERNARD, b. June 19th, 1789, d. August 14th, 1876.

This portrait, on a panel five and a half inches square, has evidently been cut out of a larger picture. It is nearly full face, turned to the left, and looking over the shoulder, and is the portrait of a young girl of about sixteen. It is in the possession of her son, Morton B. Henry, Esq., who writes: "I have often heard my mother say that Stuart was dissatisfied with the figure, and pleased with the head, which is exquisitely painted, and cut the head out and gave it to her.

Mrs. Henry, whose maiden name was Mary Miller Jackson, was the daughter of Dr. David and Susan [Kemper] Jackson, of Ches-

ter County, Penn. She was one of the "three pocket Venus" mentioned in Salmagundi, and Washington Irving writes to Henry Brevoort, from Philadelphia, March 16th, 1811: "I was out visiting with Ann [Hoffman—Mrs. Charles Nicholas] yesterday, and met that little assemblage of smiles and fascination, Mary Jackson. She was bounding with youth, health, and innocence and good humor. She had a pretty straw hat tied under her chin with a pink ribbon, and looked like some little woodland nymph lured out by Spring and fine weather. God bless her light heart, and grant that it may never know care or sorrow! it 's enough to cure spleen and melancholy only to look at her." Mrs. Henry was a younger sister of Mrs. Isaac P. Davis, of Boston, and of Dr. Samuel Jackson, a renowned physician of Philadelphia. C. H. H.

The above picture is also mentioned with that of her sister Mrs. Davis, on another page.

* HIGGINSON, STEPHEN, d. 1826.

His portrait, painted between the years 1815 and 1818, is owned by Mr. George Higginson, Boston.

HINKLEY, DAVID, d. December 19th, 1825, aged about 58 years.

He was a descendant of Thomas Hinkley, of Barnstable, and for many years a well-known merchant in Boston. Mr. Hinkley married Ann Outram, an English lady, who died soon after giving birth to a daughter.

HINKLEY, ANNE OUTRAM, b. February 18th, 1794.

She was married in Boston, October, 1826, to William Gill Hodgkinson, of Kilton, Nottinghamshire, England, who died in 1871. Mrs.

Hodgkinson, who is now living at Brampton Grange, Hinkleydon, England, has in her possession her portrait by Stuart. She has also the portrait of her father, David Hinkley. They are each a half-length, are full and rich in color, and are in a good state of preservation.

Hoffman, Josiah Ogden.

"A life-size portrait, painted at the beginning of the present century, and now owned by the widow of the late Ogden Hoffman, of New-York.

"Judge Hoffman was the son of Nicholas and Sarah [Ogden] Hoffman, and was born in New-York, April, 1766. He was admitted to the bar in 1786, appointed Attorney General of the State by Governor Clinton in 1795, and in 1800 became Recorder of the City. At the time of his death, January 24th, 1837, he was one of the judges of the Superior Court. He was twice married, his first wife being Mary Colden, a granddaughter of the very eminent Lieutenant-Governor Colden. Of his several children, the second daughter, Matilda, was the heroine of Washington Irving's life. She died in her eighteenth year, when he was only twenty-six; but she never faded from his memory or his heart, and he died half a century later, faithful to his first and only love. Judge Hoffman married, secondly, in 1802, Maria Fenno, daughter of the rampant Federal editor of Philadelphia, John Fenno. By her he had several children, the youngest of whom was the fanciful litterateur, Charles Fenno Hoffman." C. H. H.

Holley, Rev. Horace, LL. D., b. February 13, 1781, d. July, 1827.

Rev. Dr. Holley graduated at Yale, and was ordained in 1805. In 1809, he was called to the Hollis Street Church, in Boston, over

which society he presided ten years. It was while he was in Boston that his portrait was painted. In 1818, having connected himself with the Unitarian Society, he accepted a call, and entered upon his duties as president of the Transylvania Seminary, of 1795, and the Kentucky Academy, established in Virginia in 1780. In 1827 he resigned and went to New Orleans, where he issued the prospectus of a college, to be built in the immediate neighborhood of that city. But his health, already shattered, failing rapidly, he embarked for the north, but died a few days after leaving port. His portrait I have not been able to find.

* HOLKER, MR. AND MRS.

Their portraits are in the possession of their grandson, Mr. Hugh Nelson, who resides at Nilwood, near Winchester, Va.

HOOPER, ROBERT.

He was of Marblehead. This portrait, painted by Stuart, from a small water-color drawing, is now owned by his grandson, Mr. Robert Hooper.

HOOPER, MRS. POLLY.

The daughter of Mrs. C. S. Williams, she became the wife of Dr. C. S. Robbins, and her portrait is now in the possession of her son-in-law, Rev. Charles Robbins, of Boston.

The portraits of Mr. and Mrs. Hooper, with portraits of Mrs. Mary Sumner Williams, John Williams, her son, and Miss Sally Patten, were all painted for Mrs. P. Hooper, and when she became Mrs. R. G. Robbins, she bought the house in which Stuart had

lived for many years on the corner Shawmut Avenue and Washington street, Roxbury. These, with other portraits, hung on the walls of the long hall that led to the studio in which the Stuart portraits were painted.

† HOPKINSON, MR. AND MRS. JOSEPH.

In the portrait of Mrs. Hopkinson there is a piece of paper sliding from the table. On the paper there is a head sketched, said to be that of Stuart. The portraits are owned by Mrs. William Biddle, Philadelphia. Mrs. Hopkinson was the daughter of General Thomas Mifflin.

HOUGHTON, DR.

He was an Irish gentleman from Dublin. His portrait, by Stuart, was at one time owned by Mr. Charles Elliot, who had it from Dr. Houghton's family. Subsequently it found a place in the A. M. Cozzens collection. When that collection was broken up it was sold for $500. Beyond this point I have not been able to learn anything of its history.

* HOWARD, DR. AND MRS. JOHN C.

His portrait, painted after death (he died in 1810, aged 37 years), is owned by his daughter, Mrs. Arthur Pickering, Roxbury. Mrs. Howard's maiden name was Hepsy Clark Swan. Her portrait is owned by Mrs. Charles Stafford, Providence, R. I.

HUGHES, CHRISTOPHER.

This picture is said to be in Canada.

* Hull, General William, U. S. A., b. 1753, d. 1825.

His portrait, painted in 1823, is owned by his granddaughter, Mrs. J. H. Hollock, Savannah, Ga.

*† Hull, Commodore Isaac, U. S. N.

His portrait, painted in 1813 or 1814, is now in the Boston Art Museum.

*† Humphreys, General David, b. 1753, d. Feb. 21, 1818.

A soldier of distinction, and one who was on the staff of General Washington. As a diplomat he was also successful; and for his valor at Yorktown Congress honored him with a vote of thanks, and presented him with a sword.

Hunnewell, Mrs. Jonathan.

For many years before her marriage to Mr. Hunnewell she was the widow of Charles Davis, and as Mrs. Davis the portrait was probably painted. Her portrait is owned by her great-niece, Mrs. Kellogg, Boston. Mrs. Hunnewell was ·a sister of Mrs. Dr. John Bartlett, of Roxbury.

Hunt, Mrs. Jane Bethune.

The date, 1819, and the artist's name, are on the back of the picture, now in the possession of her daughter, Mrs. Maria B. Craig, widow of the late General H. K. Craig, U. S. A.

HURLBUT, REV. JOSEPH.

He was of New London, and his portrait is in that city, in the possession of his daughter.

*INCHES, MISS ELIZABETH, d. 1851.

Her portrait, painted in 1812, is owned by her nephew, Mr. Henderson Inches, Boston.

IZARD, MISS ANN.

Her portrait was painted in New-York, in 1794. She afterwards became Mrs. William Allen Deas. The picture is at the residence of her grandson, Dr. Watts, 49 West 36th street, New-York.

JACKSON, MR. AND MRS.

He was the British Minister, and was known as Copenhagen Jackson. Dunlap relates that West told Jackson when he was leaving England, that he would .find the best portrait painter in the world in America, and that his name was Gilbert Stuart. Judge Hopkinson said he saw the portraits of Mr. and Mrs. Jackson, and that they were admirable. They were probably taken to England.

JACKSON, MRS. MAJOR.

She was Miss Willing, of Philadelphia, and with her sister, Mrs. Bingham, was distinguished for her beauty and accomplishments.

Her portrait has lately come into the possession of the Philadelphia Academy of Fine Arts, having been bequeathed to that institution by the late Ann Jackson.

* JACKSON, GOVERNOR FRANCIS J.

* JACKSON, GENERAL HENRY.

He raised a regiment in 1776, and remained in active service till the close of the Revolution. His portrait is owned by Mr. Henry Winthrop Sargent, of Fishkill, on the Hudson.

JARVIS, REV. SAMUEL FARMER, D. D., b. 1786.

His portrait was painted in Boston, about 1820. It was in Stuart's studio at the time the building took fire, and was somewhat injured by smoke. The family relate the following anecdote, as evidence that the likeness is an excellent one: Mrs. Jarvis was in the studio with her little son, a child of about six years, who wandered around the room. Presently he ran to his mother and hid his face in her lap, crying as he did so, that they had cut off his father's head and he had seen it.

The picture was never finished by Stuart. While he was engaged upon it, Mrs. Jarvis ventured to criticise some of the details, which so annoyed Stuart that he refused to go on with his work. After the death of Stuart, the drapery and hands were finished by his daughter. This portrait was painted for Miss Callahan, one of the Doctor's warm friends, and after his death it was presented by her to his son, Mr. Samuel F. Jarvis, of Windham County, Conn.

John Jay

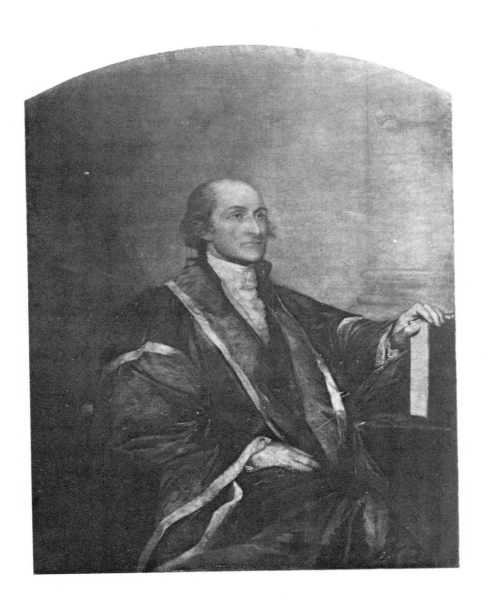

† JAY, JOHN, b. December 12th, 1745, d. May 7th, 1829.

There are a number of portraits of this distinguished man painted by Stuart. The finest, the head of which was painted in England, is owned by Mr. Augustus Jay, who inherited it from his father, Peter Augustus Jay, to whom, as his elder brother, John Clarkson Jay, M. D., already had a portrait of John Jay by Stuart, it was allotted by the family at the decease of Peter A. Jay, in 1843. It was originally given by John Jay to his eldest son, Peter A. Jay. It measures about three by four feet. It was finished in America.

In this portrait, Hon John Jay is seated by a table, one hand resting on a book on the table and the other in his lap. He wears a black silk robe, faced with salmon-colored satin, and having a white edge. The head is bald on the top. Miss Ann Jay, the second daughter, who always lived with him, considered this portrait the best likeness of him ever taken. The present owner has the original robes worn by the Chief-Justice. The previous owner, about the year 1850, displayed them to the members of the United States Supreme Court, who were very much surprised that such robes had ever been worn by any Chief-Justice of the United States. This portrait has been engraved for the United States $20 and $50 bills. It is at present in the house of Mr. Henry E. Pierrepont, No. 1 Pierrepont Place, Brooklyn, N. Y.

A second portrait of Hon. John Jay was given to his youngest son, William Jay, and is now at Bedford, Westchester County, New-York, in the possession of Hon. John Jay, late Minister to Austria, the only son of William Jay. He is seated, dressed in black, with a white cravat and frill, wearing his own hair, which is powdered and tied in a cue. The right hand hangs on the back of a chair and holds a pen, the left rests on a table, on which there are a green cloth, papers, inkstand and books.

This portrait is considered by the family to be the best likeness of all the heads of Mr. Jay that were painted. It was engraved by Cornelius Tiebout, and published at No. 16 Duke street, Portland Chapel, London, April, 1795. From one or two letters we may get at the time these pictures were painted. Mrs. Jay writes to her husband, from New-York, under date of August 2d, 1794:

——"Would you believe that Stuart has not yet sent me your picture? I call upon him often. I have not hesitated telling him that it is in his power to contribute infinitely to my gratification, by indulging me with your portrait; he has at length resumed the pencil, and your nephew [probably Peter J. Munroe] has been sitting with your robe for him; it is now nearly done, and is your very self. It is an *inimitable picture*, and I am all impatient to have it to myself. He begged me to remind you of the promise you made him the day he breakfasted with you. There is an excellent engraver in New-York, and Stuart has been solicited to permit him to copy that portrait of yours by a very respectable number of citizens, for which reason he has asked and obtained my consent."

Mrs. Jay again writes to her husband in England:

"New-York, November 15th, 1794. Just as I had laid aside my pen to take tea, Mr. Stuart arrived with your picture. He insisted on my promising it should be destroyed when he presented me with a better one, which he said he certainly would, if you would be so obliging as to have a mask made for him. In ten days hence he is to go to Philadelphia, to take a likeness of the President. He informed me that Cerrachi and his family are come out to reside at Philadelphia, and have actually been there three months. As Stuart was leaving, Judge Hobart came in, and passed the evening with me."

On the 5th of the following December, Mrs. Jay writes: "Your picture, as I mentioned formerly, is received. It hangs in the dining-room, where the little prints used to hang, and you cannot imagine how much I am gratified in having it."

This last note probably refers to the portrait at Bedford, and not to the one in robes.

The third portrait of Hon. John Jay, by Stuart, is in the possession of John Clarkson Jay, M. D., at the old family place, Rye, Westchester County, New-York, to whom it was given by his father, Peter C. Jay, about 1830. About that time, Trumbull, who had been secretary to John Jay, discovered it in a garret in London. The head was the only part finished. Trumbull put in the details, and Mr. Peter A. Jay sat for the figure.

John Jay and Van Rensselaer, while Governor and Lieutenant-Governor of New-York, exchanged portraits. That of Jay, by Stuart, now belongs to a granddaughter of the Patroon.

* † JEFFERSON, THOMAS, b. April 2d, 1743, d. July 4th, 1826.

There were two sets of portraits of the five first presidents of the United States. One set was in the library in Washington when it was burnt. Three of the portraits were destroyed; the other two, badly injured, are somewhere in Virginia. The other set is owned by Mr. T. Jefferson Coolidge, of Boston. In this set, of course, there is a portrait of President Jefferson. A full-length, similar to the portrait owned by Mr. Coolidge, is now at Edgehill, Albemarle County, Va., the home, during his life, of the late Colonel Thomas J. Randolph, grandson of the President. Originally it was a very fine picture, but it is now badly cracked and defaced. This was once the property of Jefferson, and is probably the original picture.

For many years there hung in the hall at Montécello a profile likeness of Jefferson, life-size, painted by Stuart, in a gray color, on a panel, and in imitation of an antique cameo. This very striking picture, with the date, 1804, upon it, was given to Mr.

Joseph Coolidge, Boston, after the death of Mr. Jefferson, and is now in his house, Beacon street, Boston. In the President's house, at Washington, there is a portrait of Jefferson, by Stuart, but it is not thought equal to other portraits from the same pencil. There is also a portrait of Jefferson, by Stuart, at Bowdoin College, painted for Mr. Bowdoin. In the collection of the New-York Historical Society there is another, which was presented by David Hosack, in 1828; and Mr. Edward Coles, of Philadelphia, owns one, that was painted for his father, Governor Coles.

JOHNSON, DR. SAMUEL WILLIAM, b. 1727, d. 1819.

This portrait was one of the first, if not the first, painted by Stuart after his return from England. It has on the back: "By Stuart, 1792;" and there is a tradition in the family that the artist took great pains with it, as a specimen of his skill after years of study in England. A copy of it was made at one time by a Mr. Graham, who was so unprincipled as to retain the original, and in place of it he sent his copy to the family. The cheat was detected and the original was recovered. The copy was never called for. Mention is made of this in Dr. Beardsley's Life of Dr. Johnson. The original is owned by Mrs. William Bellamy, of Dorchester, Mass., one of Dr. Johnson's descendants. In this portrait he is represented in the scarlet robes of an Oxford Dr. of Civil Law. Dr. Johnson was the first Senator from Connecticut, and President of Columbia College. Columbia, Yale, and Trinity College have each a portrait of him, but I believe the only one by Stuart is that owned by Mrs. Bellamy.

JONES, MRS.

JONES, JUDGE STEPHEN, of Maine.

Owned by Mr. Francis E. Richards, Gardiner, Maine.

KEMBLE, MR. AND MRS. JOHN.

Their portraits were painted in England. Mrs. Kemble sat to Stuart several times and in various characters. The actor and the artist were warm friends, and were much together.

KEPPELE, MR. AND MRS. MICHAEL.

Their portraits are owned by their grandson, Mr. Cadwalader Biddle, 208 South Fourth street, Philadelphia. It is a remarkably fine head.

Mr. Keppele was born September 9th 1771, and died February 2d, 1821. He was of German extraction, and for many years was President of the German Society. In the year 1811 he was elected mayor of Philadelphia for one term. There is a tradition in the family that Mr. Keppele, who was of large fine physique, stood for the figure in Stuart's full length portrait of Washington, but his age at the time, twenty-four, would seem to throw doubt upon it.

Mrs. Keppele, whose maiden name was Catherine Caldwell, was born June 7th, 1774, and surviving her husband more than half a century, died August 23d, 1862, at the advanced age of eighty-eight.

There is an incident connected with the portrait of Mrs. Keppele by Stuart, which is of importance, as showing the presumption and lack of true honor too often found, unfortunately, among the followers of the brush, and which accounts for the apparent inferiority of

the picture. Mr. Biddle writes: "A friend of my grandmother borrowed it in order that a young artist might be benefited by its study. It was removed for that purpose to his studio. Shortly afterward the family were asked if they knew that the artist had removed a great part of the picture, and upon going for it found that he had painted out all but the face and hands. When Sully was asked to replace the portion removed, he at first refused to touch anything which had been done by Stuart; but upon reflection, and seeing that the portrait was ruined as it stood, relented, and agreed to do so."

<div style="text-align: right">C. H. H.</div>

† KING, RUFUS, b. 1755, d. April 29th, 1827.

The original portrait is now at Highwood, Weehawken, New Jersey, the residence of the late James G. King. It is said there was also a portrait of Mrs. King, but I have not been able to trace it out.

* KIRKLAND, REV. JOHN THORNTON, D. D., b. 1770, d. 1840

He was President of Harvard College. His portrait is in the possession of his nephew, Rev. Dr. Lothrop, to whom it was bequeathed, and who says of it: "It was painted on wood, badly prepared, and so uneven in its surface that the marks of the plane appear, and in certain lights interferes with the impression the picture would otherwise make; with the exception of this defect, it is a splendid portrait, and an admirable likeness. The first time I saw it, in October, 1817, it was hanging in the west parlor of the President's house, at Cambridge, and I have a distinct recollection that Dr. Kirkland told me at the time that it was painted in 1810, just before he came to Cambridge. In August, 1810, Dr. Kirkland was forty years old. The picture is in good condition at the end of sixty-eight years, and has never been cleaned or retouched."

General Knox

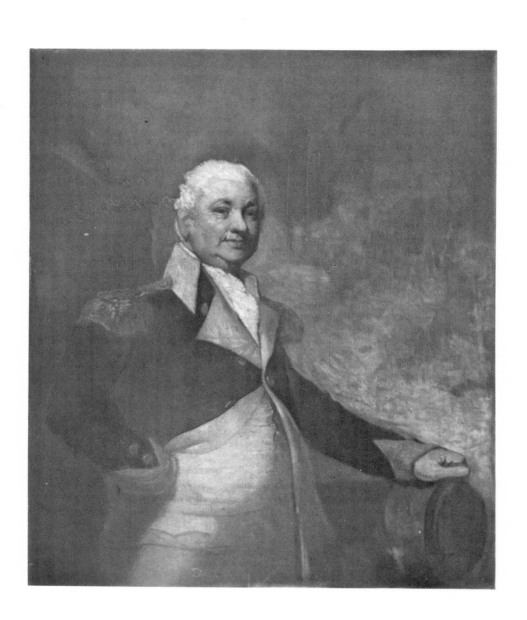

* Knapp, Charles.

* † Knox, General Henry, b. July 25th, 1750, d. October, 1806.

In connection with this picture, Miss Stuart writes:

"A great many absurd stories have been circulated about my father, which, I am happy to say, are not correct, particularly the one connected with the portrait of General Knox; and, in justice to the artist's memory, I must offer the following explanation:

"The difficulty at that time in obtaining canvas, except from England, compelled Stuart to paint on panels, and if the wood of which these panels were made was not very superior, and properly seasoned, it would, when put into a warm room, warp and split. In several instances, growing out of defects of this kind in the wood, Stuart had to throw aside pictures that he had painted, and which otherwise would have been very valuable. This was the case with a portrait of General Knox, who sat for another picture, as 'one-half in advance' had probably already been paid. The last portrait hangs in Faneuil Hall, it having been presented to the city of Boston, and is one of the artist's bold, characteristic heads.

"When the first panel began to split, Stuart instantly put it aside as a dead loss. Sometime after, wanting a cover for a mushroom bed near the stable, without a moment's thought he used the discarded and half-wrought panel for that purpose. Some one passing that way recognized the likeness of the General; and, drawing his own conclusions—that the picture had not been paid for, and that therefore it was thus dishonored—put a story in circulation that was very annoying both to the artist and the General, for they were very warm friends."

KURTZING, MR. AND MRS. ABRAHAM.

Mrs. Kurtzing's maiden name was Margaret Harbeson. They were married in 1780. Mrs. Kurtzing died in 1804, but the exact time when the portraits were painted is not known. The pictures, now in Philadelphia, are owned by their granddaughter, Mrs. Ella Kurtzing Birckhead.

LATHROP, REV. JOHN, D. D.

His portrait is in England, in the custody of Mrs. Sheridan, a daughter of Mr. J. Lathrop Motley, the historian. Dr. Lathrop was formerly pastor of a church in Boston.

LAW, MRS. THOMAS.

Her portrait,—a superb picture,—it is said, belongs to Mrs. George Goldsborough, Talbot County, Maryland. She was Eliza Parke Custis.

* † LAWRENCE, CAPTAIN JAMES, U. S. N., b. 1781, d. 1813.

In the portrait he wears his uniform. The picture, a fine one and well preserved, is owned by his granddaughter, Mrs. William Redmond, Newport, R. I.

LEAR, BENJAMIN LINCOLN.

He was the son of Colonel Tobias Lear, the warm personal friend of Washington. It is owned by Mrs. Wilson Eyre, a descendant, Newport, R. I.

LE CONTE, MRS. WILLIAM.

This portrait is owned by Miss Penington, of West Philadelphia.

† LEE, GENERAL HENRY, b. January 29th, 1756, d. March 25th, 1818.

General Lee took an active part in the Revolution, and he also served his native state, Virginia, in Congress. It was he, in his eulogy of Washington, who first used the expression: "First in war, first in peace, first in the hearts of his countrymen."

LEE, MRS. GEORGE G.

Her maiden name was Hannah F. Sawyer, and she was the sister of Mrs. Philip Schuyler. Her portrait, a half-length, painted about 1806, is owned by her granddaughter, Mrs. Charles J. Paine, 87 Mount Vernon street, Boston.

LEE, MR. AND MRS. CHARLES.

Mr. Lee held the office of attorney-general under both Washington and Adams. Mrs. Lee, who was the daughter of Richard Henry Lee, and niece of Arthur Lee, accompanied her husband in winter to Philadelphia, where she won the admiration of the society into which she was thrown. Stuart painted her portrait only six weeks before her death, and when he heard that she was no more gave vent to his feelings in tears. Her portrait he never could be induced to complete. It is in the possession of Mrs. Dr. Thomas Miller, Morrisworth, near Leesburg, Va.

Mrs. Miller writes to me of this portrait:

"She is taken in a white cap with a black ribbon round it, and the frill hangs quite low on the forehead, hiding her hair (which was said to be very beautiful) entirely, and this, together with its being unfinished, was a great disappointment to her friends; consequently it was not hung for a great many years, but was put away in a box, until one day a friend, who had known her well, was at the house, and asked to see it. It was brought down, and while it was in the parlor Lord Napier called, and was immediately so much struck with the great beauty of the picture, that he and several other friends begged me to have it framed and hung where it could be seen. This was done, and it hung in our parlor in Washington until last fall, when we brought it with other pictures to the country with us."

The portrait of Mr. Lee is owned by his daughter, Mrs. Pollock, near Warrenton, Va.

LENOX, MISSES.

They were the daughters of the late Robert Lenox, and their portraits were painted while they were on a visit to Boston. One became the wife of the late Robert L. Maitland, of New-York, and the other married Mr. William Banks, of the same city. The portraits are in the Lenox Gallery.

† LEWIS, COLONEL AND MRS.

The portrait of Colonel Lewis I have not found; that of Mrs. Lewis, whose maiden name was Nellie Custis, is at Audley, near Berryville, Clarke County, Va., the residence of the widow of her son, and of his youngest son, Mr. H. L. D. Lewis.

† LEWIS, WILLIAM.

He was a distinguished jurist in Philadelphia, and a copy—from the original by Stuart, but not by Stuart,—hangs in the Law Library, Philadelphia.

LISTON, ROBERT.

He was the British Minister, and came to Philadelphia in 1796. He had a letter to a Scotchman, named James Buchanan, an adopted American, by whom the Listons were entertained on their arrival. It was in connection with Buchanan that Mr. Liston made a mistake, as serious as it was ludicrous, he having gone so far as to say in a letter to Buchanan, "I must now endeavor to lead Mr. Adams by the nose," with other equally improper expressions, which letter found its way to England. Liston, when confronted with it, admitted that he had written it, and offered in extenuation that he had used the expressions in a playful mood, and intended no disrespect to the President.

Chauncey Goodrich, in announcing the arrival of the new minister to Oliver Wolcott, senior, May 12th, 1796, said of him: "He appears to be an amiable and worthy man; if he proves to be a candid envoy, he will be a new and valuable acquisition to the United States."

Mr. and Mrs. Liston were cordially received in Philadelphia, and during their stay resided in a house on Arch street. They were at the dinner given by Washington the day before his term of service expired, when the President said to his guests, as he lifted his glass: "This is the last time I shall drink your health as a public man."

Stuart's portrait of Mr. Liston probably found its way to England.

LIVINGSTON, MRS. MARGARET (Beekman).

She was the mother-in-law of Dr. Thomas Tillotston, and the portrait is in the possession of his granddaughters, at 23 East 28th street, New-York.

LLOYD, DR. JAMES, d. 1810, aged 80 years.

For many years he was at the head of the medical profession in Boston. His portrait is owned by his great-granddaughter, Miss Alida L. Borland, 37 Beacon street, Boston. Another portrait of Dr. Lloyd, owned by Mr. Gardiner Greene, of Norwich, Ct., is believed to have been painted by Stuart. In it he appears as a middle-aged man, seated in an arm-chair, with a red curtain behind him. His hair, dressed after the fashion of the day, is well powdered.

LLOYD, MRS. JAMES.

She was a great belle in her day, and the sister of Samuel Breck, of Philadelphia. Her husband was the son of the above-named Dr. James Lloyd, of Boston, and U. S. Senator from Massachusetts. He was an influential man at home and in Washington. Her portrait, a very fine one, is in the Aspinwall Gallery, New-York.

LOPEZ FAMILY.

They were wealthy Jews, residing in Newport, and their portraits were painted in the youthful days of Stuart. The family is extinct, and all trace of the pictures is lost.

* LORING, MR. AND MRS. CALEB.

Their portraits are owned by their grandson, Mr. Charles J. Loring, 1 Mt. Vernon Place, Boston.

LOW, DAVID.

* LOWELL, JOHN, b. 1769, d. 1840.

His portrait, painted about 1824, is owned by his son, Mr. John Amory Lowell, Boston.

LOWNDES, MR. AND MRS. THOMAS.

In the summer of 1804 Mr. and Mrs. Lowndes resided in the immediate neighborhood of Philadelphia, and Stuart was a frequent visitor at their house. It is stated that the portrait was painted at that time, but it must have been a year or two earlier that they sat to Stuart, for he was not then in Philadelphia. Mr. Lowndes was a Representative in Congress, from Charleston, from 1800 to 1808. He was a Federalist, and a supporter of John Quincy Adams. Mrs. Lowndes, to whom he was married in 1798, was Sarah Bond, daughter of Richard Jou, of Springfield, St. James, Santee: "This lady united a charm of manner to a handsome and distinguished presence, and her portrait, by Gilbert Stuart, has been ranked among the most successful of all his pictures of women."

MACDONOUGH, COMMODORE.

This portrait could not have been painted till after 1814 (the year of the battle of Lake Champlain), as is evident from his

uniform. He probably sat to Stuart in 1816 or '18. The picture shows all the admirable qualities of the artist—great force in execution and admirable flesh tints. It is owned by A. R. Macdonough, Esq., New-York, but will ultimately belong to his nephew and namesake, the son of his deceased eldest brother, Captain Macdonough. At present it hangs on the walls of the Century Club, New-York, where it is greatly admired.

* † MADISON, MR. AND MRS. JAMES.

The portraits of President and Mrs. Madison hung on the walls at Montpelier some two or three years after the death of Mr. Madison. Mrs. Madison, not feeling equal to the managing of the estate, removed to Washington in 1817, and resided there up to the time of her death. All the portraits at Montpelier she took with her ; one of them was a portrait of Mr. Jefferson, and her nephew, Colonel Richard D. Cutts, is under the impression there was also a portrait of Washington by Stuart, and also of Adams and Monroe. After the death of Mrs. Madison the pictures were sold. That of Madison was purchased by Judge Edward Coles, of Philadelphia, who had been a private secretary to the President. This picture is now owned by Mr. Edward Coles, son of Governor Coles, now residing in Philadelphia. The portrait of Mrs. Madison was assigned to her niece, Miss Ann Payne, afterwards Mrs. Kunkle, of Baltimore.

Mrs. W. W. Seaton, in one of her delightful letters, says : " I would describe the dignified appearance of Mrs. Madison, but I cannot do her justice. 'Tis not her form, 'tis not her face, it is the woman altogether whom I should wish you to see. She wears a crimson cap that almost hides the forehead, but which becomes her extremely, and reminds one of a crown, from its brilliant appearance, contrasted with the white satin folds and her jet black curls ; but

her demeanor is so far removed from the hauteur generally attending on royalty, that your fancy can carry the resemblance no further than her dress. In a conspicuous position every fault is rendered more discernible to common eyes, and more liable to censure; and the same rule certainly enables every virtue to shine with more brilliancy than when confined to an inferior station in society; but I, and I am by no means singular in my opinion, believe that Mrs. Madison's conduct would be graced by propriety, were she placed in the most adverse circumstances in life."

Mr. A. A. Low, of Brooklyn, N. Y., owns a Madison painted by Stuart; there is one in the set of the first five Presidents of the United States, owned by Mr. T. Jefferson Coolidge, already referred to, and at Bowdoin College there is another.

MANIGAULT, GABRIEL.

Painted in London, in 1779. The portrait is owned by Mrs. Heyward Manigault, and it is at the residence of Mr. Martin Zborowski, Westchester, County, N. Y.

MANIGAULT, JOSEPH.

Painted in London in 1781. It is owned by Mr. Henry M. Manigault, Charleston, S. C.

MANIGAULT, MR. AND MRS. GABRIEL.

Painted in New-York in 1794.

The portrait of Mr. Manigault belongs to the heirs of the late Charles Manigault, Charleston, S. C., and that of Mrs. Manigault

is owned by Mrs. Heyward Manigault. It is at the residence of Mr. Martin Zborowski, Westchester Co., New-York.

This anecdote is related in connection with the portrait of Joseph Manigault, who was studying in the Middle Temple, London, at the time that his portrait was painted. He was then quite a young man. In 1821, while spending the summer at the north, he was bowed to and stopped in the street by a gentleman, who called him by name. He expressed some surprise, and said he was quite unconscious of ever having met the stranger, who then told him he was Stuart, the artist, who had painted his portrait in London forty years before.

MARSHALL, MRS. JAMES MARKHAM.

NIXON, MRS. HENRY.

These ladies, represented as playing a game of chess, were the only daughters of Mr. and Mrs. Robert Morris. Hetty Morris, born July 30th, 1774, was married April 10th, 1795, to James Markham Marshall, of Fauquier Co., Va., and died April 13th, 1817. Maria Morris, born April 24th, 1779, married March 4th, 1802, Henry Nixon, of Philadelphia, and died September 17th, 1852. Judge Marshall was a younger brother of Chief-Justice Marshall. The picture of these two ladies is at Happy Creek, Warren Co., Va., in the old Marshall homestead, built by Judge Marshall shortly after his marriage, and now owned by Misses Marshall.

It is related that some member of the family criticised this picture in the presence of Stuart, who, giving way to his temper, dashed a knife through the canvas. The picture was repaired and the defect has been in a great measure concealed.

* MASON, MR. AND MRS. JONATHAN.

His portrait was painted in Washington in 1805. At that time Mr. Mason was a Senator in Congress from Massachusetts, and it was through his solicitation that Stuart the same year removed to Boston, and there set up his easel. The portrait is now owned by the family of the late David Sears, 3d, Boston, Massachusetts. Mr. Mason was born August 30th, 1752, and died November 1st, 1831.

Mrs. Mason, whose maiden name was Susan Powell, born in 1761, and died in 1836, sat to Stuart at the same time. Her portrait is owned by her grandson, Mr. Herbert C. Mason.

MASON, MR. AND MRS. JEREMIAH.

Mr. Mason was one of the foremost lawyers of his day. Born at Lebanon, Ct., April, 1768, he graduated at Yale, and in 1797, settled at Portsmouth, N. H. From 1813 to 1817 he was a representative in Congress from New Hampshire. November 9th, 1799, he married Miss Meanes, daughter of Colonel Meanes, of Amherst, N. H., and in 1832 he removed to Boston, where he died in 1848. Their portraits are owned by the heirs of their son, the late Mr. Robert M. Mason, Boston.

MASON, MRS. J. THOMPSON.

Her portrait is owned by Mrs. Judge Mason, Baltimore.

* May, Colonel Joseph.

His portrait is now owned by his grandson, Mr. Joseph Edward May, of Cambridge, Mass.

* May, Mrs. John.

She was one of the founders of the Orphan Asylum, Boston, and her portrait has a place in that institution.

† McKean, Chief-Justice, b. 1734, d. 1817.

An upright Chief-Justice, an enlightened lawyer, and a sagacious politician, he was looked up to as one of the most reliable men of his day. His portrait is at Binghamton, N. Y., where it is owned by the family of Mr. S. M. McKean. There is a copy of it in the Law Library, Philadelphia, but not by Stuart.

* McLean, Mr. and Mrs. John.

After the death of Mr. McLean, who left a large legacy to the Massachusetts General Hospital, the trustees wanted Stuart to paint his portrait, and asked him to view the corpse. He reluctantly consented, not liking to paint from a dead face. The moment he saw him, he exclaimed: "I can paint that man's portrait. I remember seeing him one day on State street, with his head out of a carriage window, in earnest conversation with a gentleman, and was struck with the expression of his face." From that recollection he painted a fine portrait. It is a three-quarter length. A similar portrait, also by Stuart, is owned by Dr. George A. Bethune, of Boston; the only

apparent difference being in the size of the pictures. Dr. Bethune's is a half-length.

Mrs. McLean's maiden name was Ann Amory, daughter of John Amory. Her portrait is owned by her nephew, Dr. Bethune.

MERRY, MR. AND MRS.

Mr. Merry was the British minister, and these portraits were painted in Washington. In connection with the portrait of Mrs. Merry, the following was found among Mr. Stuart's papers:

"Mr. Merry presents his best compliments to Mr. Stuart, and begs leave to accompany the enclosed notes (for $200), with his acknowledgments, for the valuable portrait of Mrs. Merry, on which Mr. Stuart has had the goodness to exert his known talents with so much success."

Washington, July 3d, 1805.

When they returned to England they probably took the pictures with them.

MIERES, MR. AND MRS.

MIERCHER, MR. AND MRS. PETER.

Their portraits were painted in 1798. At that time Stuart was residing at Germantown, a distance of eight miles from Philadelphia, and during the sittings Mr. and Mrs. Miercher drove daily to and from the studio. Mrs. Miercher's maiden name was Maria Snowder. These portraits are owned by Miss Estelle Miercher, Philadelphia.

MIFFLIN, GENERAL THOMAS.

He is dressed in a general's uniform; his hair white and flowing; his complexion ruddy, and on his face there is a pleasant expression. Owned by F. E. Dixon, Esq., of Farley, Bridgewater, Bucks County, Penn., a son-in-law of the late George Mifflin Dallas, to whose father, the late Alexander James Dallas, General Mifflin presented the picture.

Thomas Mifflin was born in Philadelphia in 1744, of quaker parents. He was graduated by the college in Philadelphia, afterwards the University of Pennsylvania. In 1772 he was elected one of the two burgesses to represent the city in the General Assembly of the Colony, and two years later a delegate to the first Congress. On Washington's appointment as commander-in-chief of the army, he selected Mifflin as his aid-de-camp, and the two journeyed together to the camp at Cambridge. A few months later he was commissioned by Congress a brigadier-general. He did yeoman service in the cause of his country in the gloomy closing months of '76, by exhorting the militia of his native city and state to come forward in the defense of their country. Early in '77 he was present at the battle of Princeton, and in February Congress made him a major-general. In the fall of 1783, then a member of Congress, he was chosen president, and in this capacity received from Washington the resignation of his commission as commander-in-chief—a striking coincident, taken in connection with his first service eight years before. He was a member of the convention, called in 1787, to frame a constitution for the United States, and the next year he became the president of the Supreme Executive Council of Pennsylvania. He was president of the convention called to reform the plan of Government of the state, and was the first governor elected under the new constitution. A great sufferer for many years from gout, he died after a short confinement at Lancaster, then the

seat of government of the state, on the 20th of January, 1800. General Mifflin possessed a gay and generous temper and extraordinary powers of conversation, which, with his frank, popular manners, gave him a magnetic influence over his fellow-citizens and friends. C. H. H.

† MORRIS, MR. AND MRS. ROBERT.

The head in the portrait of Mrs. Morris is the only part finished. It came into the possession of the late Mr. Beaumont, of New-York, in 1836, and at the sale of his pictures it was bought by Mr. James Lenox. The coloring is as brilliant as when first spread upon the canvas. It is said to have been the last female head on which Stuart worked. It displays a handsome, vigorous face, much resembling her only brother, the late Bishop White. It is now in the Lenox Gallery.

The portrait of Robert Morris, who was born in 1734, and died in 1806, is owned by the daughter of his son, Thomas Morris, at Bay Ridge, Long Island. A copy of it is owned by Mr. Charles Henry Hart, of Philadelphia, and for his memoir of Robert Morris it has been engraved. The picture—24x30—is a full face, with flowing hair. The expression is very fine, and the full character of the man is portrayed in the face. It is what would be called "a speaking likeness," and was painted in 1795. A replica is in the possession of his granddaughter, Miss Nixon, of Philadelphia.

See *Penn. Mag. of Hist. and Biog.*, vol. 1, p. 333.

* MORTON, MRS. PEREZ.

There are two portraits of this gifted woman, and, possibly, three, painted by Stuart. For the first, Mrs. Morris sat to Stuart; the other he painted without sittings, at the request of Counsellor

Dunn, and at his death his family sent it to Mrs. Morton. It is on a panel. These pictures are in the possession of Rev. J. H. Clinch, East Boston. Mrs. Clinch was the granddaughter of Mrs. Morton. The finished picture has always been considered one of Stuart's finest works. Mrs. Morton was called the American Sappho. She and her friends were greatly pleased with the picture, and after it was finished she addressed the following lines to the painter. They appeared in the Portfolio of 1803.

<div style="text-align:center">

To Mr. Stuart,

On his Portrait of Mrs. M.

</div>

Stuart, thy portrait speaks with skill divine:
Round the light Graces flows the waving line,
Expression in its finest utterance lives,
And a new language to creation gives.
Each varying trait the gifted artist shows,
Wisdom majestic in his bending brows;
The warrior's open front, his eye of fire,
As when the charms of bashful youth retire;
Or patient plodding, and with wealth content,
The man of commerce counts his cent. per cent.
'Tis *character* that breathes, 'tis *soul* that twines
Round the rich canvas, trac'd in living lines,
Speaks in the face, as in the form display'd,
Warms in the tint and mellows in the shade.
Those touching graces and that front sublime,
Thy hand shall rescue from the spoil of Time;
Thence the fair victim scorns the threatening rage,
And stealing steps of slow advancing age;
Still on her cheek the rose of beauty blows,
Her lips full tint its breathing sweetness shows:
Like the magician's wand, thy pencil gives
Its potent charm, and every feature lives;

Quick as the powerful eye's transcending ray
Steals its soft glance, and bids the heart obey,
Thy fine perceptions flow, by heaven design'd,
To reach the thought, and pierce the unfolded mind:
Through its swift course the rapid feeling trace,
And stamp the sovereign Passion on the face.
E'en me, by no enlivening grace array'd,
Me, born to linger in affliction's shade,
Hast thou, kind artist, with attraction drest,
With all that Nature in my soul express'd.

Go on—and may reward thy cares attend,
The friend of Genius must remain thy friend;
Though sordid minds with impious touch presume
To blend thy laurels with the cypress gloom,
With tears of grief its shining leaves to fade,
Its fair hopes withering in the cheerless shade,
The well-earn'd meed with sparing hand deny,
And on thy talents gaze with dubious eye.
Genius is Sorrow's child, to Want allied,
Consol'd by Glory and sustain'd by Pride;
Unknown—unfelt—unshelter'd—uncaress'd—
In walks of life where worldly passions rest."

Stuart immediately replied as follows:

To Mrs. M——.

Who would not glory in the wreath of praise,
Which M——n offers in her polished lays?
I feel their cheering influence at my heart,
And more complacent I review my art;
Yet, ah, with Poesy, that gift divine,
Compar'd, how poor, how impotent is mine!

What though my pencil trace the hero's form,
Trace the soft female cheek, with beauty warm:
No farther goes my power: 'tis *thine* to spread
Glory's proud ensign o'er the hero's head;
'Tis thine to give the chief a deathless name,
And tell to ages yet unborn his fame —
'Tis thine to future period to convey
Beauty enshrin'd in some immortal lay.
No faithful portrait now Achilles shows,
With Helen's matchless charms no canvas glows;
But still in Homer's mighty verse portrayed,
Ne'er can her beauty or his glory fade.
Nor wonder, if in tracing charms like thine,
Thought and expression blend a rich design:
'Twas heaven itself that blended in thy face,
The lines of Reason with the lines of Grace;
'Twas heaven that bade the swift idea rise,
Paint thy soft cheek, and sparkle in thine eyes:
Invention *there* could justly claim no part,
I only boast the copyist's humble art.
Mid varied scenes of life, howe'er deprest,
This blest reflection still shall soothe my breast;
M——n commends—and this alike outweighs
The *vulgar's censure*, or the *vulgar's praise*.
With such distinction, wrapt in proud content,
No more my adverse fortune I lament:
Enough for me that *she* extends the meed,
Whose approbation is applause indeed."

Moses, Mr. and Mrs. Solomon.

These portraits were painted in 1806, and are owned by Mr. Horace Moses, 1429 Chestnut street, Philadelphia.

* MOTLEY, THOMAS.

This picture was begun by Stuart about 1825, and then thrown aside. It was secured by the family, and is now in the possession of the daughter of Mr. Motley, Mrs. L. W. Rodman.

* MONROE, JAMES.

A portrait of President Monroe is owned by Mr. A. A. Low, Brooklyn, N. Y., one is owned by Mr. T. Jefferson Coolidge, Boston, and there is one in Washington.

President Monroe sat to Stuart in Boston. A few days after his arrival in that city, he went out early one morning in his carriage to sit to the painter. A stranger in the place, he stopped a countryman seated in his cart, and asked him to direct him to Mr. Stuart's house. The countryman looked steadily at him for a moment, and then exclaimed, "It is the President, I vow!" Instantly taking off his hat, he gave three loud and hearty cheers, and then drove off, leaving the President unanswered and astonished. This anecdote is taken from the *Salem Register* of that date—1817.

MURRAY, JOHN R.

His portrait, painted about 1800, at which time he was not far from twenty-seven years of age, is owned by his son, Mr. John R. Morris, of Mount Morris, New-York. It has always been considered an excellent likeness, and is in an excellent state of preservation.

MURRAY, MRS. AND MISS.

Mrs. Murray was the sister of Winthrop Sargent, the first governor of Mississippi. The portraits are owned by Mrs. W. Butler Duncan, New-York, and are in Stuart's best style.

NEWTON, EDWARD.

Owned by Mr. Edward N. Perkins, Jamaica Plain, Mass.

NICHOLAS, GOVERNOR WILSON C. N.

His portrait was painted in Philadelphia. At that time he was a member of Congress from Virginia. It is owned by his grandson, J. Louis Smith, of Harmony Village, Middlesex Co., Va.

NICKLIN, PHILIP 24 x 30.

Faces to the right. It represents a fine-looking man of about forty, with blue eyes and powdered hair, dressed in a blue coat with brass buttons, and a large white neckerchief.

Mr. Nicklin was a native of Staffordshire, England; came to this country and settled in Philadelphia, where he entered into mercantile pursuits. In 1786 he became a contributor to the Pennsylvania Hospital, and was treasurer of the society of the Sons of St. George from 1797 to 1799, in which latter year he

was elected vice-president, and continued to hold the office until his death. Mr. Nicklin died November 1st, 1806, in his forty-seventh year, and was buried in St. Peter's burying-ground, but no stone marks his grave. He was married April 1st, 1793, by Bishop White, to Julianna, daughter of Chief-Justice Chew, and was the father of Mrs. George M. Dallas, and of Philip Holbrook Nicklin, author of "A Pleasant Peregrination through the Prettiest Parts of Pennsylvania. By Peregrine Prolix."

<div style="text-align:right">C. H. H.</div>

NICKLIN, MRS. PHILIP, 24 x 30.

Faces to the left. She is seated in a red velvet chair, with her hands crossed upon her lap, holding in the left a book with her fore-finger between two open pages. She is dressed in thin white muslin, cut surplice, with a ruffle around the neck. She wears a gold necklace, set with pearls and a pendent cross. Around her waist a blue sash is tied. From this picture she must have been an exceedingly handsome woman, of dignified mien, and with her head set beautifully upon her shoulders. The complexion is brilliant, the eyes deep blue, and the hair powdered. It is one of Stuart's best pictures; quite equal to his portrait of Mrs. Peters.

Mrs. Nicklin was the fourth child of Benjamin Chew,—sometime Chief-Justice of Pennsylvania,—by his second wife Elizabeth Oswald, and was born April 8th, 1765. Mrs. Nicklin survived her husband many years, dying in Philadelphia in the summer of 1845, in her eighty-first year. The two portraits of Mr. and Mrs. Nicklin are now in the possession of their granddaughter, Mrs. Charlotte Dallas Morrell, of West Philadelphia, Pa.

<div style="text-align:right">C. H. H.</div>

NICOLS, HENRY, b. December, 1746, d. January, 1831.

He was a gentleman of great refinement, and noted for his hospitality at his mansion on the Eastern shore of Maryland. It is related of him that in 1799 (there must be an error in the date, for Stuart was not then in Boston) he determined to have his portrait painted by Stuart, and to this end, attended by his body-servant, he drove from Baltimore to Boston in his own carriage, giving three weeks to the journey. Stuart rewarded his enthusiasm by painting a remarkably fine head of him, which picture is now in the possession of his grand-nieces, Misses Troup, of Baltimore.

† NIXON, COLONEL JOHN, d. December 31, 1808, aged 76 years.

He was an officer of the Revolution, took part in the battle of Princeton, and held several offices of trust in Philadelphia. His portrait, painted prior to 1800, is owned by Mr. Henry Cramond, of that city.

NORTHUMBERLAND, DUKE OF, and his two children.

When Stuart was ready to begin the portraits of the children, he asked the Duke if he had any particular fancy about the composition of the picture. The Duke replied: " I think my girl has found out that she is very pretty, and her brother, who has also discovered it, like a true boy, is fond of teasing her about it." Stuart took the hint, and painted a picture of the girl looking at herself in the water, while the boy behind her is throwing a stone into the pool to spoil the mirror.

Ogden, ——.

Oliver, John.

His portrait, a florid one, is owned by his niece, Miss Emily O. Gibbes, Newport, R. I.

Oliver, Robert.

He was a brother of John, and his portrait is owned by his niece, Mrs. Edwin A. Post, of New-York. John and Robert Oliver made their home in Baltimore.

* Oliver, Mr. and Mrs. Ebenezer.

Ormand, Lady.

Painted in Ireland.

Orne, William, b. 1761, d. October 15th, 1815.

He was a very successful East India merchant, of Salem, and was about fifty years of age when he sat to Stuart. His portrait descended to his son, the late William W. Orne, and it is now in the possession of his widow, Mrs. Lucy G. Orne, Springfield, Mass.

OSSORY, LORD BISHOP.

His portrait was painted in Dublin. While sitting to Stuart, "the Bishop," writes Miss Stuart, "thought he would give the conversation a religious turn, believing it to be a duty to improve every moment of his valuable time. Stuart painted away until he came to the lower part of the face, and not caring to be lectured any longer, bowed and politely said, 'Will your lordship please close your mouth,' a request with which the Bishop at once complied, while an amused expression passed over his face. Notwithstanding this rebuff, he admired the artist, and at parting presented him with a valuable snuff-box, made of tortoise shell and mounted with silver. Since Stuart's death this snuff-box has been presented to the Boston Art Museum."

The above anecdote has been erroneously credited to Jarvis, but it properly belongs to Stuart. It calls to mind another story of Stuart. He was painting the portrait of a very beautiful woman who was a great talker. When the picture was nearly finished she asked permission to look at it, and on seeing it, exclaimed, "Why, Mr. Stuart, you have painted me with my mouth open!" "Madam," said he, "your mouth is always open." The portrait he never finished, for he would never after touch it.

OTIS, MR. AND MRS. GEORGE ALEXANDER.

Mr. Otis was the translator of Botta's history of "The American Revolution," and his portrait is now in the possession of his son, Mr. George A. Otis, Cambridge.

The portrait of Mrs. Otis is owned by Miss Georgiana Otis, Highland street, Roxbury.

*† OTIS, MR. AND MRS. HARRISON GRAY.

Their portraits, painted about 1814, are owned by Mr. George W. Lyman, of Boston. Mrs. Otis is in full dress, and Mr. Otis is in a morning costume.

OTIS, SAMUEL ALLEYNE, b. Nov. 24th, 1740, d. April 22d, 1814.

He was the father of Harrison Gray Otis, and the portrait, a remarkably fine one, is in the possession of Mrs. James W. Otis, 14 West 12th street, New-York. Mr. Otis was a member of Congress in 1788, and after the adoption of the Constitution he held the office of Secretary of State up to the time of his death. His portrait was painted about the year 1800.

PAINE, ROBERT TREAT.

* PARKER, D. P., b. August 30th, 1781, d. August 31st, 1850.

Mr. Parker was the father of Mrs. Edmund Quincy, and his portrait is now at Dedham, at the residence of the late Edmund Quincy, whose children have inherited it. Stuart painted a portrait of Mrs. Parker, but it has been destroyed.

* PARKER, JOHN.

His portrait is owned by Mr. E. F. Shimin, Boston.

Parkman, Mr. and Mrs. John.

Their portraits are owned by their grandson, Rev. John Parkman, Boston.

* Parkman, Mr. and Mrs. Samuel.

Mr. Parkman died in 1825, aged 72 years, and Mrs. Parkman died 11 years later. The hair in Mr. Parkman's portrait is powdered. These portraits are at the house of Mr. Francis Parkman, his grandson, Beacon street, Boston. There is another portrait of Mr. Parkman, by Stuart, painted when the hand of the artist had become enfeebled by sickness and age. It is very inferior to the above. Mr. Parkman was the donor to the city of Boston of the fine picture by Stuart, known as Washington at Dorchester Heights.

* † Parsons, Chief-Justice, b. 1750, d. 1813.

His portrait was painted after death. This was easily done, for Stuart knew him intimately and had often dined with him. The sketch was made at the request of the Judge's brother, William. It is an unfinished head, but as a whole it is an admirable likeness. From it Stuart painted a finished picture for Mr. William Parsons, and it is thought that he made one or two copies of it. One is owned by Mr. J. Lewis Stackpole, Boston. The sketch was subsequently engraved for the Memoir of Chief-Justice Parsons, written by his son, Professor Parsons; but before this was done it was necessary to paint in the eyes, a work that was intrusted to Alexander, the artist. This book is now out of print, and the plate was destroyed in the great fire in Boston.

PATTEN, MISS SALLY.

This is the portrait of a plump, rosy-cheeked child of seven years, and is now owned by her daughter, Mrs. George Hollingsworth, of Mattapan, Mass.

PATTERSON, WILLIAM.

He was a merchant, and the circumstance attending the painting of his portrait has already been alluded to. His daughter became the wife of Jerome Bonaparte, of Baltimore. His portrait is owned by Mrs. Edward Patterson, the widow of his son, a venerable lady of eighty years.

It is said there was also a portrait of Mrs. Patterson by Stuart.

PENINGTON, MISS ANN.

Miss Penington was half-sister to Elizabeth (Harvey) Wister, wife of John Wister, deceased, and made her home in New Jersey. It is owned by Mr. John Wister, who, with his sisters, resides in the old house in Germantown. Mr. William Rotch Wister says of the portrait: "It is in excellent preservation, and is rich in color. It was said by my grandmother to be an excellent likeness, and it was no doubt painted for Miss Penington for the purpose of presentation to my godmother."

PENINGTON, MR. AND MRS. EDWARD.

Mr. Penington's portrait is owned by Mrs. John Penington, of Philadelphia, and that of Mrs. Penington is the property of Mrs. Robert Smith, of that city.

* PERKINS, JAMES, b. March 30th, 1761, d. August 1st, 1822.

He was a benefactor of Harvard College, and his name is asso-
ciated with the founding of the Boston Athenæum. This portrait
was painted after his death. It is owned by his grandson, Mr.
Edward N. Perkins, Boston, who has related to me the following
anecdote, told him by his great-uncle, the late Colonel Thomas H.
Perkins. It illustrates Stuart's great power of memory and his keen
observation.

"About the time of my grandfather's death he was sitting to
Stuart for his portrait, which was supposed by his brother and the
family to be in a forward state, and, indeed, nearly finished. After
his death, he having died very suddenly from pneumonia, Colonel
Perkins called at the studio, and was very much disappointed to
find that the artist had only a mere sketch on his easel. The
fact was, the hours given to sittings had been passed in con-
versation, for the two were well acquainted, and the result was
the faithful memorial of one so dear, which my uncle had counted on
seeing, did not exist. After some words of explanation from Stuart,
the Colonel, being very indignant, left the studio, saying, 'Very
well, Mr. Stuart, you have inflicted an irreparable loss by your
dilatoriness, and I never shall enter your studio again." He
accordingly left without hearing the artist's explanations. Some
weeks passed, when they met by chance one day in the street, and
Stuart, who had been busy painting on the portrait from memory,
begged the Colonel to reconsider his resolution. To make a long
story short, my uncle yielded, and, as he told me, 'I entered the
studio, and there on the easel I saw the perfect portrait of my dear
brother, which (pointing to the picture on the wall) now hangs
before you.'"

A copy of this picture, made by Stuart, is now owned by the
Athenæum, but it is not as good as the original.

PERKINS, THOMAS.

He was a merchant, and his portrait is owned by Mr. William P. Perkins, 34 Mount Vernon street, Boston.

PERKINS, MRS. ANNA DUMMER.

Her portrait is owned by her daughter, Mrs. Henry B. Rogers, 5 Jay street, Boston.

PERKINS, MR. AND MRS. THOMAS HANDASYDE.

Mr. Perkins was born in 1764, and died in 1854. Mrs. Perkins, whose maiden name was Sarah Elliot, daughter of Simon Elliot, of Brookline, died in 1852. Their portraits are in the possession of Mrs. T. G. Cary, Boston. Mrs. Perkins wears a turban and the short-waisted dress of the early part of the century. Mr. Perkins' portrait must have been painted just at the close of Stuart's life. There is another portrait of him, owned by Mrs. William Howard Gardiner, 17 Marlborough street, Boston. It was taken at a comparatively early age, as his hair is worn in a cue.

† PERRY, COMMODORE O. H., U. S. N.

His portrait is owned by his grandson, Mr. Oliver H. Perry, Lowell, Mass.

PERVIANCE, MRS. WILLIAM Y.

This was an early portrait, thought at one time to be in Baltimore, but no clue to it has been found. She was an English lady of great beauty, who lived and died in New-York.

PETERS, MRS. RICHARD.

She is seated before a table, on which there are writing materials; her hands are folded across her lap, and her hair is powdered. The portrait, a very beautiful face, and exquisitely painted, at about the age of thirty-five, is in the possession of her daughter, Miss Nancy Bingham Peters, of Philadelphia.

Mrs. Peters was Abigail Willing, the ninth child and fifth daughter of Thomas Willing, and was born May 13th, 1777. Louis Philippe, when sojourning an exile in this country, is said to have sought her hand, but she refused his offer, and married Richard Peters, Jr., sometime reporter to the Supreme Court of the United States. He was the son of Washington's friend, Judge Richard Peters, of Belmont. Mrs. Peters died in Philadelphia, October 29th, 1841. C. H. H.

PHILLIPS, LIEUT.-GOVERNOR WILLIAM.

There is a good portrait of him in the Massachusetts General Hospital, of which institution he was a benefactor.

PHILLIPS, MRS.

PHILLIPS, SOPHIA CHEW.

* † PICKERING, COLONEL AND MRS. TIMOTHY.

Colonel Pickering, who sat to Stuart a number of times, was born July 17th, 1745, and died January 29th, 1829. A portrait

of him, painted in 1808, for the late William Pratt, of Boston, whose wife was a niece of Colonel Pickering, is now in the possession of Miss Mary Pratt, Mr. Pratt's only surviving daughter, Mount Vernon street, Boston. In 1814 Colonel Pickering sat to Stuart for a portrait for the late Alexander C. Hanson, of Maryland. This picture is now owned by Mrs. Thomas Donaldson (granddaughter of Colonel Pickering, and daughter of Mrs. Hammond Dorsey). Mr. Hanson, a warm personal friend of Colonel Pickering, married a sister of Hammond Dorsey. Mention has already been made of this portrait. The portrait of Colonel Pickering, owned by Miss Pratt, was engraved in 1873, for the Life of Colonel Pickering.

Mrs. Pickering's maiden name was Rebecca White. Her portrait was painted by Stuart for her son, the late Henry Pickering, and is now owned by his nephew, Mr. Henry W. Pickering, 249 Beacon street, Boston.

PLUMSTEAD, MR. AND MRS. GEORGE.

Their portraits, painted in 1800, are owned by C. R. Plumstead, 1122 Girard street, Philadelphia.

PORTER, MRS. W.

PORTER, MRS. WILLIAM.

She was Miss Field, of New-York. After her death it was given by her husband to Mrs. William H. McLellan, of Boston, the present owner.

* Powell, Mrs. Ann Catharine.

Her portrait was bequeathed to Mr. Jonathan Mason (she was his grandfather's second wife), and by him given to his daughter, Mrs. Alice Mason.

* Prescott, Judge William, b. 1762, d. 1844.

His portrait is owned by his daughter, Mrs. Franklin Dexter, who has it at her house, Beverly, Mass. This is said to have been the last portrait on which Stuart painted.

Another portrait of Judge Prescott, painted by Stuart, is owned by the heirs of the late James Lawrence.

Preston, ———.

There was a portrait of one of the family at one time in New Orleans.

† Priestley, Dr. Joseph.

He earnestly espoused the cause of the Democrats when he came to this country, and opposed the Federalists with the most determined spirit. In 1840 there was a portrait of him in Liverpool, owned by Mr. T. B. Barclay, which has been engraved. It is also said there is a portrait of him in Pennsylvania, owned by members of the Priestley family.

* † Quincy, Mr. and Mrs. Josiah.

The first portrait of Mr. Quincy, who was born February 4th, 1772, and died July 1st, 1864, was painted in 1806, when he was

thirty-four years of age. It is a half-length, and one of the most finished of Stuart's pictures. That of Mrs. Quincy, whose maiden name was Eliza Susan Morton, was painted at the same time. She was born September 21st, 1775, married June 6th, 1797, and died at Quincy, September 1st, 1850. Their portraits are at Dedham, in the possession of the family of the late Edmund Quincy, of that place.

Permission has been granted me to make the following extract, from a letter from Miss Eliza Susan Quincy, touching the Quincy family portraits :

"The rest of the family were satisfied with the portrait painted in 1806, but I thought there ought to be another, at the age of fifty-two years. My father complied with my request, promised to give me the portrait, and in November, 1824, I accompanied him to the house of Mr. Stuart, in Essex street, Boston. He was gratified that Mr. Quincy, in the midst of his engagements as mayor, and in the erection of Faneuil Hall market, was willing to give him time for a portrait. His canvas was ready on his easel, a bold outline was sketched in chalk, and while conversing rapidly, Mr. Stuart began to put on his colors, apparently at random, but of course every touch told. Presently a bright shade of blue appeared in the upper part of the canvas, and Mr. Stuart said to me, 'Your father is an active man, and likes to be in the open air; he shall have blue sky behind his head. Few artists would attempt to give effect to a portrait with such a light background. It is a bold effort; but I will try it.'

"I asked if he had any particular mode or rule for mixing his colors: He said, 'No, I mix them as I put sugar in my tea; according to my taste. The whole theory of shadow may be taught by a billiard ball—the simplest object I can think of. Lay it on a table and draw it. You first sketch a circle; you then look at it, and see there is one light, one shadow, and one transparent reflection; on the gradation of these all painting depends. My rule for a portrait is, one-third light, one third dark, and one-third demi-tint.'

"Mr. Stuart asked for the elevation and plan of the new market, as he intended to represent Mr. Quincy as seated at a window of Faneuil Hall, commanding a view of the edifice.

"This portrait remained at Mr. Stuart's studio till May, 1825, when I told him that Allston had said 'the head was worthy of the old masters.' He replied, with a sharp glance of his piercing eye, 'And am not I an old master, Miss Quincy? You deserve half the credit of the portrait, as you persuaded your father to sit to me a second time. You must always say that we painted that portrait.'

"As Mr. Stuart chose to represent Mr. Quincy as the mayor, I intended to give this portrait to Faneuil Hall, but as that edifice was deemed unsafe, in 1876 I presented it to the Museum of Fine Arts, as my gift to the city of Boston.

"To the deep regret of the family, there is no portrait of my grandfather, Josiah Quincy, Jr. [He was born in Boston, February, 1744, and died at sea, near the entrance to Gloucester Harbor, April 26th, 1775.] There was an engraving that his widow, Mrs. Abigail Quincy, considered an excellent likeness. This print Stuart had declined to copy; but after reading the memoir of J. Quincy, Jr., published in 1825, he said: 'I must paint the portrait of that man,' and requested that the print, and the portrait of his brother, Samuel Quincy, by Copley, should be sent to his studio.

"Stuart expressed a wish to see the family portraits at Quincy, and on the 1st of October, 1825, came here with Mr. I. P. Davis. As he entered the house my father said: 'Here is a family, Mr. Stuart, who are looking to you for a head.' He appeared much pleased, and said: 'It is seventeen years since I was here last, and I am very glad to find myself here again.' He admired the portrait of Colonel Josiah Quincy, of Braintree, painted by Copley in 1769.

"Seeing a print of the 'Battle of the Boyne,' Mr. Stuart said: 'I was studying with West when he painted that picture,

and I had to lie on the floor, dressed in armor, for hours, for him to paint me in the foreground as the Duke of Schomberg. At last West said: "Are you dead, Stuart?" "Only half, sir," was the reply: and my answer was true, for the stiffness of the armor almost deprived me of sensation. Then I had to sit for hours on a horse belonging to King George, to represent King William. After the picture was finished, an Irishman came into West's room and said, looking at the painting: "You have got the battle-ground there correct enough; but where is the monument? I was in Ireland the other day, and saw it." He expected to see the monument of a battle in the representation of its commencement.'

"These reminiscences were interrupted by the entrance of Mr. John Quincy Adams, who had arrived the day previous, on a visit to his father, for the first time as President of the United States, and who had that morning accepted an invitation from Mr. Quincy to dine at his house and meet Mr. Stuart. Mr. Adams was in fine spirits, gave Mr. Stuart a cordial greeting, and conversed with animation. Speaking of the departure of Lafayette, and of the arrangement for his voyage, he said:

"'The first of June the Superintendent of the Navy Yard came to inform me that the frigate, then on the stocks, was nearly ready to be launched, and that they called her the *Susquehanna*. I told him to apprize me of the day, as I intended to be launched in her. Accordingly, on the 16th of June I went on board the frigate, and when all was ready, and a lieutenant, with a bottle on a string, asked me her name, I said, "*The Brandywine.*" Amazement appeared on every countenance. But when I explained that the battle of the Brandywine was the first Lafayette fought in our cause, and in which he was wounded, and that I intended to send him to France in this frigate, approbation and pleasure became universal. The next day, the 17th of June, I wrote to Lafayette, expressing my regret that I could

not be with him on Bunker Hill on that day; but to prove that we had been thinking of him at Washington, I mentioned the name of the frigate to be placed at his command for the voyage home. His reply to me was that he was indeed highly delighted.'

"Every one present listened with great interest to the conversation of the President, on this and many other subjects; and before he parted with Mr. Stuart, they arranged a day when his portrait, at full length,—now in Memorial Hall, Cambridge,—should be begun.

"In the evening Mr. Stuart took leave of Mr. and Mrs. Quincy, in a graceful and courteous manner, saying: 'I have had a delightful day, and hope it will not be seventeen years before I am here again.'

"Mr. Stuart painted the portrait of Josiah Quincy, Jr., without delay, and soon requested his sister, Mrs. Storer, then eighty years of age, to come and see it. She thought a good likeness had been obtained, and made some criticisms, which were adopted. According to his promise, Mr. Stuart finished the portrait in November, and on the morning of Thanksgiving day, when Mrs. Quincy requested it, he sent it to Hamilton place (then the winter residence of the family), saying: 'There, take your picture, and I hope you will all be happy together.'

"After regarding this portrait steadily for some time, the late Jonathan Mason, of Boston, who studied law in the office of J. Quincy, Jr., in 1770, said: 'Stuart has given you seven-eighths of a likeness;' and it was also recognized by two of his other contemporaries, who had seen him in London in 1774. It hung in the President's house, in Cambridge, for sixteen years. In May, 1829, when Mr. Webster brought Mr. Wirt to visit Mrs. Quincy, he advanced to the portrait and said: 'Mr. Wirt, Josiah Quincy, Jr., of whom you have heard so much,' as if he were introducing them to each other. Mr. Wirt also approached the picture and said: 'It is not the spirit that vapors within these walls,' etc., and recited

Mr. Quincy's speech in the Old South, on the 16th of December, 1773—the night of the destruction of tea in Boston harbor."

This picture is now in the possession of the Quincy family.

The full length portrait of President John Quincy Adams, above referred to, has already been noticed under its proper head.

RAINIER, ADMIRAL PETER.

Painted in England. After his death it descended to his nephew, who bore his name, and to whom he left a large fortune.

RAWLE, MRS. WILLIAM.

Mr. Rawle was the attorney of the United States for the District of Pennsylvania at the time that Stuart was painting in Philadelphia. For him Stuart painted a portrait of Washington, already noticed, and one of Mrs. Rawle, which last is now in the possession of Mr. Francis W. Rawle, of Fairfield Farm, Lycoming County, Penn.

REED, MRS.

* REID, J.

REIGARD, MRS.

This is an unfinished head, upon a mahogany panel, and is now at Lancaster, Penn. Mrs. Reigard was the daughter of Wager, the wine merchant of Philadelphia, with whom Stuart had dealings, and of whom mention is made by Dunlap.

REIGNOLD, GEORGE.

Owned by H. D. Sherwood, Philadelphia.

* REVERE, MR. AND MRS. PAUL.

Paul Revere, who was born in 1735 and died in 1818, was an engraver, a colonel of artillery, a grand master of the society of Free Masons, and a patriot,—one whose name is intimately associated with the struggle for Independence. He was alive to the wants of others, and was the first president of the Massachusetts Charitable Society. These portraits are now in the possession of their grandson, Mr. John Revere, Boston.

REVERE, JOSEPH W.

He was the son of Paul, and his portrait is owned by his son, Mr. John Revere, Boston.

* REYNOLDS, DR. EDWARD.

His portrait, loaned at the time of the exhibition of the Stuart pictures in 1828, was never returned, and no trace of it has ever been found.

† REYNOLDS, SIR JOSHUA, b. July 16th, 1723, d. 1792.

His portrait was painted in 1784, for Alderman Boydell, and was afterwards purchased for two hundred and fifty guineas by Lord Inchiquin.

* RICE, COLONEL NATHAN.

An officer of distinction in the Revolution. His portrait is owned by his grandson, Mr. Benjamin T. Rice, Millbury, Mass.

RICHARDS, MR. AND MRS. JOHN.

In the possession of Mr. Francis E. Richards, Gardiner, Maine.

RIDGELEY, COLONEL, U. S. A.

RITCHIE, MRS. ANDREW.

She was a very beautiful West Indian. Her maiden name was Durant. After her death, Mr. Ritchie gave the picture to his intimate friend and classmate, Hon. James T. Austin, who in turn gave it to his son-in-law, Dr. George H. Lyman, Boston, who now has it at his house, 131 Boylston street.

RIVINGTON JAMES.

He was a printer and bookseller, and during the revolution he gave the title of *Royal Gazette* to his paper. He was then known as "Printer to the King." At the time that his portrait was painted by Stuart he was residing in Philadelphia. The picture, now owned by Mr. William H. Appleton, New-York, was purchased by him at the John Hunter, of Hunter's Island, sale. There is a copy of the picture, but not by Stuart, in the rooms of the New-York Historical Society.

ROBINSON, MRS.

Formerly Miss Stewart, half-sister of Mrs. Thomas Law. Her mother was the second wife of John Parke Custis. The picture is owned by Mrs. George Goldsborough, of Talbot County, Maryland.

RODMAN, MRS.

RODNEY, LORD, b. 1718, d. 1792.

From this picture a bronze statue was modeled.

* ROGERS, MR. AND MRS. DANIEL DENNISON.

Mrs. Rogers, born 1763, and died 1833, was Miss Elizabeth Broomfield, daughter of Henry Broomfield. The portrait was taken when she was quite young. She is seated on a red chair, dressed in white, with a white lace scarf pinned in her hair and falling around her figure. It is owned by Mrs. Walter C. Cabot, Brookline. The portrait of Mr. Rogers is owned by Mr. John Rogers, Boston Highlands.

* RUSSELL, NATHANIEL POPE, b. August 15th, 1779, d. July 3d, 1848.

His portrait was painted about 1818, and is a remarkably fine specimen of Stuart's work. He is seated in the conventional studio chair, with a table and writing implements before him. Mr. Russell, who was the treasurer of the Bunker Hill Monument Association, was descended from a family that settled in Boston in 1680. He

Elizabeth Willing

(Mrs. Jackson)

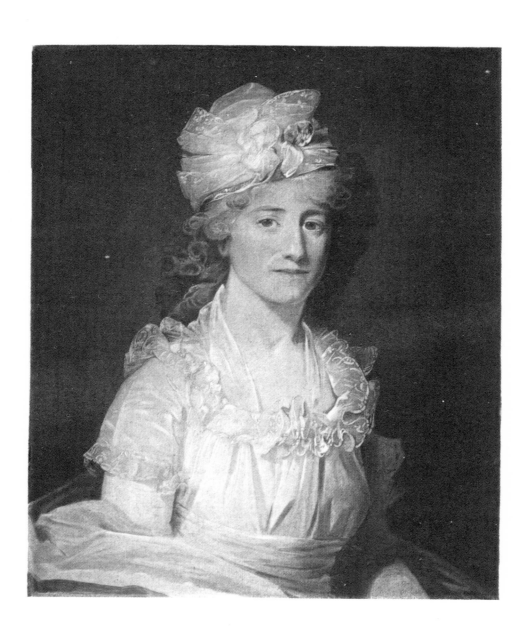

held many offices of trust in Boston, and took an active part in the state and city government. His portrait is owned by his son, Mr. Samuel H. Russell, Boston.

* RUSSELL, MRS. JOSEPH.

She was Miss Lydia Smith, and her portrait was probably painted before her marriage. It is owned by Mrs. G. B. Upton, of Boston.

RUTLEDGE, MISS MARY, of South Carolina.

All traces of this picture were lost during the recent war.

* SALISBURY, DEACON SAMUEL, of Boston, b. November 29th, 1739, d. May 2d, 1818.
* SALISBURY, STEPHEN, of Worcester, b. Sept., 1749, d. May 11th, 1829.
* SALISBURY, MRS. ELIZABETH, b. Jan. 10th, 1768, d. Oct. 19th, 1851.

Samuel and Stephen were brothers, and Mrs. Salisbury was the wife of Stephen. The above portraits are owned by Hon. Samuel Salisbury, son of Stephen. That of Stephen was painted in 1823. Stuart's receipt for one hundred dollars, the amount paid for it, is dated July 23d of that year, and the picture was ready for delivery on the 6th of the following September. It is on canvas. The portraits of Samuel and Mrs. Stephen are on panels, and were painted earlier, probably in 1810.

SARGENT, GOVERNOR AND MRS. WINTHROP.

He was the first Governor of Mississippi. Their portraits, painted about 1805, are owned by Mrs. W. Butler Duncan, of New-York.

* SAVAGE, MRS. SAMUEL, b. March 24th, 1756, d. December 22d, 1830.

Her maiden name was Hope Doane, daughter of Colonel Elisha Doane, of Wellfleet. She was married to Dr. Samuel Savage, February 18, 1777, and resided at Barnstable during the remainder of her days. Her portrait, in the possession of her daughter, Mrs. Lemuel Shaw, 49 Mt. Vernon street, Boston, represents her to have been a woman of fifty or sixty years of age at the time that it was painted. It is on a panel.

* SCHUYLER, MR. AND MRS. PHILIP J.

Mr. Schuyler was born at Rhinebeck, Dutchess County, N. Y., in 1768, and died in 1835. Mrs. Schuyler, whose maiden name was Mary Ann Sawyer, daughter of Dr. M. Sawyer, of Newburyport, was born in 1786, and died in 1852. Their portraits were painted at about the time of their marriage, 1806, and are now owned by Mr. George L. Schuyler, of New-York.

* SEARLE, MRS.

She resided in Newburyport, and was a sister of Dudley A. Tyng, whose portrait is spoken of under its proper head. This picture is owned by Mrs. Edward A. Newton, Pittsfield.

* SEARS, DAVID, the elder, b. 1753, d. 1816.

His portrait belongs to the heirs of his grandson, the late David Sears, 3d.

SEARS, MR. AND MRS. DAVID.

Hon. David Sears was the son of David, the elder, born 1787, and died in 1871. One portrait of him, painted in 1806, was given to his brother-in-law, Mr. Jonathan Mason, in 1822, on the eve of his departure for England. This portrait was given by Mr Mason to a cousin of Mr. Sears, in London, after whom Mr. Knyvet Sears was named. Another portrait of Mr. Sears is owned by his daughter, Mrs. William Amory, Boston. Mrs. Sears, whose maiden name was Miriam Mason, was a daughter of Jonathan Mason. Her portrait, painted in 1806, is owned by the family of her son, the late David Sears. A portrait of Mrs. Sears, painted by Stuart in 1809, is owned by her daughter, Mrs. William Amory, Boston. Mrs. Sears was born in 1790, and died in 1870. She was one of the most beautiful women of her day. Stuart painted her several times. One of the portraits was painted with the eyes looking up—their finest expression—but for some reason Stuart cut the head out of the canvas.

SEDGWICK, THEODORE.

He was the first Speaker of the House of Representatives under Washington. Subsequently he was United States Senator from Massachusetts, and Judge of the Supreme Court, at Washington. His portrait is owned by Mrs. S. P. Parker, Stockbridge, Mass., who inherited it from her Mother, Mrs. Pomeroy, the eldest daughter of Judge Sedgwick.

SELFRIDGE, THOMAS O.

His portrait is in the possession of his son, Commodore Thomas O. Selfridge, U. S. N. It is a fine picture, and was painted in 1814 or 1815.

Serris, **D.**

Painted in London in 1782.

Seton, William.

Owned by Mr. Burgwynn Maitland, Baltimore. Mr. Seton was the uncle of "Mother Seton," who founded the order of "Sisters of Charity" in the United States.

* Shattuck, Dr. George **C.**

His portrait, painted between the years 1818 and 1820, is owned by his son, Dr. George C. Shattuck, Boston.

Shaw, John.

He was a wine merchant, and the owner of the ship in which Stuart returned to America. Stuart had not the means to pay his passage, and he agreed to paint Mr. Shaw's portrait. For this work he had three sittings, on Sundays, for Mr. Shaw was too much occupied with business to give him any other time. The picture is now in the possession of his granddaughter, Mrs. John Foley, 210 East 10th street, New-York.

* Shaw, Mr. and Mrs. Robert G.

Their portraits were painted in 1816 or 1817, when Stuart had his **studio on** "the Neck," near Boston. Mr. Shaw was born June

4th, 1776, and Mrs. Shaw, whose maiden name was Eliza Willard Parkman, was the youngest daughter of Samuel Parkman. These pictures are owned by Mrs. George R. Russell, 1 Louisburg Square, Boston.

* SHAW, WILLIAM SMITH.

He took an active part in the formation of the Boston Athenæum, and for many years was its librarian. His portrait is owned by that institution, and justice has been done his memory by President Quincy, in his history of the Athenæum.

SHEPARD, R. D.

This portrait is owned by Mrs. Gorham Brooks, 91 Beacon street, Boston.

† SHIPPEN, CHIEF-JUSTICE, b. 1729, d. 1806.

When this portrait was sent to New-York a few years ago to be cleaned, a large price was offered for it and refused. It was given by Miss Bird, a granddaughter of Judge Shippen, to Mrs. Julius Izard Pringle, of South Carolina, who disposed of it to the Corcoran Gallery of Art, Washington, D. C.

SHIPPEN, MISS SALLY.

She was the daughter of Judge Shippen, and became the wife of Thomas Lee, a lawyer from Dublin, residing in Philadelphia. She was one of the Queens of Love and Beauty at the Mischianza, when that city was occupied by the British. Stuart is said to have

spoken of her as one of the most beautiful women he ever painted. She lived for many years with her grandmother, Mrs. Luquer, of Brooklyn, and died at her house,—her last gift to her grandmother being this portrait. It hangs in Mrs. Luquer's parlor, and is in fine condition.

SHURTLEFF, DR. BENJAMIN.

His portrait is owned by Dr. Benjamin S. Shaw, Marlborough street, Boston.

SHURTLEFF, DR. SAMUEL A.

Owned by Dr. Augustine Shurtleff, Boylston street, Brookline, Mass.

SIDDONS, MRS.

Painted in England, for her brother-in-law, Mr. Twiss, and said to be very fine.

* SIGOURNEY, MRS. ANDREW, d. May 19th, 1843, aged 77 years.

Her maiden name was Elizabeth Williams, a daughter of Henry Howell Williams, who owned and occupied Woddle's Island, now East Boston. His house was then the only one in the neighborhood. This portrait became the property of Mr. Andrew J. C. Sigourney. After his death it was purchased by his widow, who is now the wife of Surgeon William M. King, U. S. N. The picture will become the property of Miss Martha Sigourney, a daughter of Mrs. King, and now a minor.

SLADE, MRS.

Her portrait is owned by her son, who resides at Chestnut Hill, near Boston.

SMITH, MRS.

Owned by Mrs. M. J. Rheer, Freehold, N. J.

SMITH, MR. AND MRS. ABIEL.

Their portraits are owned by their great-niece, Mrs. John Wilson, Framingham.

SMITH, MR. AND MRS. BARNEY.

Mr. Smith's portrait is owned by his granddaughter, Mrs. G. B. Upton, Boston, and Mrs. Smith's is in the possession of another granddaughter, Miss R. G. Russell.

† SMITH, REV. WILLIAM, LL.D.

He was Provost of the University of Virginia. The following interesting paragraph is taken from the *Newport* (R. I.) *Mercury*, of June 25th, 1764, under the head of Philadelphia:

"Late on Wednesday evening, the 6th inst., the Rev. Dr. Smith, provost of the college of this city, arrived in perfect health, having come in the Halifax packet in about six weeks, from Falmouth. The day following the professors of the college, in their proper habits, and many of the principal gentlemen of the city, gave

him a most cordial welcome at his house, and on Tuesday last the Trustees of the college received him at the college, and, after perusing the papers and accounts which he laid before them, they did, by the mouth of the president, return him their unanimous thanks for the great zeal, ability, and address which he had shown in the management of the collection, carried on in connection with Sir James Jay, for this college and that of New-York, by means of which about £13,000 sterling will come clearly to be divided between the two seminaries."

Dr. Smith was painted by West in his youth, and by Stuart in his old age. This portrait is a large half-length. A theodolite stands on a table near him, and in the background there is a landscape. The head is superb. It was well engraved by Edwin, about 1800, and has been engraved of late by a youth named George Herbert White. The portrait is owned by Dr. Brinton, Philadelphia, and in the University of Pennsylvania there is a good copy, made by Mr. E. D. Marchant.

Among Stuart's papers the following letter was found:

"Falls of Schuylkill, February 28th, 1803.

"My dear sir:—By Dr. Rush's order, I am now wholly confined to my bed-chamber, and the Doctor, my brother, and my friends who have any regard for me, or business with me, visit me here. I grow every day weaker, but, thank God, he keeps my mind sound and my intellect not much impaired. I beg the pleasure and comfort of a short visit from you in a day or two. My son in two or three weeks will embark for England; I shall never see him again, as I believe. He has consented to sit to you for his picture before he goes. I shall pay you cash down, as we may agree. An answer per bearer is requested, by your affectionate,

"GILBERT STUART, ESQ. "WM. SMITH."

Stuart at this time was making his arrangements to go to Washington, and there is no evidence that he ever filled the order.

SMITH, HENRY.

His portrait is owned by his niece, Miss R. G. Russell.

SMITH, GENERAL AND MRS. SAMUEL.

General Smith was an officer of the Revolution. His portrait was painted while Congress was holding its sessions in Philadelphia. In it he is dressed in the Continental uniform, and on his breast he has the order of the Cincinnati. Mrs. Smith wears a black silk, cut surplice, with short sleeves. These pictures were given by General Smith to his son, John S. Smith, of Baltimore, who gave them to his daughter, Mrs. Robert Hill Carter, of Albemarle, Va., the present owner.

SMITH, COLONEL WILLIAM, b. 1751.

Colonel Smith was on the staff of Washington all through the war, and when the Society of the Cincinnati was organized he took a prominent part in its affairs. He was married to Abigail Adams in London, by the Bishop of St. Asaph. At that time he was secretary of Legation, Mr. Adams being minister to the Court of St. James. The above portrait, painted in early life, is now in the possession of his niece, Mrs. A. M. King, Newport, R. I.

† SPARKS, JARED, b. May 10th, 1789, d. March 14th, 1868.

He became the president of Harvard College in 1849, and resigned in 1853. Of him it was said by Lord Campbell, in the House of Lords, he was "the first of living writers on the law."

His portrait, of which the head alone is finished, was painted in 1827–8, just at the close of Stuart's own life. It is owned by Mrs. Parks, Cambridge, and has been engraved.

SPRING, MRS. MARSHALL B., b. 1791, d. 1825.

She was Miss Willing, of Philadelphia, and after her marriage, in 1816, she resided in Boston. Her portrait was painted in or about 1820. It was the property of Mrs. Peter, wife of Judge Peter, of Philadelphia, and the aunt of Mrs. Spring. The picture now belongs to Mrs. John Field, the daughter of Mrs. Peter, who, on her departure for Europe some years ago, deposited it with Mrs. Edward N. Perkins, the daughter of Mrs. Spring, Pinebank, Jamaica Plain. It is an admirable specimen of Stuart's genius as a portrait painter.

STACKPOLE, WILLIAM.

Owned by his grandson, Mr. J. Lewis Stackpole, Boston.

* STEWART, MRS. DELIA TUDOR.

Mrs. Stewart was the wife of the late Admiral Charles Stewart, U. S. N. It is unfinished, but is still a very beautiful picture, and is owned by Mrs. Frederick Tudor, Boston.

* STORY, JOSEPH, LL. D., b. Sept. 18th, 1779, d. Sept. 10th, 1845.

Mr. W. W. Story, in his biography of his father, says: "No satisfactory portrait was ever made of him. There are many paintings, but they lack that which was most charming in his face. The best is one by William Page, which gives pretty well the

earnest expression of his face. Two busts were made of him; one by Frazee, and the other by myself. I believe that the last is generally considered the best likeness which remains of him. The constant change of expression, and the actual form of his face, made it a most difficult task to express it in sculpture or painting. Every representation lacks the life and animation and glow of the original, and that union of strength and sweetness which it so beautifully displayed."

Stuart's portrait of Judge Story is now owned by Harvard College, and that of Mrs. Story is in the possession of her son, Mr. W. W. Story.

† STRONG, GOVERNOR CALEB.

Owned by Rev. Mr. Anderson, Roxbury. It was engraved by Longacre.

STUART, GILBERT, SENIOR.

This portrait of the artist's father was painted when the son was sixteen years of age. All traces of the picture have been lost.

* † STUART, GILBERT.

This is the artist's portrait, painted by himself. He has on a Rubens hat. The picture is now in the Redwood Library, to which institution it was presented by Mrs. Dr. Waterhouse. It is very inferior to Stuart's later works, and has evidently been injured by the application of bad varnish. On the back there is written, in Stuart's hand: "G. Stuart, Victor Se Ipso Pinxit. A. D. 1778. Aetatis Suae 24."

A portrait of Stuart, painted by himself in London, is owned by Mr. Henry Graves, of that city.

* STURGIS, MR. AND MRS. RUSSELL.

There are three portraits of Mr. Sturgis by Stuart, and one of Mrs. Sturgis. The earliest of Mr. Sturgis is owned by Rev. John Parkman, 20 Brimmer street, Boston, who has also that of Mrs. Sturgis. The next in order is owned by Mr. Russell Sturgis, London. This was painted in middle life. The last and finest is owned by Mrs. Frederick William Paine (Ann Cushing Sturgis), who has it at the family mansion, Worcester, Mass. It is a superb picture. The costume, a fur-bound maroon robe, is rendered with great care and truth.

ST. VINCENT, LORD.

Painted in England.

SULLIVAN, GOVERNOR JAMES, b. 1744, d. 1808.

There are two portraits of him by Stuart, painted in 1807; one of them is in the rooms of the Massachusetts Historical Society, where it was placed by his grandson, Mr. Richard Sullivan, and the other is owned by Mrs. S. W. Oakey, his granddaughter, 44 West 17th street, New-York. This last is the finer of the two.

SULLIVAN, MRS. GEORGE.

Noticed among the Winthrops.

SULLIVAN, MRS. RICHARD.

This beautiful portrait is at the Boston Art Museum.

* SULLIVAN, MRS. WILLIAM.

Her maiden name was Sarah Webb Swan, daughter of Colonel James Swan, and her portrait is owned by Miss Sullivan, daughter of Dr. James Swan Sullivan, Savannah, Ga.

* STILLMAN, MRS.

Her portrait hangs on the wall in the Female Orphan Asylum, Boston.

STUYVESANT, PETRUS.

His portrait, at present deposited in the rooms of the New-York Historical Society, is owned by a descendant, Mr. R. Van Rensselaer Stuyvesant, of New-York.

* SWAN, COLONEL AND MRS. JAMES.

Colonel Swan's portrait, painted about 1808, is owned by his granddaughter, Mrs. Elizabeth Howard Bartol, Manchester, Mass. Mrs. Swan, whose maiden name was Hepsibah Clark, sat to Stuart early in the century. Her portrait is in the possession of Mrs. Charles Stafford, Providence, R. I.

SWAN, JAMES.

He was a son of Colonel James, and married a daughter of General Knox. This portrait is supposed to have passed into the hands of Judge Thatcher, of Maine.

Swett, Mr. and Mrs. Samuel.

Their portraits, painted in 1807, are owned by Mr. William Gray, of Boston. Mrs. Swett's maiden name was Gray.

Tappan, Rev. and Mrs. Benjamin.

The portrait of Mrs. Tappan is noticed in Mr. Winthrop's letter.

Tayloe, Colonel and Mrs. John.

He was born in 1771, and died in 1828. Mrs. Tayloe, who was the daughter of Governor Benjamin Ogle, of Maryland, and granddaughter of Governor Samuel Ogle, of the colony of Maryland, was born in 1772, and died in 1855. Their portraits, painted in 1804, and which have never been cleaned or retouched, are as fresh, apparently, as when first painted. They are now owned by Mrs. B. Ogle Tayloe, who, it is understood, intends to give them, with a portrait of Washington, also by Stuart, to the Corcoran Gallery, in Washington, after her death.

Taylor, Rev. Dr.

This portrait was burnt in the Charlestown Convent, at the time that building was destroyed.

* Temple, Sir John, Bart.

His portrait is in the possession of Hon. Robert C. Winthrop, Brookline.

* Temple, Miss Eliza.

She was the daughter of Governor Bowdoin, and the wife of Sir John Temple. The portrait is owned by the heirs of General Grenville T. Winthrop.

Duplicates of the above are owned by Sir Grenville Temple, bart., Ryde, England.

Temple, Miss Eliza Bowdoin.

She was the daughter of Sir John, and became the wife of Hon. Thomas L. Winthrop. The portrait is owned by Hon. Robert C. Winthrop.

The portraits of the Bowdoins and the Winthrops are referred to in the following letter from Hon. Robert C. Winthrop to Miss Stuart, under date of August 29th, 1876.

"Your note of the 22d reached me a few days ago; to-day I have turned to a letter from my mother to her aunt Bowdoin. The letter is dated Boston, November 26th, 1806. Mrs. Bowdoin, to whom it was addressed, was then in Paris, where her husband was United States minister. After speaking of the health of Lady Temple (her mother), my mother goes on as follows:

"'Stuart has just finished her picture, which is an excellent likeness. He is also copying my father's, and my mother gives them to me, to take the place of those done by Copley. I have sat three times for mine, as my mother is determined to have all her children taken by him. He is a very pleasant companion, and promises himself much pleasure in conversing with my uncle when he returns. He has seen these pictures, which were sent out from Paris, and thinks several of them have merit. He is also pleased with yours. Sarah [my sister, Mrs. Sullivan] he knows nothing of,

but is surprised that you both have acquired the French character, which appears the case from these pictures. I asked him if he could alter the drapery of the one which he took of you, which he can with much ease when you return.'

"This letter, as you perceive, is full of information on the portraits which you inquire about. It fixes the date of Lady Temple's portrait, and of my mother's. But it also proves that your father *copied* the portrait of Sir John Temple. Sir John died in New-York ten years before the date of this letter. He was a great friend of Colonel Trumbull, who had taken more than one portrait of him during his life, and it was his portrait which your father consented to copy, as a *pendant* to the portrait of Lady Temple. I have never seen the original Trumbull, but every one who looks at the copy perceives your father's touch and color in it.

"I have never seen the portrait of Sir Grenville, by your father; I presume it went to England. But I have a very good Sir Grenville, as a young man, by Trumbull.

"Twenty years nearly after the date of my mother's letter, her youngest brother, Mr. James Temple Bowdoin, sat to your father, and the portrait is in Italy, in the possession of his daughter, my cousin, the Princess di Pandolfina. I saw it in Florence last year, and with it a portrait of Mrs. Temple Bowdoin, which my uncle had induced your father to take from sketches and crayons after death.

"There is a very beautiful portrait, by your father, of my eldest sister, Miss Eliza Temple Winthrop, afterwards the wife of the Rev. Benjamin Tappan, of Augusta, Maine. I have a copy of it by your father, but the original is in the possession of my niece, Mrs. E. B. Webb. Nothing more beautiful ever came from your father's pencil than this. It must have been taken about the same time with Lady Temple's and my mother's, as my sister Eliza was then living with her grandmother, Lady Temple, as an adopted daughter, almost.

"Your father, as you may possibly remember, commenced a portrait of my father, somewhere about 1824. It remained unfinished when your father died, and my father purchased the sketch. Strange to say, that precious piece of canvas has disappeared! I would give much to recover it. I have often heard my father say, that when Stuart first came to Boston, he advanced him the sum necessary for opening a studio. There was always a warm regard between the two, and nothing gave me greater pleasure than to supply him with any information in my power. I may add that your father painted Hon. James Bowdoin, after his return from Europe, and the portrait is at the Bowdoin College, together with portraits of Jefferson and Madison, painted by your father for Mr. Bowdoin. There is also a portrait of my sister Sarah, afterwards Mrs. George Sullivan, painted by your father, probably about the time he was painting Mr. Bowdoin.

"You will see by this how large a number of Temples, and Bowdoins, and Winthrops, have enjoyed the privilege of your father's pencil.

"I have a miniature copy, by Malbone, of your father's portrait of Hon. James Bowdoin: thus I have Stuart's copy of a Trumbull, and a Malbone copy of Stuart. It was a rare thing, I imagine, for these great artists to condescend to copy anything.

"One thing more, and I will relieve your patience. Mrs. Winthrop has on our walls what purports to be the only landscape your father ever painted! It was purchased by her former husband, the late Mr. John E. Thayer."

THAYER, REV. NATHANIEL, D. D., b. July 11th, 1769, d. June 23d, 1840.

Dr. Thayer was ordained October 23d, 1793, in Lancaster, Mass., and continued to be the pastor of the Congregational Church

in that place up to the time of his death, which took place while on a journey to Niagara Falls. His portrait is owned by Mrs. Robert C. Winthrop, Brookline, Mass.

* THORNDIKE, COLONEL, MRS. ISRAEL, AND MRS. ISRAEL THORNDIKE, JR.

Mr. Thorndike was born at Beverly, Mass., and died May 11th, 1832, aged about 75 years. He was a successful merchant. His portrait, painted between the years 1815 and 1820, is owned by his granddaughter, Mrs. Robert C. Winthrop, Jr., Boston. A duplicate belongs to the heirs of Colonel Thorndike's eldest son. A portrait of Mrs. Israel Thorndike, senior, is owned by her nephew, Mr. S. T. Dana, 3 Arlington street, Boston. A portrait of Mrs. Israel Thorndike, Jr. is owned by Mrs. George H. Thorndike, Newport, R. I. The head in this picture is fine, but the arms are carelessly drawn.

THORNTON, SIR EDWARD.

He came to this country in 1790, and remained here till 1803. He died in 1853, aged 86 years. While in America he sat to Stuart at least three times; for he and the artist were warm friends, and lived very much together. Sir Edward often told his son, the present British Minister, that Stuart's conversation was brilliant, and that he talked in the most pleasing way and painted at the same time, so as to catch the most interesting expression of his sitters.

One portrait of Sir Edward Thornton is in England. Another portrait of him was painted for Lord Hammond, when he was the British Minister. This portrait, when it came into the possession of the son of Lord Hammond, was given by him to the present Sir Edward, who has it at the Legation, in Washington. In the estimation of all who have seen it, and who are familiar with the

artist's works, Stuart never painted a finer portrait. Sir Edward also owns the portrait of his father, by Stuart, now in England.

The third portrait of Sir Edward Thornton was painted by Stuart for Sir Robert Liston, who came to this country, as British Minister, in 1796. This picture was probably taken to England.

THORNTON, DR. AND MRS. WILLIAM.

Dr. Thornton came to America from Antigua, in 1788. He was a strong advocate for colonizing Africa with , blacks from America, as the most humane way of treating those who were in bondage. DeWarville spoke of him as wedded to the project of Frothergil. He was not only willing to devote his fortune to the cause he had espoused, but was ready, if need be, to lead the colonists to Africa.

These portraits are now owned by Miss Talbot, daughter of Hon. Hiram Talbot, of Kentucky. There is also a portrait of Dr. Thornton in the Patent Office, painted by Stuart and presented by Miss Talbot.

* TILDEN, BRYANT T.

His portrait is owned by his daughter, Miss K. B. Tilden, Boston.

TILGHMAN, WILLIAM, b. August 12th, 1756, d. 1827.

The portrait of Chief-Justice Tilghman, by Stuart, is owned by the heirs of the late Mrs. Greenleaf, who was his sister-in-law. There is a copy of it, by Neagle, in the Law Library, Philadelphia.

TILLOTSON, DR. THOMAS.

He was a surgeon in the army of the Revolution, and subsequently Secretary of State in New-York. His portrait is in the possession of his granddaughters, at 23 East 28th street, New-York.

TODD, MR.

TORRY, MISS FRANCES.

She became the wife of a gentleman named Rollins. Her portrait is owned by Mr. John T. Morse, her son by a second marriage.

TOURO, ISAAC.

His portrait was painted from memory, after his death. The Touros were a wealthy family of Jews, in Newport, R. I. Judah, the last of the name, moved to New Orleans prior to the war of 1812, and died in that city. What became of the portrait of his brother is not known.

* TOWNSEND, ALEXANDER.

He was a graduate of the Harvard class of 1802, and died in 1835. He never married. His portrait was left by his sister, Miss Mary P. Townsend, to her cousin, Mrs. Calvin W. Clark, who presented it to her eldest son, and it is now in his possession, at 31 Moreland street, Boston Highlands. Miss Townsend bequeathed a very considerable sum to Harvard College, and endowed the "Townsend Ward" in "The Old Ladies' Home."

TRACY, NATHANIEL.

He was a prominent merchant in Newburyport. His portrait, it is understood, was painted in England, probably soon after Stuart left West's studio. He is dressed in the fashionable green coat and powdered hair of the period. The picture is now in the public library in Newburyport, to which institution it was presented by his daughter.

TRAVIS, MR. AND MRS. JOHN.

He is dressed in a blue coat with brass buttons, white vest and neckerchief. Mr. Travis was an Englishman, who came to this country after the war, and married Elizabeth, daughter of Dr. Thomas Bond, a native of Maryland, but resident in Philadelphia, where he was the leading physician of his day. Mr. Travis was the father of Lady Erskine, before mentioned. He died in Philadelphia in 1803.

The portrait of Mrs. Travis faces left. She holds a half-opened book in her hand, and is dressed in white, with hair powdered. The head alone is well painted. Miss Bond was one of the ladies of Andri Mischianza. She died in 1818.

Their portraits are owned by their daughter, Mrs. William G. Cochran, of Philadelphia.

TRUMBULL, COLONEL JOHN, b. 1756, d. 1843.

There are, or should be, two portraits of Colonel Trumbull painted by Stuart; one, painted in England, has already been referred to, the other was painted in this country.

TUCKERMAN, REV. JOSEPH, D. D.

His portrait is a striking likeness, and is fresh and vivid in color. Between the artist and sitter there was always a pleasant intercourse, and the portrait shows that the painter was interested in his work. It was painted in 1808, and is owned by Mr. Lucius Tuckerman, New-York.

* TUCKERMAN, MR. AND MRS. EDWARD.

These portraits were painted prior to 1814, in which year Mrs. Tuckerman died. The portrait of Mr. Tuckerman is owned by his son, Mr. Edward Tuckerman, Amherst; and that of Mrs. Tuckerman, who was a daughter of Samuel Parkman, is in the possession of her grandson, Mr. Edward T. Mason, of New-York.

Stuart also painted the portrait of Mr. Tuckerman's second wife. She was the daughter of John May. The first head was not successful, and Stuart would not go on with it. He then painted another picture, which he finished. This was about 1820. Many years later, Harding put in the drapery of the unfinished portrait. These portraits are owned by Mr. Edward Tuckerman.

TUDOR, WILLIAM, SENIOR.

He was Judge-Advocate under Washington. His daughter, Emma, married Robert Hallowell Gardiner, and his portrait is owned by Mr. Robert Hallowell Gardiner, of Gardiner, Maine.

TUDOR, MRS.

Tudor, William.

He was the son of the above, and author of the " Life of James Otis." His portrait is also owned by Mr. Gardiner.

* Tyng, Dudley A., b. 1760.

His portrait, painted in 1820 or '21, is owned by Mrs. Edward A. Newton, a daughter of Mr. Tyng, Pittsfield, Mass.

Van Ness, John P.

He was a remarkably handsome man, with finely cut features and a fair complexion. In the portrait of him he is dressed in a dark-blue coat, and the heavy folds of a white neck-cloth encircle his throat. His hair, parted in the middle, is powdered. The portrait, painted in 1803 or '4, when he was of the age of about 35 years, is owned by his nephew, Colonel William H. Phillips, Lafayette Square, Washington.

Van Rensselaer, Stephen.

He was the Patroon. He is seated in a crimson chair, near a crimson-colored table-cloth, and is dressed in a dark-brown coat, showing a double row of gilt buttons. The vest is buff, and in his left hand he holds a buff-colored glove. The white cravat is tied in an elaborate bow ; there is scarcely a ruffle on his shirt, and the powdered wig, which comes down on his forehead with a slight curve near the eye, falls in curls over a double standing collar. At

the back his hair is gathered into a cue. His complexion is fair, and the expression is pleasing. The portrait, owned by Hon. John Jay, is at Bedford, Westchester County, New-York.

VAUGHAN, JOHN, b. July 15th, 1756, d. December 13th, 1841.

He was an English gentleman, and a man of fortune, residing in Philadelphia. Alarmed at the riots, at the time of the destruction of the house of Dr. Priestley, 1793, he removed to Hallowell, Maine. His portrait is owned by Dr. Charles E. Vaughan, Cambridge, Mass.

VOLNEY, COUNT CONSTANTINE FRANCOIS.

He came to this country in 1795. He is represented as seated in the conventional red damask chair, wearing a brown coat, a ruffled shirt, and a white neck-cloth. The forehead is quite bald. He has a shut book in his right hand, and the other hand crosses it.

Volney wished to be taken with open throat, after the manner of the portraits of Voltaire, for whom he had great admiration; but the painter followed his own bent, and painted him as above described. The sittings were at Germantown. Stuart was then residing there, and the Binghams were at Lansdowne, their country seat, in the immediate neighborhood. Volney was then giving instruction in French to the children at Lansdowne, and it was an easy matter to walk daily to Stuart's studio. The picture is at Trenton, and is owned by Miss Mary Willing Clymer.

WALKER.

WARREN, JOHN COLLINS, M. D., b. 1788, d. 1856.

His portrait is owned by his son, Dr. John Collins Warren, Boston.

WATERHOUSE, DR. BENJAMIN, b. 1754, d. 1846.

His portrait, painted at the age of 22 years, is now in the Redwood Library, to which institution it was presented by Mrs. Waterhouse.

WATERSTON, MR. AND MRS. ROBERT.

Mr. Waterston was born in Edinburg, in 1778, and died in 1869. His portrait was painted in 1828, the year that Stuart died. Mrs. Waterston, who was ten years younger than her husband, was Miss Lord, of Kennebunc, Maine. Their portraits are owned by their son, the Rev. R. C. Waterston, 71 Chester Square, Boston, who says:

"I remember Stuart perfectly, and often went to his room when he was at work on my father's portrait, as well as on that of my mother. He was a marked man; in all his conversation showing his genius, his quickness, and sparkling wit."

* WEBSTER, DANIEL, b. January 18th, 1782, d. October 24th, 1852.

This is an unfinished picture, the head being the only part painted in. In it the head is smaller than it is represented in pictures that were painted later in life. Mr. Jonathan Mason, of Boston, said of this picture: "Daniel Webster's head, taken

when he first removed from Portsmouth to Boston, I saw years ago—the most intellectual head of Webster ever taken."

This portrait, which has been criticised, was painted for Mrs. Edmund Dwight, and is owned by her daughter, Mrs. Mary Eliot Parkman, Boston.

WELCH, MR. AND MRS. FRANCIS.

Their portraits are owned by their son, Mr. Charles H. Welch, Waltham, Mass.

WELLS, REV. WILLIAM, D. D., b. 1774, d. December 9th, 1827.

His portrait was painted for William Wells, his eldest son, and it remained in the family mansion, Cambridge, till about three years ago, when it passed into the hands of Mr. Kirk Boott Wells, of Philadelphia, the present owner, and only surviving son.

Rev. Dr. Wells was a dissenting minister, who came from England in 1793, and settled in Brattleborough, where he was revered and beloved by his people. In 1818 he went to England to visit his daughter, the wife of a merchant in Liverpool, and it was just before he sailed that this portrait was painted. He is represented as a fine-looking old gentleman, of seventy or seventy-five years of age. Silliman, in his "Tour between Hartford and Quebec," in 1819, speaks of Dr. Wells, whom he saw at Brattleborough, with much admiration.

WESTMEATH, LADY.

Her portrait was painted in Dublin.

† WEST, BENJAMIN, P. R. A., b. 1738, d. 1820.

He is seated in an easy-chair, at a table; one hand is resting upon a book, and in the other he holds a porte-crayon. The picture is a small half-length, the same size as the portrait of Woollett, and was presented in 1853 to the National Gallery, England, by Mr. J. H. Anderson.

There are two pictures in Fitzroy Chapel, Fitzroy Square, London. One represents Moses kneeling and receiving the Commandments; the other is a whole length of our Saviour, designed by West, and painted by Stuart.

West painted a large picture of the "Order of the Garter," in which he introduced the head of Stuart among the spectators. Stuart then painted the head of West in the same group. The head of Stuart has frequently been recognized by those who knew him.

WETMORE, JUDGE.

His portrait belonged to his daughter, the late Mrs. Judge Story, and at her death it became the property of her son, Mr. William Wetmore Story, who is now residing at Rome.

† WHEELER, MR. M. AND WIFE.

† WHITE, RT. REV. BISHOP WILLIAM.

He is represented in his Episcopal robes. The portrait, one of great force and character, was painted about 1798, when the Bishop was about fifty years of age. It is owned by Mrs. George H. White, 245 South 16th street, Philadelphia.

WHITEFOORD, CALEB.

Painted in London, in 1782.

WHITING, MR.

His portrait is owned by his daughter, Mrs. Noah Allen, Medfield, Mass.

WILLIAMS, MR. AND MRS. CUMBERLAND.

Their portraits are owned by Mrs. Harry McCoy, Baltimore.

WILLIAMS, SAMUEL.

His portrait is in the possession of his great niece, Miss Lizzie Burnap, Baltimore. It was painted after death.

WILLIAMS, MRS. GEORGE.

Her maiden name was Lydia Pickering, sister of Colonel Timothy Pickering, and her portrait was painted by Stuart when she had reached the advanced age of eighty-eight years. It has been spoken of as a very beautiful and striking representation of old age. It is owned by her granddaughter, Miss Mary Pratt, 85 Mount Vernon street, Boston.

* WILLIAMS, MISS SUSAN MAY.

Her portrait was painted when she was a child three years old. It is now owned by her cousin, Mr. George H. Williams, Baltimore. Miss Williams became the wife of Jerome N. Bonaparte.

WILLIAMS, JOSEPH.

His portrait is owned by his grandson, Mr. George H. Williams, Baltimore, but, with the one above, is at his country seat, in Harford County, Md. This picture has frequently been copied by artists who have been anxious to study Stuart's coloring. It hangs in the dining-room, surrounded by family portraits—two by Sir Peter Lely, two by Sir Godfrey Kneller, two by Sully, and a number of others. "They all look like what they are—paintings," says Mr. Williams; "but that by Stuart looks like living flesh and blood."

* WILLIAMS, MR. AND MRS. S. K.

The portrait of Mr. Williams was painted in 1824. The hand is unfinished. That of Mrs. Williams was painted in 1823. Stuart received for these portraits one hundred dollars each. They are owned by Mrs. S. K. Williams, 68 Boylston street, Boston.

WILLIAMS, MRS. MARY SUMNER.

Her portrait is now owned by Mrs. George Hollinsworth, Mattapan, Mass., the great granddaughter of Mrs. Williams.

WILLIAMS, JOHN.

He was the son of the above Mrs. Williams, and is represented as a middle-aged man. His portrait belongs to his daughter, Miss Anne Williams, Boston.

WILLING, ELIZABETH.
See JACKSON, MRS. MAJOR.

WILLING, MR. ———.

Owned by Mr. Edward Willing, Philadelphia.

† WILLING, THOMAS.

It is a full face, to the left, with a wig. The lips are compressed and the expression is severe. It is a very poor specimen of Stuart's work, and has apparently been cleaned by some later-day artist. Owned by his great-grandson, George Willing, of Germantown, it is at present deposited in Independence Hall, and has been engraved,—private plate,—for Mr. Charles Henry Hart, to whom I am indebted for these lines.

"Mr. Willing, who was the father of Mrs. Bingham, Mrs. Jackson, and Mrs. Peters, and the partner in business for thirty-nine years of Robert Morris, has had his life delineated by the late Horace Binney, in the following epitaph upon his tombstone, in Christ churchyard :

"'In memory of Thomas Willing, Esquire ; born nineteenth of December, 1731, O. S., died nineteenth of January, 1821, aged

eighty-nine years and thirty days. This excellent man, in all the relations of private life, and in various stations of high public trust, deserved and acquired the devoted affection of his family and friends, and the universal respect of his fellow-citizens. From 1754 to 1807, he successively held the offices of Secretary to the Congress of Delegates at Albany, Mayor of the city of Philadelphia, her representative in the General Assembly, President of the Provincial Congress, Delegate to the Congress of Confederation, President of the first chartered Bank in America, and President of the first Bank of the United States. With these public duties he united the business of an active, enterprising, and successful merchant, in which pursuit, for sixty years, his life was rich in examples of probity, fidelity, and perseverance upon the stability of commercial establishments, and upon that which was his distinguished reward upon earth, public consideration and esteem. His profound adoration of the Great Supreme, and his deep sense of dependence on His mercy in life and in death, gave him at the close of his protracted years, the humble hope of a superior one in Heaven.' "

Hon. T. F. Bayard, of Delaware, writes that he has also a portrait of Thomas Willing, painted by Stuart.

WINTHROP, JOSEPH, b. 1757, d. 1828.

His portrait is owned by the heirs of the late Joseph A. Winthrop, of Charleston, S. C.

WINTHROP, WILLIAM, b. 1756, d. 1827.

He was of New London, and his portrait, a fine one, is somewhere in Pennsylvania, where it is owned by Mrs. G. F. Chester.

† Wolcott, Oliver.

Woollett, William, b. 1735, d. 1785.

His portrait is on a canvas, three feet high by two feet four inches wide. It is a half-length. He is seated, has a red cap upon his head, and behind him one sees part of a copperplate, on which is represented part of his engraving of West's "Death of Wolfe." It belonged to the Alderman Boydell collection, and in 1850 was presented to the National Gallery, London, by Messrs. Henry Graves & Co., successors to Boydell.

Yates, Mr. and Mrs. Lawrence Reid.

Mr. Yates was an English merchant, who resided in New-York, and died in that city in 1797. Mrs. Yates' maiden name was Caroline Matilda Cruger, daughter of Henry Cruger, who was also an English merchant, residing in New-York, and had been a member of Parliament in 1774. The married life of Mr. and Mrs. Yates was short, their daughter, who afterwards became Mrs. Taylor, having been born after the death of her father. Mrs. Yates became the wife of Judge Henry Walton. The above portraits, painted about 1797, were left to Mrs. Ward Hunt, of Utica, New-York, by her step-mother, Mrs. James Taylor, of Albany.

————

At the exhibition of pictures in 1828, there was a pencil drawing of a naked child, done by Stuart at Lambeth, in 1777.

Mr. Henry Graves furnished Miss Stuart with the following list of her father's pictures which had been exhibited at the Royal Academy:

"1777. His first work exhibited was 'a portrait of a gentleman.' He then resided at 27 Villiers street, London.

"1779. A young gentleman; a little girl; a head. He then resided at West's house, Newman street.

"1782. Caleb Whitefoord; a gentleman skating [W. Grant]; a gentleman. He was still residing with Mr. West.

"1785. Admiral Barrington; a gentleman, whole length; Lord Dartrie, an Irish Lord. He then resided at New Burlington street, London.

"A full length of General Washington is at Carlton Terrace, Pall Mall, London."

INDEX